P9-DEB-638

THE BIG BOOK OF
Airbrush
BASIC TECHNIQUES AND MATERIALS

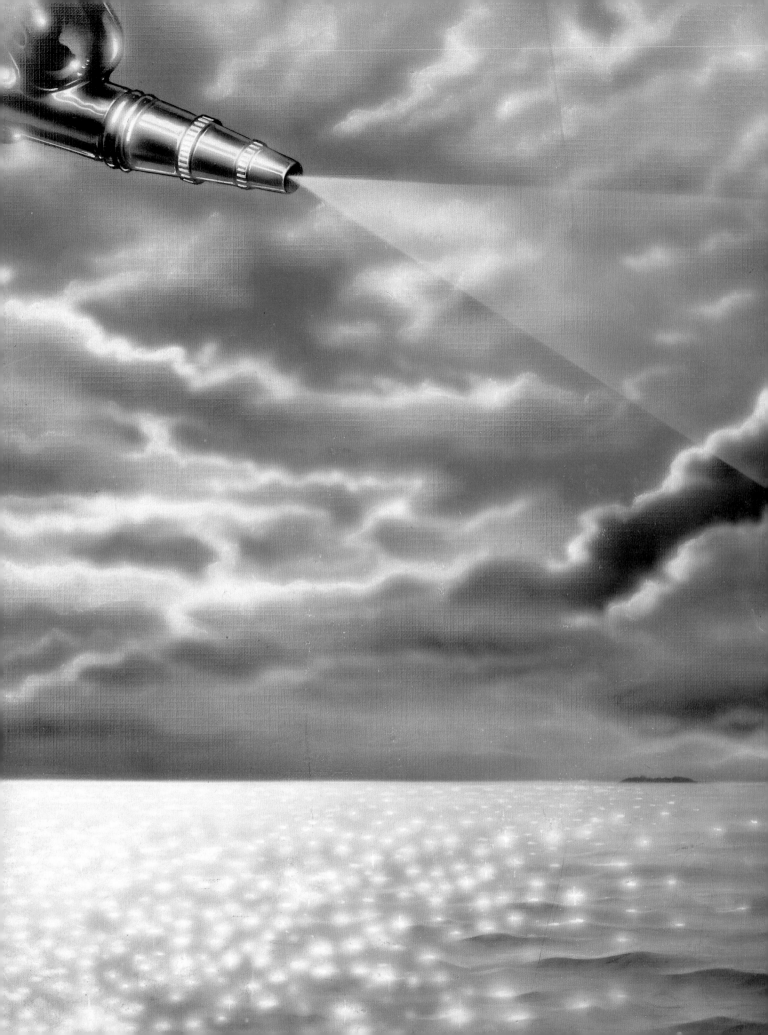

THE BIG BOOK OF
Airbrush
BASIC TECHNIQUES AND MATERIALS

José M. Parramón

and

Miquel Ferrón

WATSON-GUPTILL PUBLICATIONS/NEW YORK

Contents

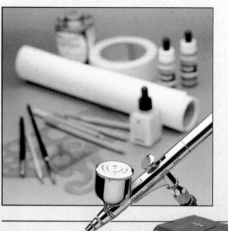

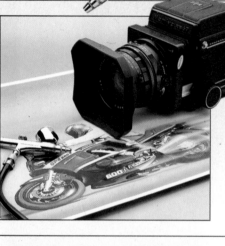

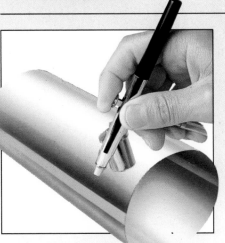

Introduction

In 1970, Oxford University Press published a dictionary, *The Oxford Companion to Art,* that was highly acclaimed for its detail and wide range of information (3,000 entries, 1,200 pages). On page 169 there are 80 lines devoted to the term *brush.* This "instrument for painting," the entry tells us, dates back to prehistory, was employed by the ancient Egyptians, the Chinese, the medieval artists. *The Oxford Companion* goes on to weigh the relative merits of different kinds of brushes —cow's hair, sable, bristle, watercolor vs. oil brushes— and to examine the brush styles of Dürer, Delacroix, and Cézanne. By contrast, page 21 contains a mere four and a half lines on the subject of the Air Brush (sic): "An instrument used chiefly by commercial artists, for spraying paint or varnish by means of compressed air. It can be controlled so as to paint large areas of flat color, gradations of color, or a fairly fine line."

The last edition of the dictionary was published in 1984, a late date, indeed, for the lamentable dissemination of misinformation about the airbrush and its role as a creative artistic instrument. But this ubiquitous tool has never had an easy time gaining art-world acceptance. It was invented in 1893 by the English watercolorist Charles L. Burdick, who that year crossed the Atlantic, founded the Fountain Brush Company, and launched the first series of airbrushes onto the market. Burdick was the first artist to run into trouble with the art establishment over the airbrush, though he was far from the last.

The Royal Academy of Arts rejected his airbrush executed watercolors for its annual exposition, not for lack of artistic quality but because they were the product of a mechanical instrument.

Man Ray was lambasted for his airbrush experimentation, too. The American painter, drawing teacher, sculptor, photographer, and man of the cinema, born in 1890 in Philadelphia, is perhaps best known as one of the founders of the Dada movement, the forerunner of Surrealism and Pop Art. In 1918, always searching for something new —"and finding it," as Picasso once said— Man Ray discovered the airbrush. With it he produced a series of pictures that he exhibited in Paris under the title *First Object Aerated.* The show was a disaster. Art critics denounced Ray as "a swindler, a criminal for having devalued the art of painting using mechanical means." After that debacle, the airbrush languished as an instrument of fine art, consigned instead to the commercial realm.

Fig. 1. Man Ray, *La Volière,* Foundation Roland Penrose, Chiddingly Sussex, England. One of Ray's first airbrush works, it was painted around 1918.

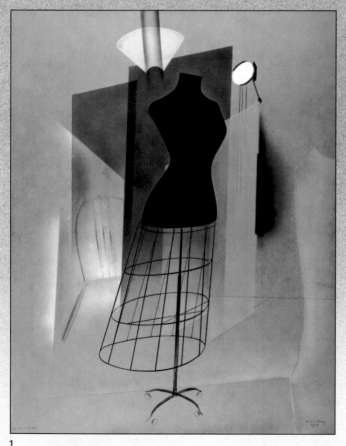

1

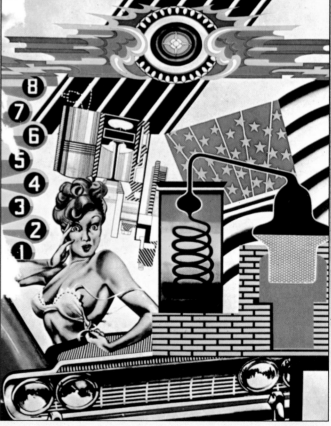

2

Here it was used for painting pin-ups of the Vargas and Petty variety, for example, or for touching up photographs, painting posters, and illustrating advertisements. But by the 1960s, the world of commercial art was exerting a pull on fine artists, and as the founders of Pop Art began to find inspiration in images from advertising, they rediscovered the airbrush. Warhol's images of Marilyn Monroe and Campbell's soup cans, Lichtenstein's amplified comic vignettes, Wesselmann's stylized nudes, and other Pop expressions unabashedly used all manner of artistic expression: oils, acrylics, enamels, serigraphy—and the airbrush. Peter Philips and Allen Jones were two Pop artists who particularly relied on this tool.

The airbrush's place in the fine arts became more solid with the next artistic wave, Photorealism. This movement was exemplified by the Guggenheim Museum's landmark exhibition *The Photographic Image* in New York, an enormous display of oversize pictures painted with absolute realism. They were emotionless and mechanical, and to all appearances photographic, boasting ultrasharp images in the form of gigantic portraits, blown-up details of motorcycles and cars, interiors, and urban landscapes dotted with super-detailed neon signs. Other exhibitions followed, culminating in the 1972 Paris Biennial, where a new form of artistic expression was introduced: Hyperrealism, or realism taken to its limit. Of course, the airbrush was the ideal medium for this particular art form, its principal characteristics being sharpness and a perfect finish of the images. Hyperrealism's acceptance ensured that the airbrush had finally and irrevocably won its place in the world of fine arts. Today it is seen as just another tool in the artist's arsenal. There are expositions dedicated exclusively to airbrush paintings, and many well-known artists rely on the airbrush to execute their works.

But this hard-won prestige should be safeguarded. Along with the widespread use have come abuses of the airbrush technique.

It's perfectly acceptable to use the airbrush to doctor a photograph or a painting reproduced from a photograph— improving, deleting, accentuating, and reducing forms, color, or contrasts to meet an artist's vision. What is not acceptable is to simply copy from a photograph and present the result as an original work, a tactic that happens all too often. Some airbrush aficionados barely know how to draw or paint, but execute works of "art" by means of photocopies, tracing, and transfers. Naturally, their works contain errors in construction and drawing, sometimes in perspective, and nearly always in contrast and color harmony. In short, to paint with an airbrush, it is necessary to master the arts of drawing and painting.

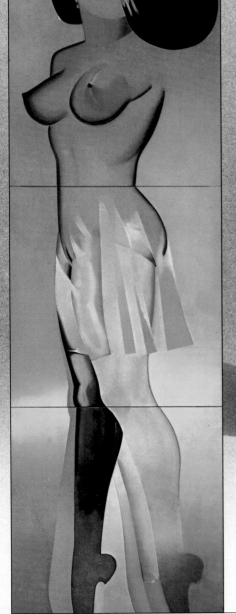

Figs. 2 (opposite page) and 3, Peter Phillips, *Painting for a Client,* Binoche Collection, Paris. (This page), Allen Jones, *Perfect Match,* Sammlung Ludwig Gallery. Phillips and Jones were among the Pop artists who embraced the airbrush.

Introduction

The magnificent image of the tube of paint at the bottom of the page is a work by Miquel Ferrón, co-author of this book, who drew and painted it with the model—this tube—in front of him. The construction, effects of light and shade, contrast, and color harmony are the work of a skilled artist and draftsman with a personal vision (Ferrón is a teacher of figure painting and drawing). The dramatic and fantastic image that appears opposite is a work by Gottfried Helnwein. Painted with an airbrush using watercolors, it is another good example of the mastery of painting and drawing applied to an airbrush image.

In writing this book we have taken this idea into account: that to paint well with an airbrush, you must first paint well. On the following pages you will find a detailed study of the nuts and bolts of painting—perspective and shadows, proportion and dimension, color and mixes, color harmony and contrasts, and so on. It terms of the airbrush itself, the book begins with information on the materials and implements needed to start, including a detailed look at the different types of airbrush models and systems available and an analysis of the most common colors used in airbrush painting. This is followed by information on auxiliary materials, papers and canvases, and masks. The next section delves into the photograph as an auxiliary medium and explores techniques for transferring photographic images, including step-by-step explanations.

The last part of this book presents a brief account of the materials and techniques used by six great airbrush painters, and reproduces some of their best work. Next comes a series of exercises painted with different airbrushes and demanding different techniques, such as painting free-hand, painting a technical image, creating reflections, and painting flesh colors.

We hope this unique book will be useful to those who want to try their hand at airbrush painting.

José M. Parramón

Figs. 4 and 5. Miquel Ferrón, *Tubo de Color,* private collection. (Opposite page), Gottfried Helnwein, *Selbstportrait III,* private collection, watercolor on paper. These pictures show that mastery in the art of drawing is a decisive factor in successful airbrush painting.

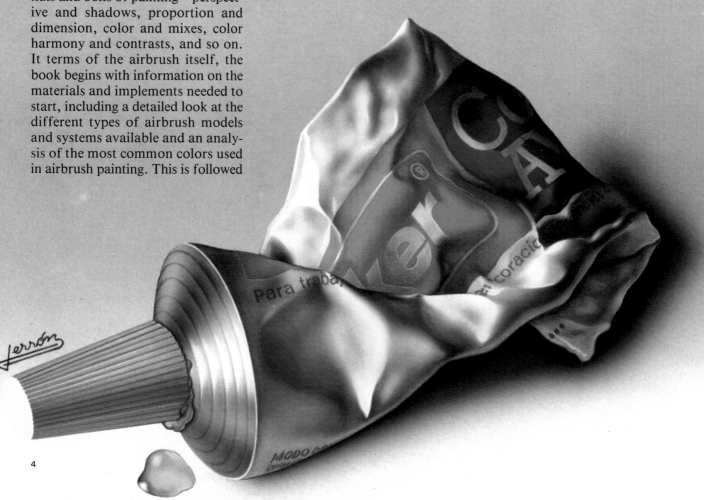

4

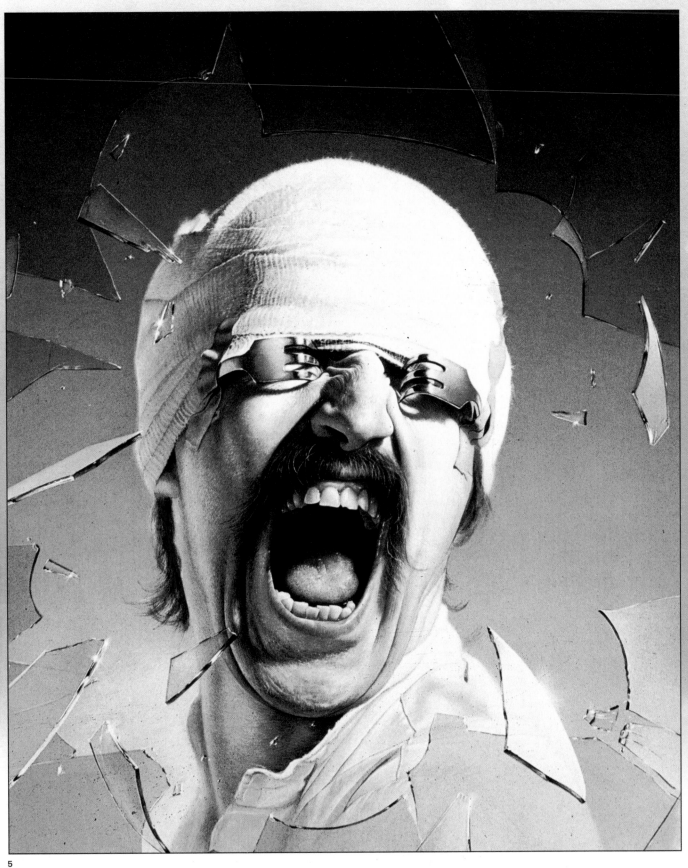

5

This important chapter, the longest in the book, contains a wide range of information on virtually every technical aspect of the airbrush along with descriptions of different airbrush systems, from the simplest single-action types to the most sophisticated, state-of-the-art varieties, such as the Paasche Turbo AB, the Aerostat, the Chameleon, and the Kodak Aztek. The latter, with its four nozzles for four corresponding needles, is the sine qua non of airbrushes. You will also find out about makes and models of compressors and the necessary colors and auxiliary materials. Finally, there is a practical, step-by-step explanation of self-adhesive, fixed, and mobile masks and masking liquids. This chapter is required reading for both the neophyte and the expert.

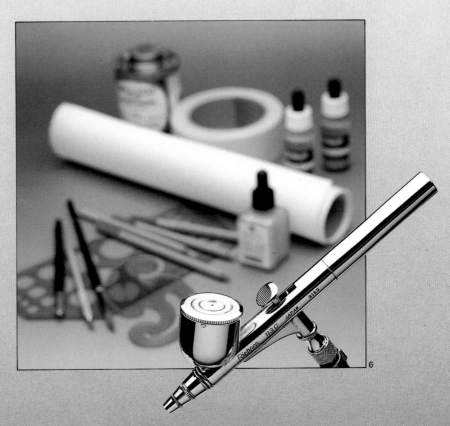

MATERIALS
—AND—
EQUIPMENT

The studio

For most people, an artist's studio is a paint-spattered garret or more realistically, an unused room he has taken over as a place to work. But the technology of the airbrush means that an airbrush artist's workspace must meet some minimum conditions in terms of space and ventilation. It's advisable to have a space at least 17 ft^2 (16 m^2) in order to avoid the noxious effects of paint atomization. For the same reason, good ventilation is an absolute must. A direct ventilation system is best, but failing that, an extractor will do. Figure 7 shows an ideal studio setup, a model of the distribution of furniture, materials, and accessories. There's the studio easel (a) for painting in large formats; cork board (b), which is useful for pinning up color samples and the like; light box (c) for copying and tracing images; large chest of drawers (d) to store paper, artwork, etc.; box of special markers for sketching (e); brushes in a variety of sizes (f); curve templates (g); adhesive film for masking (h); inclined table (i); studio lamp for illuminating the work table (j); adjustable swivel stool with wheels (k); auxiliary table for holding airbrush equipment (see alternative options on the following pages) (l); and on the top right-hand shelf, jars of aniline dyes (m) plus solvents and rubber cement (n). Finally, at the far right of the illustration is a sink with running water (o). This is an absolute necessity in the airbrush studio for cleaning the airbrush after use and between color changes.

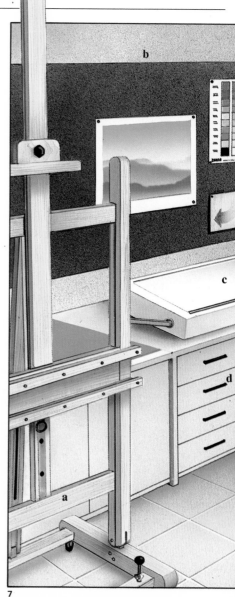

Fig. 7. This is an ideal airbrush studio, spacious enough to allow a rational layout of furniture, materials, and accessories. A beginning airbrush artist need buy only the basics, progressively adding equipment as needed.

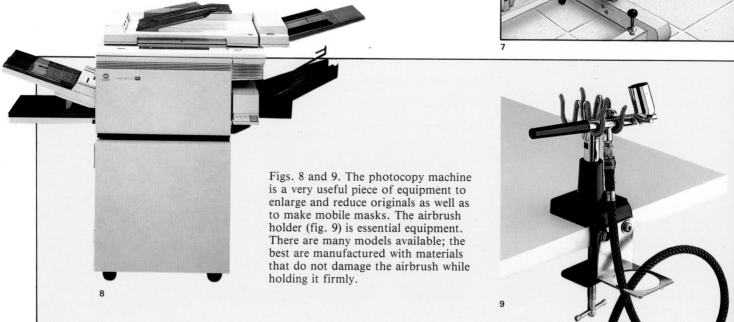

Figs. 8 and 9. The photocopy machine is a very useful piece of equipment to enlarge and reduce originals as well as to make mobile masks. The airbrush holder (fig. 9) is essential equipment. There are many models available; the best are manufactured with materials that do not damage the airbrush while holding it firmly.

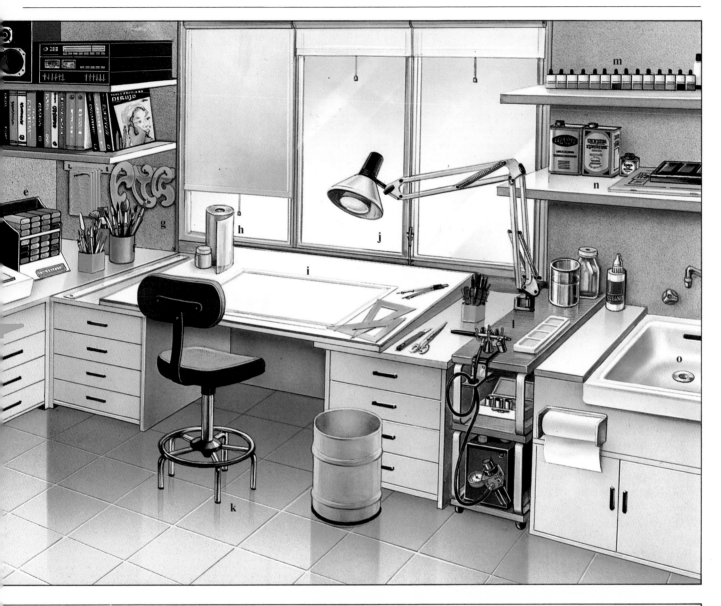

Figs. 10 and 11. The projector at left can come in handy to project photographs or other originals at different sizes; the light table at right is useful for tracing the drawing.

10

11

Furniture and accessories

The centerpiece of the airbrush studio is the work table. Its design, size, and firmness are points worth considering. You can work flat on a table with a board —quite a few artists do— but many others prefer a work surface that's slightly inclined: 10° or so. Some boards come mechanized and can be installed on a horizontal table to give the desired slant. Such boards must be firm. They should also be strengthened with wooden beams to prevent any strain on the surface. Even better is a surface such as the table illustrated on this page (fig. 12). The design is totally adaptable to all the needs of airbrush work: it has an inclined board, a chest of drawers to store material, and a cabinet in which to install the airbrush's compressor with enough room left over to stash away the airbrush holder. This eliminates the problem of an overly lengthy hose.

Another advantage is that the board is removable, so the whole table can be easily moved if necessary.

An alternative is the auxiliary table (fig. 13), which puts important accessories within easy reach. It also offers a place to install the compressor, and since the table has wheels, the compressor can follow the artist around the studio. Moreover, this model boasts special airbrush holders, which maintain the airbrush almost automatically. A shelf keeps auxiliary materials within easy reach.

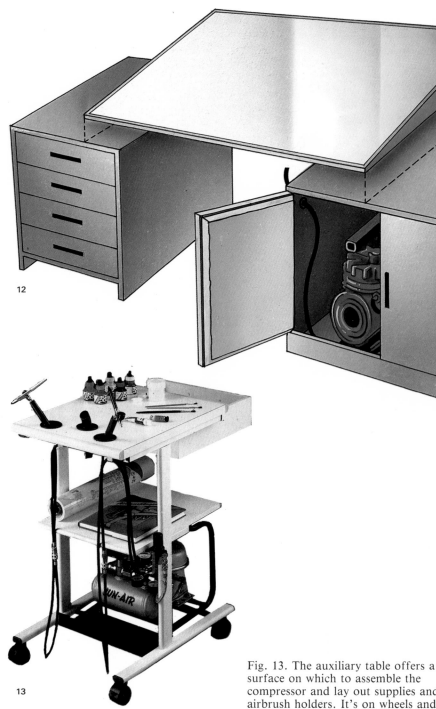

12

13

Fig. 12. The work table with an inclined board rests on a set of drawers to store material and a cabinet to hold the compressor. Since compressors, even the most up-to-date models, tend to overheat, it is advisable to keep the door of the cabinet open while working or, even more practical, remove the back wall of the cabinet.

Fig. 13. The auxiliary table offers a surface on which to assemble the compressor and lay out supplies and airbrush holders. It's on wheels and can be rolled to wherever the artist is working, eliminating the need for long hoses that can get in the way of the work. (The photo of the Air Caddy table shown here has been supplied courtesy of Jun-Air.)

Figs. 14 to 16. The studio easel, the table easel in the form of book stand, and a tripod-shaped rack are common accessories in an airbrush studio.

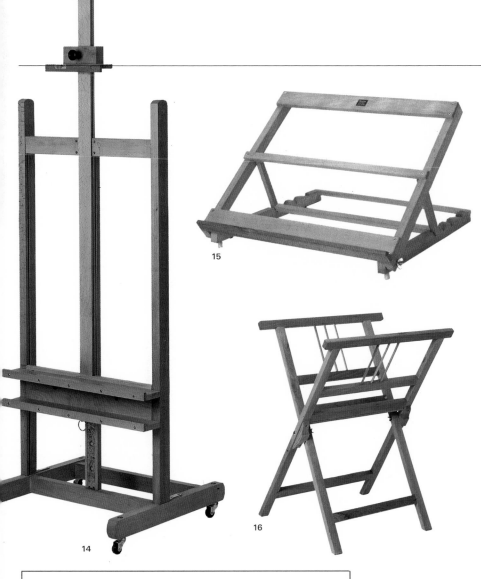

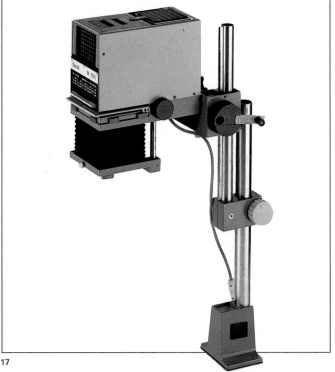

For the making of large-format art-works, an easel is an important item in the airbrush studio. The one shown in the illustration (fig. 14) is the so-called studio easel. It is firm, solid, and mounted on wheels so it can be rolled over to wherever the airbrush holder has been installed. Once the airbrush work is complete, the same easel can be used for painting fine lines or small finishing details by brush; the tray below provides space to keep paint pots or tubes.

If an artist is working in small formats, especially in freehand, the book-stand-style easel shown in figure 15 is a good choice. It allows a slant of 45°, a board is needed for support, unless the painting is on a sturdy material such as cardboard. Another accessory that can be of great use is the rack shown in figure 16. Its function is to store folders containing completed work, sketches, paper, etc. Its big advantage is that is doesn't take up as much space as a chest of drawers. This particular model has a display stand upon which the artist can show work to a visitor or a potential client. An enlarger such as the one shown in figure 17 is useful for projecting slides on the paper, cardboard, or other material upon which the artist intends to work.

Fig. 17. Many airbrush images originate as transparencies or slides. To transfer a transparency to paper or canvas at the desired size, an enlarger is needed.

The airbrush: characteristics and systems

18

19

20

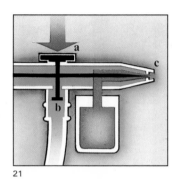

21

The airbrush is an instrument that allows painting by means of a flow of pulverized, or atomized, colored liquid. The control of this flow largely depends on the pressure of the air that the pulverization produces, on the consistency of the paint, and on the distance between the airbrush and the surface that is being painted. To understand the behavior of the airbrush, it's helpful to take a look at how a mouth atomizer, made of two little tubes joined at right angles, works (fig. 18). If tube *(a)* is sunk into a liquid paint jar and air is blown hard through the horizontal tube *(b)*, the pressure sucks in the paint. On mixing with the air, the paint is pulverized and pushed forward (fig. 19). With this rudimentary approach, the pulverized color is unleashed in an uneven ''splashing'' (fig. 20).

Figure 21 is a diagram of the control system of a typical airbrush. Lever *(a)*, which is kept raised by a spring, keeps valve *(b)* closed, blocking the air intake (in blue). When the artist presses lever *(a)* with his finger, the air valve *(b)* opens and air rushes in. The airflow moves through the body of the airbrush and sucks in the color, which mixes with the air and is then pulverized through nozzle *(c)*. From the basic concept, a number of sophisticated systems have been devised to control air pressure and the thickness of the paint flow. These systems can be classified as follows:

1. Single-action airbrushes
a) *External atomization airbrushes without needle*
b) *External atomization airbrushes with needle*
c) *Internal atomization airbrushes*

2. Double-action airbrushes
a) *Fixed-action airbrushes*
b) *Independent double-action airbrushes*

3. Airbrushes with special characteristics
a) *Eraser airbrush*
b) *Paasche Turbo AB Airbrush*
c) *Chameleon Airbrush*
d) *Kodak Aztek 3000 S Airbrush*
e) *Fischer Aerostat Airbrush*

Fig. 22. External atomization airbrush without needle
Badger Pistol 250
a) Lever.
b) Air control.
c) Paint control.

22

Single-action airbrushes
In the single-action airbrush, the lever has only one function: to control the air-flow rate. When the lever is depressed, the resulting intake of air is mixed with paint outside or inside the body of the airbrush, depending on whether the airbrush is of the external or internal atomization type.

External atomization airbrushes without needle
The external atomization airbrush is based on the same principle as the mouth atomizer (figs. 18, 19) and occupies the bottom rung of the model spectrum. The very simplest is the spray gun, which is the equivalent of a mouth atomizer adapted to a source of air supply. It does not have a needle, and neither air nor paint flow can be controlled. The spray gun is used for painting large areas with a plain color, without shading, as in painting car bodies and models.

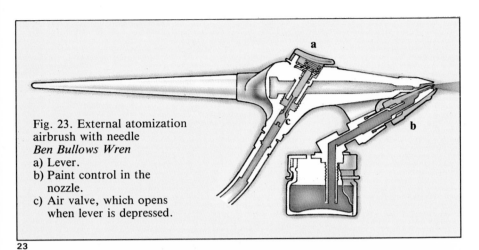

Fig. 23. External atomization airbrush with needle
Ben Bullows Wren
a) Lever.
b) Paint control in the nozzle.
c) Air valve, which opens when lever is depressed.

23

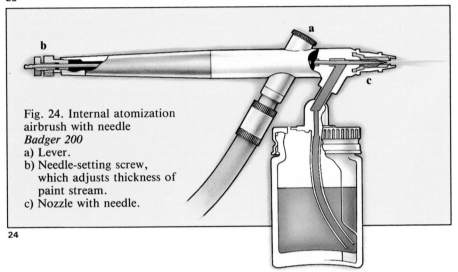

Fig. 24. Internal atomization airbrush with needle
Badger 200
a) Lever.
b) Needle-setting screw, which adjusts thickness of paint stream.
c) Nozzle with needle.

24

Fig. 18. Basic diagram showing how the normal airbrush works. In this and all the other diagrams in the book, blue represents air, while red represents color.

Figs. 19, 20, and 21. Here are three diagrams showing the workings of *single-action airbrushes*, which are distinguished by having a lever that controls only air entry and provides no direct control over the color (fig. 19). Within this range there are, however, airbrushes that incorporate a needle that, when adjusted in relation to the nozzle, allows some degree of control over the color squirt. The need to constantly readjust the needle makes for a very laborious process, though, so this type of airbrush is best suited for painting large surfaces in which there will be no change in color intensity or need for gradations, as in industrial painting (fig. 20).

But in some needle-less external atomization models the air flow and paint rate can be adjusted by means of valves situated at the nozzle and at the outlet of the paint jar (fig. 22). This type of airbrush offers only a modicum of control, since it remains difficult to readjust the proportion of paint and air while spraying.

External atomization airbrushes with needle
Inside the body of this second variety of airbrush runs air alone. The air is expelled and mixed with the flow of paint, which is sucked from the jar through a tube by means of a needle and nozzle (fig. 23).
The quantity of color can be controlled by adjusting the needle to the nozzle, but to do so it is necessary to stop spraying. Such airbrushes have more applications than the spray gun, since they allow for more precise work. They are used in model making, illustration, and graphic design.

Internal atomization airbrushes with needle
In this variety (fig. 24), the mixing of air and paint occurs inside the airbrush. When the lever is depressed, the air intake valve opens and paint is atomized and expelled through the nozzle in greater or lesser quantity, according to the position of the needle. To control the volume of paint released, the user removes the holder cap and loosens or tightens the needle-setting screw.
For a finer flow, the needle is moved forward; for a thicker flow, it's adjusted backward.

The airbrush: characteristics and systems

Double-action airbrushes
All double-action airbrushes rely on internal atomization and come with a needle.

Fixed-action airbrushes
With the double-action airbrushes (fig. 25) the artist can regulate the opening of the air valve by means of the lever and thereby control the movement of the needle. The lever is capable of double movement — backward and forward— but performs only one function: when it moves backward, it lets in air and at the same time pushes the needle setting. For this reason, the needle retreats only when the air valve has been opened and the relation between the flow of air and pulverized paint is fixed. These units offer far more possibilities than the single-action devices but carry the same risk: splashes when the user first begins to spray.

Independent double-action airbrushes
In this sort of airbrush —the most versatile and the most commonly used in artistic and technical airbrushing— the lever has two movements, with which it can perform two independent functions. When the lever is pressed downward, the air-intake valve gradually opens; when it's pulled back, the color comes out in a progressive flow, too. This means that the artist can control separately both the air flow and the paint flow, depending on the pressure placed upon the lever and its backward motion (fig. 26). With this type of unit, it's easier to avoid splashing, too. On starting to airbrush, only air should be projected. Then the lever can be slowly moved backward, releasing the paint evenly.

Airbrushes with special characteristics
The eraser airbrush
These single-action units consist of a pulverizer of compressed air, which

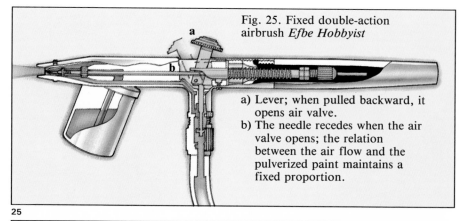

Fig. 25. Fixed double-action airbrush *Efbe Hobbyist*

a) Lever; when pulled backward, it opens air valve.
b) The needle recedes when the air valve opens; the relation between the air flow and the pulverized paint maintains a fixed proportion.

25

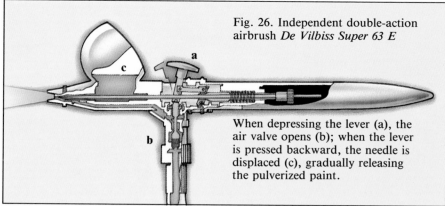

Fig. 26. Independent double-action airbrush *De Vilbiss Super 63 E*

When depressing the lever (a), the air valve opens (b); when the lever is pressed backward, the needle is displaced (c), gradually releasing the pulverized paint.

26

instead of pulverizing and moving a liquid propels an abrasive powder that attacks the paper fiber and erases the paint. When the air flow increases, so does the amount of powder projected (fig. 31, overleaf).

Paasche Turbo AB Airbrush
In this model (fig. 27) the air-paint mixture is not produced by suction. Rather, the color is collected and dragged by the needle with the help of a high-speed (20,000-rpm) turbine, which gives it a to-and-fro motion. The control lever regulates the needle's course. The paint (the more there is of it, the longer the run of the needle) falls by means of gravity to the nozzle and is pushed forward and atomized by the air that the nozzle expels.
Turbine speed and the pressure of the air in the nozzle can be regulated independently, which makes the Paasche a highly accurate instrument.

The Chameleon Airbrush
This is a double-action independent airbrush, which is distinguishable by the fact that its jar is divided into nine compartments. Eight of them are loaded with different colors and the ninth is filled with a solvent to clean the nozzle every time a paint change takes place.
The Chameleon also allows for mixing colors by placing the selector on its midpoint between any two adjacent colors (figs. 37 and 38, next page).

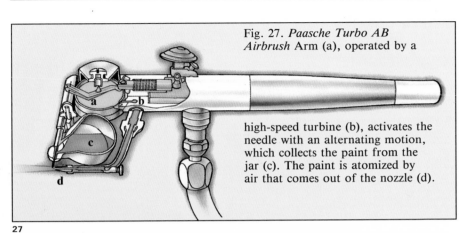

Fig. 27. *Paasche Turbo AB Airbrush* Arm (a), operated by a high-speed turbine (b), activates the needle with an alternating motion, which collects the paint from the jar (c). The paint is atomized by air that comes out of the nozzle (d).

27

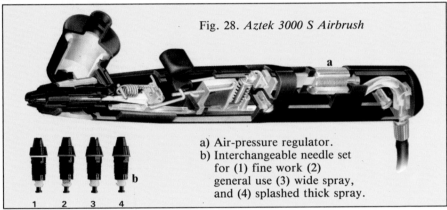

Fig. 28. *Aztek 3000 S Airbrush*

a) Air-pressure regulator.
b) Interchangeable needle set for (1) fine work (2) general use (3) wide spray, and (4) splashed thick spray.

28

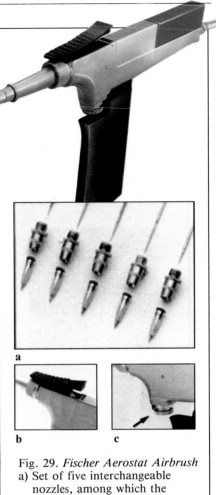

29

Fig. 29. *Fischer Aerostat Airbrush*
a) Set of five interchangeable nozzles, among which the finest in the world can be found: 0.1 mm diameter.
b) Special lever with a micro-mechanical system that reduces the speed of transmission between the lever and the needle, allowing more efficient control.
c) Air-pressure regulator.

Aztek 3000 S Airbrush

Instead of the usual needle in the double-action airbrushes, the Aztek (fig. 28) is equipped with four interchangeable nozzles, each with its corresponding needle, including one of 0.1 mm. And it's unique in the functioning of the lever, which opens the air and paint intake, and is equipped with a micro-mechanism that reduces the speed of transmission between lever and nozzle. This produces more efficient and accurate control of the amount of air and paint. Also, the airbrush comes with a handle that can be moved forward or backward, making the unit easier to manipulate. The color jars are interchangeable and can be placed on either the right or the left of the unit, and the air-pressure control gear is located in the body of the airbrush itself.

Fischer Aerostat Airbrush

Although the Aerostat was not yet available on the market at press time, its preproduction model boasts a number of interesting features. It comes with a set of five interchangeable nozzles, each with its corresponding needle, including one of 0.1 mm. And it's unique in the functioning of the lever, which opens the air and paint intake and is equipped with a micro-mechanism that reduces the speed of transmission between lever and nozzle. This produces more efficient and accurate control of the amount of air and paint. Also, the airbrush comes with a handle that can be moved forward or backward, making the unit easier to manipulate. The color jars work independently of the mechanical system and can be attached to either side of the airbrush. Finally the Aerostat has a system of fixed regulation of the needle, the hose, and also the air intake.

Airbrush models

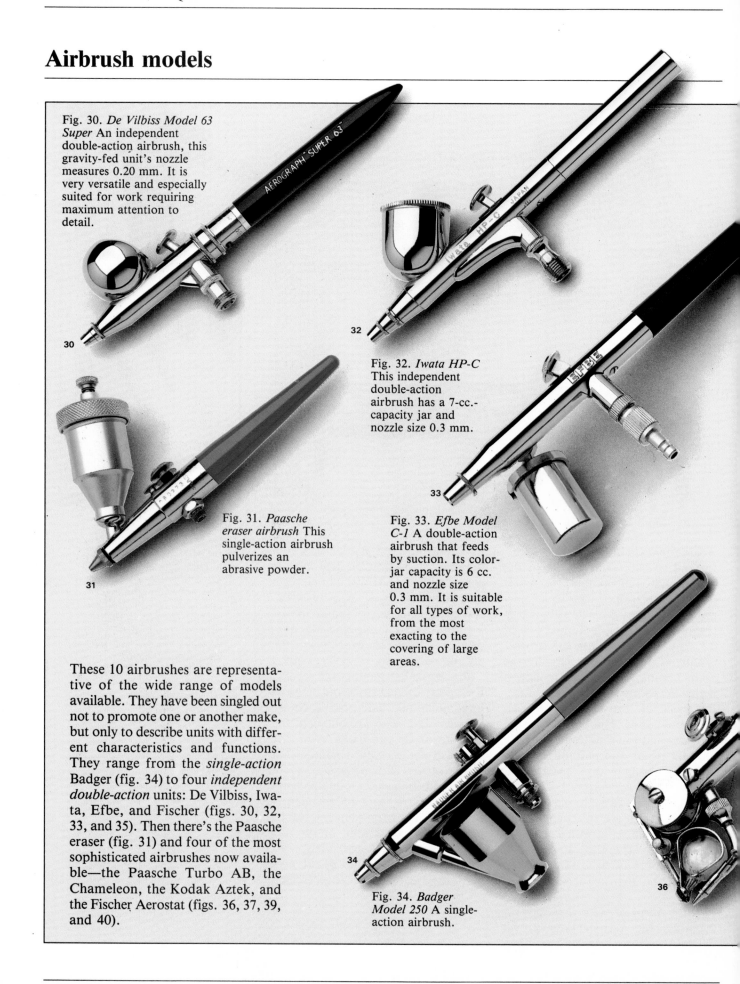

Fig. 30. *De Vilbiss Model 63 Super* An independent double-action airbrush, this gravity-fed unit's nozzle measures 0.20 mm. It is very versatile and especially suited for work requiring maximum attention to detail.

Fig. 31. *Paasche eraser airbrush* This single-action airbrush pulverizes an abrasive powder.

Fig. 32. *Iwata HP-C* This independent double-action airbrush has a 7-cc.- capacity jar and nozzle size 0.3 mm.

Fig. 33. *Efbe Model C-1* A double-action airbrush that feeds by suction. Its color-jar capacity is 6 cc. and nozzle size 0.3 mm. It is suitable for all types of work, from the most exacting to the covering of large areas.

These 10 airbrushes are representative of the wide range of models available. They have been singled out not to promote one or another make, but only to describe units with different characteristics and functions. They range from the *single-action* Badger (fig. 34) to four *independent double-action* units: De Vilbiss, Iwata, Efbe, and Fischer (figs. 30, 32, 33, and 35). Then there's the Paasche eraser (fig. 31) and four of the most sophisticated airbrushes now available—the Paasche Turbo AB, the Chameleon, the Kodak Aztek, and the Fischer Aerostat (figs. 36, 37, 39, and 40).

Fig. 34. *Badger Model 250* A single-action airbrush.

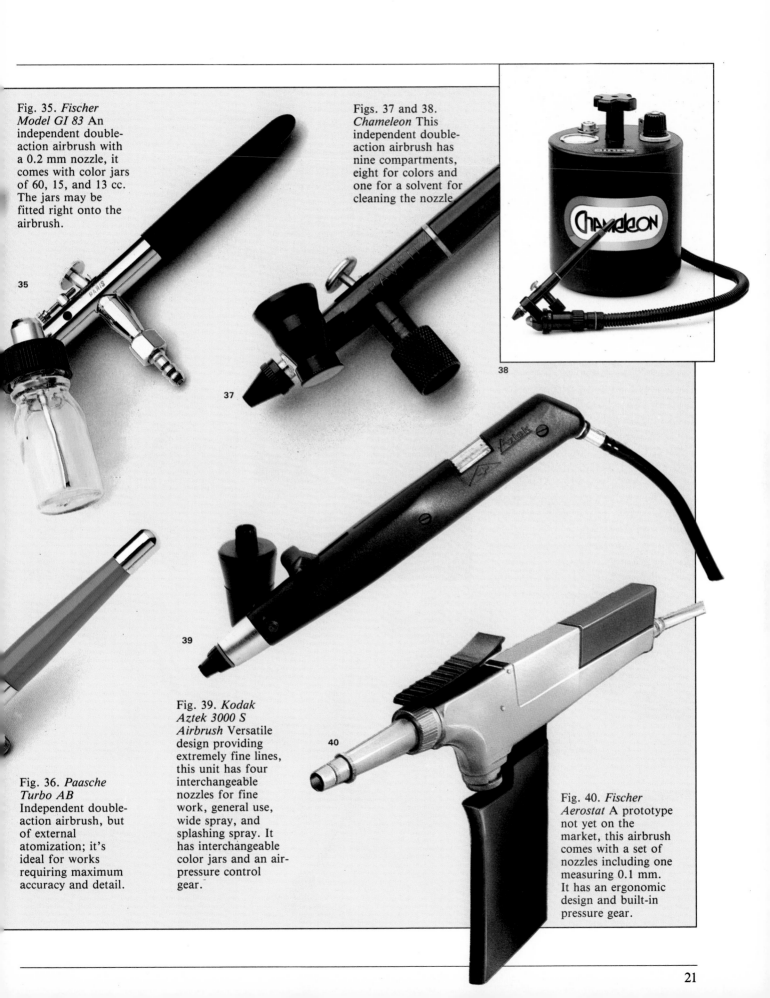

Fig. 35. *Fischer Model GI 83* An independent double-action airbrush with a 0.2 mm nozzle, it comes with color jars of 60, 15, and 13 cc. The jars may be fitted right onto the airbrush.

Figs. 37 and 38. *Chameleon* This independent double-action airbrush has nine compartments, eight for colors and one for a solvent for cleaning the nozzle.

Fig. 36. *Paasche Turbo AB* Independent double-action airbrush, but of external atomization; it's ideal for works requiring maximum accuracy and detail.

Fig. 39. *Kodak Aztek 3000 S Airbrush* Versatile design providing extremely fine lines, this unit has four interchangeable nozzles for fine work, general use, wide spray, and splashing spray. It has interchangeable color jars and an air-pressure control gear.

Fig. 40. *Fischer Aerostat* A prototype not yet on the market, this airbrush comes with a set of nozzles including one measuring 0.1 mm. It has an ergonomic design and built-in pressure gear.

Cleaning the airbrush

The airbrush must be cleaned every time the color is changed and also when the work session is over. The air and paint conduits are very narrow and are easily clogged by the remnants of dry paint. This can damage or even destroy the airbrush, at the least it well reduce the level of precision considerably. If watercolor, gouache, or other water-based paints are used, the airbrush is cleaned by filling the jar with water and spraying several times until the water runs clear, with no residue of color remaining.

However, when acrylic colors are used, either from tubes or pots, the airbrush should be cleaned not only with water but also with a final spray of a solvent such as turpentine.

In either case, follow the procedure illustrated below; first clean the jar with a brush, then fill it with water of solvent and operate the lever forward and backward until the spray is free of all color (fig. 41). Then loosen the needle's locking nut, making sure that the airbrush lever is pressed forward (fig. 42). Carefully remove the needle and clean it with a damp piece of cotton to remove any bits of paint; be careful (fig. 43).

Replace the needle in the body of the airbrush, again taking care not to blunt or bend it (fig. 44). Next, unscrew the nozzle (fig. 45) and clean it with a brush dampened with water or solvent—or, even better, blow through it. Let the nozzle dry, screw it back on (fig. 46), set the holder cap in place (fig. 47), and place the airbrush on the holder (fig. 48). It's now ready to be used again.

Figs. 41 to 48. The proper maintenance of the airbrush corresponds with the medium. When a nonaqueous-based paint is used, it must be sufficiently diluted with solvent so that it remains free of clots that can block the flow of paint or get stuck in the needle. The safest way to keep the airbrush in good working condition is to clean it whenever color is changed and at the end of every work session.

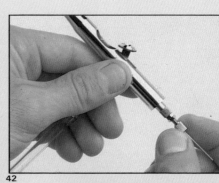

41

42

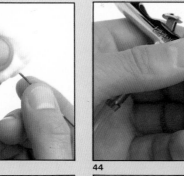

43

44

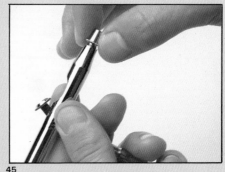

45

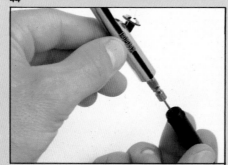

46

47

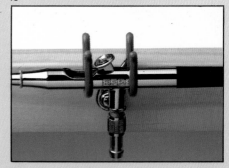

48

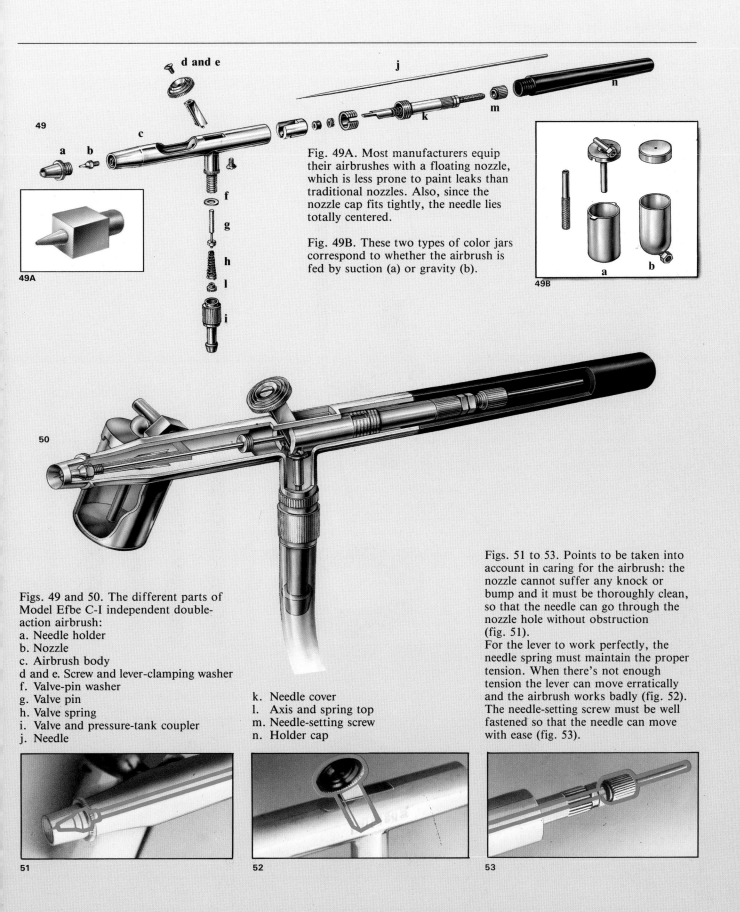

Fig. 49A. Most manufacturers equip their airbrushes with a floating nozzle, which is less prone to paint leaks than traditional nozzles. Also, since the nozzle cap fits tightly, the needle lies totally centered.

Fig. 49B. These two types of color jars correspond to whether the airbrush is fed by suction (a) or gravity (b).

Figs. 49 and 50. The different parts of Model Efbe C-I independent double-action airbrush:
a. Needle holder
b. Nozzle
c. Airbrush body
d and e. Screw and lever-clamping washer
f. Valve-pin washer
g. Valve pin
h. Valve spring
i. Valve and pressure-tank coupler
j. Needle
k. Needle cover
l. Axis and spring top
m. Needle-setting screw
n. Holder cap

Figs. 51 to 53. Points to be taken into account in caring for the airbrush: the nozzle cannot suffer any knock or bump and it must be thoroughly clean, so that the needle can go through the nozzle hole without obstruction (fig. 51).
For the lever to work perfectly, the needle spring must maintain the proper tension. When there's not enough tension the lever can move erratically and the airbrush works badly (fig. 52). The needle-setting screw must be well fastened so that the needle can move with ease (fig. 53).

Airbrush accessories

The accessories of the airbrush are the hose, an adapter to join the hose to the air supply, a moisture filter, and a pressure gauge.

Hoses come in different lengths — from to 3 ft. or more— and are made of different materials: vinyl, which is lightweight but wears out quickly; taped rubber, which lasts longer; or articulated rings, which are light, compact, and long-lasting (figs. 55 and 56).

The adapters that connect the hose to the compressor can be quite simple. They may link with just one airbrush or may attach several together so the artist can employ various airbrushes simultaneously (fig. 57). The use of multiple airbrushes is common in advertising and graphic-design studios, and sometimes in fine arts. Most compressors today come already equipped with a moisture filter and pressure gauge; but if cylinders, air cans, or diaphragm-style compressors that do not have these filters are used, it is advisable to install them (fig. 58).

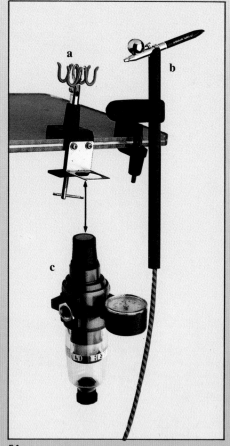

54

55

Fig. 54. Airbrush holder (a) to be fixed on a table (b). Below, pressure gauge (c) to control the air pressure in the compressor. Some compressors come equipped with gauges.

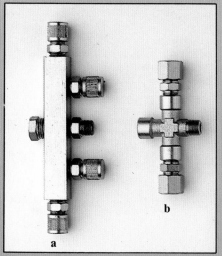

57

Figs. 55 and 56. Different types of hoses produce different results, depending on the material in which they are manufactured. Vinyl hoses (a), for example, crack quite easily, although some artists prefer them because they come in lightweight varieties (b).

Fig. 57. Two types of adapters to couple compressor to airbrush, with outlets for five airbrushes (a) or three airbrushes (b).

Fig. 58. Elements of the pressure gauge coupling of air escape (a); regulator pommel (b); pressure gauge (c); pressure regulator group (d); filter element (e); filter deposit (f); and condensation purge valve (g).

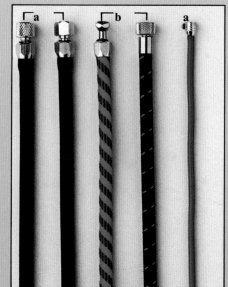

56

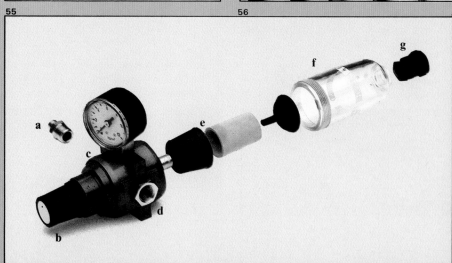

58

Air supply

Compressed air cans

These small cylinders, which resemble common aerosol spray cans and come loaded with propellant, are very handy for airbrush artists (fig. 61).

Their main disadvantage is that the simpler models tend to gradually lose pressure.

Compressed air cylinders

Compressed air cylinders are the most popular way of supplying air to airbrushes. With their autonomous silent supply of compressed air, they have quite a large capacity. Once a pressure gauge has been attached, they give a continuous and adjustable air flow (fig. 62).

Figs. 59 and 60. Sketch of a compressed air cylinder (fig. 59) and a compressor with diaphragm (fig. 60). The basic difference between them is that the one with the diaphragm works with an engine, which takes in air and sends it directly out to the hose, while the one with the cylinder stores the compressed air it produces in a reservoir. This type has a pressure regulator at its outlet to keep pressure constant.

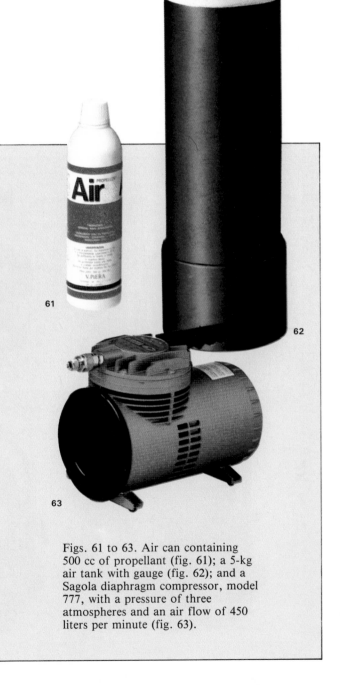

COMPRESSED AIR CANS

59

60

COMPRESSED AIR CYLINDERS

61

62

63

Figs. 61 to 63. Air can containing 500 cc of propellant (fig. 61); a 5-kg air tank with gauge (fig. 62); and a Sagola diaphragm compressor, model 777, with a pressure of three atmospheres and an air flow of 450 liters per minute (fig. 63).

Air supply

Compressors

These are devices that take in atmospheric air, compress it to the appropriate pressure, and release it through an outlet conduit. The two fundamental parameters of a compressor are air-flow capacity, which is measured in liters per minute (l/min), and the maximum pressure that the air can reach inside the device. The pressure—that is, the force that the compressed air exerts on the walls of the reservoir—is measured in kilograms per square centimeter (kg/cm^2) or in "bars." One bar equals 1 kg/cm^2. The air flow a compressor can produce is directly proportional to the induction capacity.

Most compressors fall into one of two large groups: those with diaphragms and those with reservoirs.

Compressors with diaphragms

These are single, direct-action compressors —that is, they act only when the compressing mechanism is at work. These units take in air through an inlet conduit and compress it in an interior chamber, expelling it immediately through another conduit, which may or may not have a control valve (see fig. 60, preceding page). These compressors do not store compressed air. They simply take air in, compress it, and let it out. Such devices are simple, inexpensive, and small; their main disadvantages are that they're rather noisy and somewhat unreliable as far as continous flow is concerned. They may also produce an irregular spraying of paint.

Compressors with reservoirs

These compressors come with a tank or reservoir where the compressed air is stored before it is supplied to the airbrush (see fig. 59, preceding page). In these units, air pressure is always higher in the reservoir than it is at the exit of the apparatus. This setup, together with the action of a control valve at the exit of the tank, guarantees the airbrush a constant pressure, eliminating the unreliable-flow problem characteristic of compressors with diaphragms. But not so with the gradual loss of maximum pressure due to the emptying of the reservoir. To attain the proper pressure, the compressing mechanism must be set to work. For this reason, the most sophisticated compressors come with an automatic

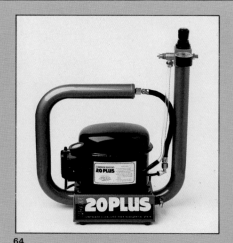

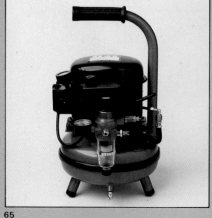

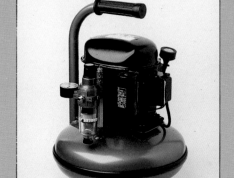

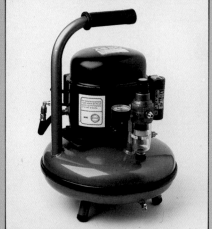

Figs. 64 to 67. Four models of small compressors with reservoirs. They are the varieties most used by professionals and serious amateurs.

Fig. 64. *20 PLUS*. This compressor has a tubular 1.5-liter-capacity reservoir and produces an air flow of 20 liters per minute.

Fig. 65. *AS 15*. A 5-liter reservoir and an air flow of 15 l/min.

Fig. 66. *AS 30*. A 10-liter capacity reservoir and an air flow of 30 l/min.

Fig. 67. *AS 50*. A 10-liter reservoir and air flow of 50 l/min.

pressure-control mechanism, which allows pressure to be set in the upper tank higher than that of the air released through the hose. Compression stops when this previously set value is reached and begins again when values drop too low. There are a wide variety of compressors with reservoirs on the market (figs. 64 to 69) in different sizes and with different features.

The smallest ones have low-power engines, and are prone to frequent overheating. The artist must stop working until the unit cools down. But whether large or small, virtually all models of this type are equipped with automatic control —a gauge that constantly displays the current pressure—and with other accessories,

such as a moisture filter to regulate the water vapor in the suctioned air (not doing so could seriously damage the airbrush) and a viewfinder to check that the engine is properly lubricated and cooled.

Figs. 68 and 69. *Model Woessner CW-S* A 5-liter reservoir, a pressure up to 8 bars, and an air flow of 15 liters per minute (fig. 68A). *Model Richcon KS-707.* Compressor with diaphragm with a pressure up to 2.4 bars and an air flow of 10 liters per minute (fig. 68B).

Fig. 69. *15 PLUS a.* Automatic compressor with 1.5-liter reservoir and air flow of 15 liters per minute (fig. 69).

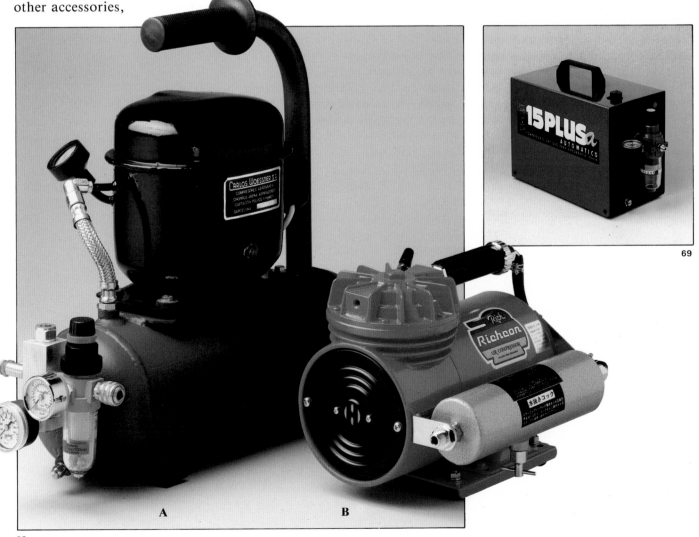

A B

68

69

Transparent colors

Whether working with watercolors, inks, or special airbrush colors, the artist seeking transparency must keep two airbrush principles in mind. First, he must paint from "lesser to greater," beginning with the lighter tonalities and taking into account that both light vs. shadow and color saturation will be obtained by applying successive coats. Second, he must avoid white pigments, instead using the white of the paper. Because of these demands, it's best to work on a very accurate drawing, one that offers a detailed layout of the placement of colors and whites. And although one can rely on the opacity of white gouache to obtain certain reflections, this technique should be regarded as a last resort.

Mediums that yield transparent effects include traditional watercolors in tubes, liquid watercolors, liquid inks, and special pigments designed expressly for the airbrush.

Watercolors

These are still the best paints for airbrushing and the most convenient for beginners, since they are relatively inexpensive and rarely cause maintenance problems for the airbrush. Watercolors in tubes must be diluted at least 50:50 with water.

Liquid watercolors

They are ideal for airbrushing. They come in small pots (of 29 to 35 ml) or larger bottles in a vast range of colors, and can be used directly from the pot or diluted in water. The stopper on the small pots usually has a drop counter, which allows for highly precise measuring of quantity. These colors offer high luminosity and concentration, which produce perfect color mixtures. In airbrushing, watercolors and other aqueous mediums should be diluted in distilled water, especially if the tap water has a high concentration of lime.

Liquid inks

These are solutions pigmented with synthetic colors (anilines). Most are water soluble though a few are alcohol-based. They are available in matt colors or in bright, glossy shades and boast good color stability. They are often used in design and illustration.

Fig. 70. These bright, transparent effects were achieved by overlapping three hues of liquid watercolor.

Fig. 71. This range of transparent colors was produced by the tubes of watercolors shown. The rectangles at the top of each bar of color show the colors at full saturation. Below, gradated color stripes are seen.

70

71

Special colors for the airbrush

Nontoxic acrylic solutions with a high concentration of pigment offer very intense colors for the airbrush artist. These paints are of ultrafine grain so they won't clog the airbrush, and once dry, they are water- and light-resistant. Treated without white, which is opaque, they give an outstanding transparency. They come in either small pots of concentrated colors that have to be diluted or in larger volumes that need no dilution.

Although the standard solvent is distilled water, certain brands provide liquids for cleaning and diluting that give a brighter, more stable color film.

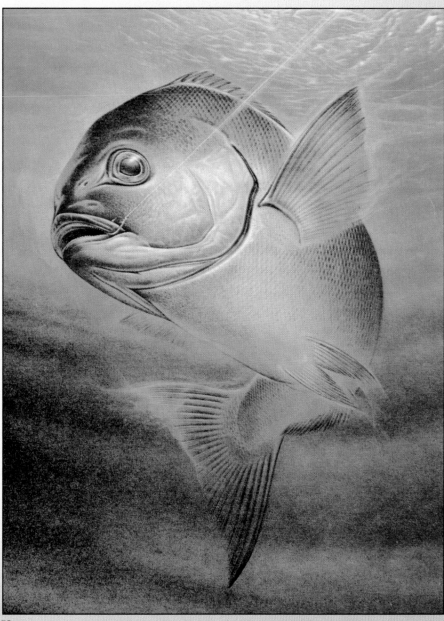

Fig. 72. Shiro Nishiguchi, the artist of this airbrushed illustration, has maximized the transparent-color effect.

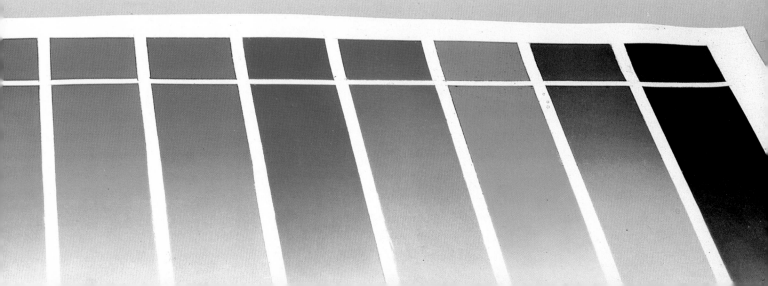

Opaque colors

Whenever white is used as a base for mixing the colors, airbrush paints can become an opaque medium.

Gouache
Also called *tempera,* gouache is a water-soluble paint that is very opaque. It comes in tubes or in jars, and because its consistency is pasty or creamy, it must be diluted in water to the proper fluidity. A too-fluid gouache covers irregularly, but one that is thick will block the nozzle of the airbrush. Because of this, it's worth experimenting with the special fine-pigmentation gouaches made by Schmincke, Talens, Lefranc, and others. In painting with gouache, the covering potential of each color must be taken into account. Cadmium pigments (yellows and reds), as well as emerald green and rose madder, provide a certain transparency. So when these colors are to overlap a dark background, it's advisable to add a bit of white.

With gouache, the airbrush should be cleaned with water.

Acrylic colors
Acrylic paints are very popular among airbrush artists.

They are usually classified in two groups according to their viscosity: low-viscosity colors that can be diluted only in water, and denser, high-viscosity paints to which a special solvent must be added along with the water. Acrylic colors dry very quickly, leaving a hard, plastic film that's not water-soluble. It is necessary, then, to use a special liquid to clean the airbrush with every color change. When working on one picture for an extended time, the artist must also add to the colors a special dry-retardant solution (these are sold by every manufacturer of acrylics). Artists should be aware that some of the components of acrylic colors are toxic. Therefore, it's advisable to wear a protective mask during lengthy exposure.

Fig. 73. These surfaces were obtained with consecutive sprays of an opaque paint, with light colors overlapping darker ones.

Fig. 74. A small sample line of opaque colors for the airbrush, made up of two drop-bottles of acrylics (a); a drop-bottle of fine-pigmentation paint specially designed for use with the airbrush (b); and two tubes of gouache (c). The color bars were done with a sample line of acrylic colors (top row) and of gouache colors (bottom row).

Fig. 75. Hideaki Kodama, *Harley-Davidson Motorbike.* This is a magnificent example of how to obtain shiny, bright, smooth color shading by the judicious use of opaque and light colors on dark surfaces.

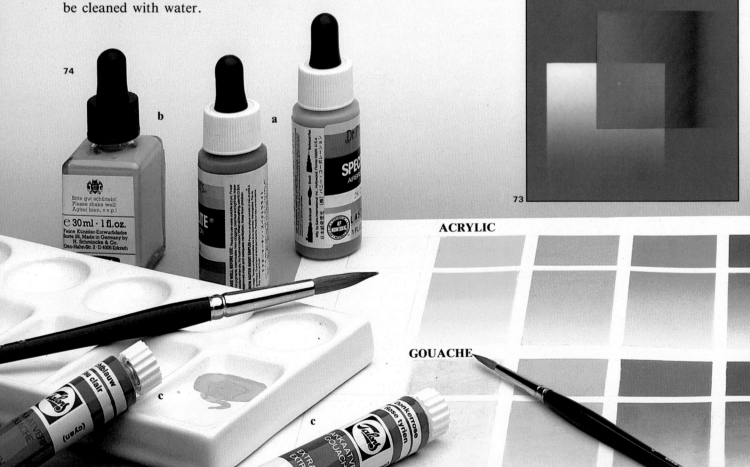

ACRYLIC

GOUACHE

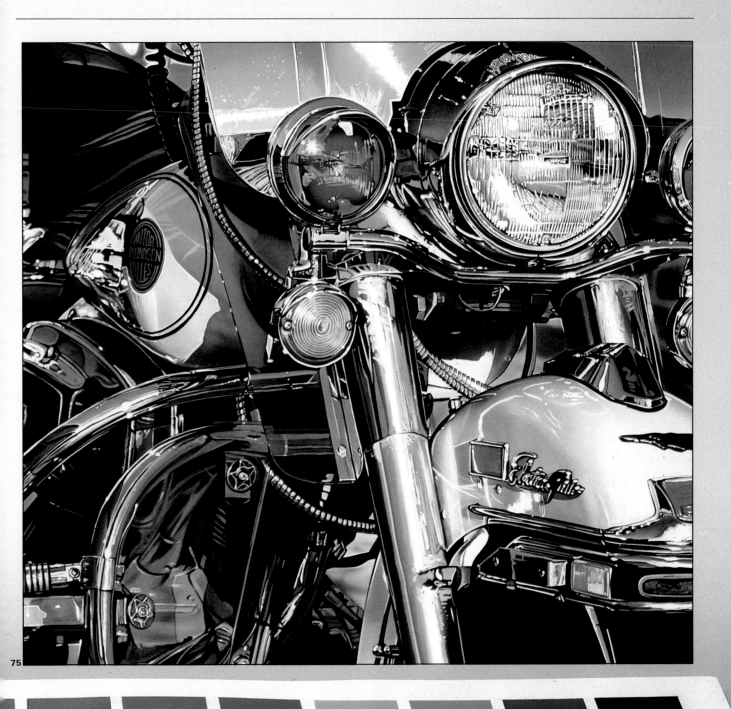

Oils and enamels

Oil colors

Typically, oil paints are used on canvas, but this venerable medium lends itself to a host of other possibilities as well: wooden boards (with primer), plastic materials (polyvinyls, acetates), ceramics (tiles, porcelain, pottery, stoneware), metal, and even glassware. One that doesn't make the list is paper, since oils and varnishes can stain it.

To use oils with an airbrush, dissolve the paste that comes from the tubes in refined turpentine essence to which a few drops of a dryer can be added, since oil paint is slow to dry. Normally, a 50:50 mix will guarantee a uniform paint flow.

Although oil colors are opaque, some of them, properly diluted, can provide a great deal of transparency. These colors, which in some catalogs are termed "lakes," include cadmium yellows and reds, rose madder, emerald green, ultramarine, and some violets. These colors yield outstanding effects on porcelain, pottery, and glassware.

Synthetic enamels

Synthetic enamels are suspensions of pigmented materials in cellulose and nitrocellulose solvents. They are used in a wide range of industrial applications in which color is applied by spray gun (furniture, car, and toy making and the construction industry), in hobbies such as model making, and in ceramics. Depending on the application, they will vary in hardness and drying speed.

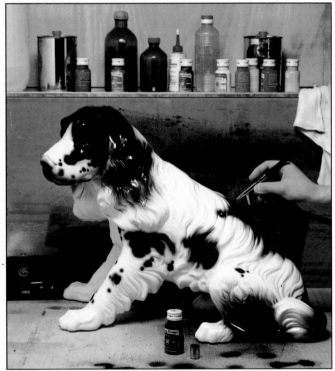

76

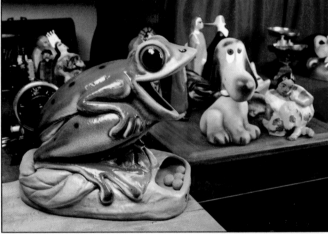

77

Figs. 76 and 77. On the left, the ceramic dog is sprayed with black enamel paint. On the right, the papier-mâché frog was painted with oil colors and a spray of bright varnish.

Fig. 78. Oil paints in tubes and pots, enamel paints, bristle-hair brushes, and a bottle of essence of turpentine, which is the solvent of choice for both mediums.

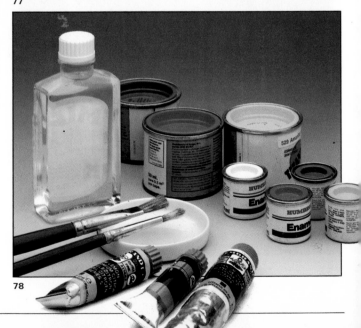

78

Available in large cans (10 lb— 5 kg—or more) or tiny bottles (35 ml), enamels reach an incredible hardness and brightness once dry. All of them cover well and dry fast. When working with them, the airbrush must be carefully handled, since some enamels, once hardened, resist the action of solvents. Cleaning must be done before the paint dries with strong solvents such as nitrobenzene. Handle with extreme caution: these are highly inflammable, volatile toxic liquids. Wear a mask at all times. And be aware that the "nitro" solvents attack some plastics, which are "eaten" easily, so not all plastics can be painted with enamels.

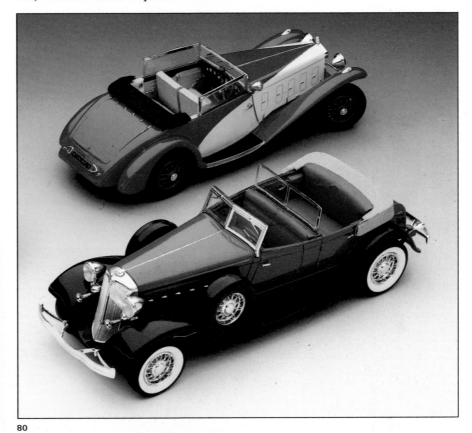

79

80

81

Figs. 79 to 81. These model cars and airplanes were painted with enamels in a process involving masking and the use of templates, as well as a steady hand. (Models reproduced by kind permission of their builders, T. Eugeni González and Donato García.)

Other accessories and tools

Among the other tools found in the airbrush studio are those standard to all artists—paintbrushes, pencils, erasers, and so on—along with a few auxiliary items especially suited to help or complete the airbrush work. On this page (fig. 82) are some of the most useful:

A water jar (a); opaque adhesive tape (b); transparent adhesive tape (c); large scissors for cutting paper (d); a paper cutter with retractable blade (e); eraser pencil (f); eraser (g); razor blade (h); transparent ruler of 2 ft (60 cm) or more (i); metal ruler (j);

plastic mat for cutting upon (k); set of triangles, which are often used as movable masks (l); toothbrush for obtaining spattering effects (m); sable brush (n); masking liquid (o); magnifying loupe (p); crepe eraser to remove masks (q); magnifying glass to view very precise details (r); rubber cement for special setups (s); polyester nonadhesive masking paper (t); ruling pen (u); special compass for cutting circles (v); standard compass for both pencil and ink (w); special cutter for parallel cut (x); gas mask (y); and adhesive polyester masking paper (z).

On the next three pages is a display of strokes, lines, grays, and shades of color that can be obtained by the airbrush and some of the auxiliary tools commonly used with it: graphite pencils, colored pencils

(watercolor and otherwise), and felt-tip pens.

French-curve templates and templates used in technical drawing (circles, ellipses, sine curves, and so on), can also be found in the airbrush artist's studio.

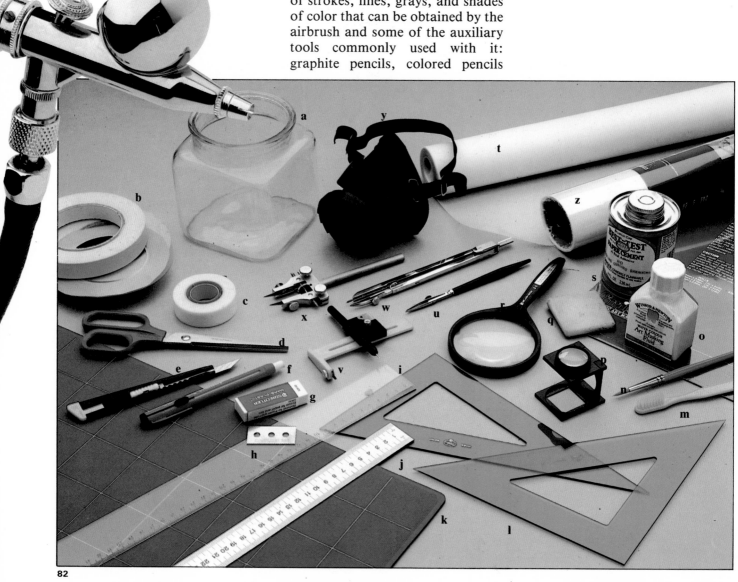

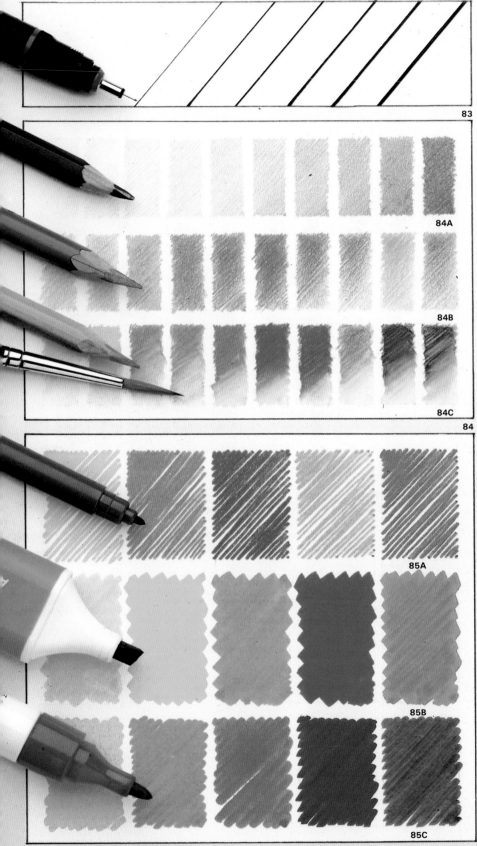

83

84A

84B

84C

84

85A

85B

85C

85

Figure 83: Rapidograph. Airbrush artists working on technical illustrations often use rapidographs, or rotating pens, which come in different thicknesses, from 0.1 up to 2 mm, for a wide range of lines. The rapidograph can also be loaded with cartridges of colored ink.

Figure 84: Graphite pencil and colored pencils. Graphite pencils of soft grade, such as 4B or 8B, are the most suitable for drafting and sketching. For the final drawing, a medium-grade pencil should be used, such as HB or B. Hard pencils — such as H, 2H, and 5H— can also come in handy.
Colored pencils are generally used in airbrushing to sketch and test color mixtures and to color fine details in the final work. High-quality colored pencils may be water-resistant or water-based. The latter allow the artist to thin the color with a wet brush, much as in watercolor painting. This illustration shows a range of grays obtained with a graphite pencil (fig. 84A), a range produced with water-resistant colored pencils (fig. 84B), and another obtained with watercolor pencils (fig. 84C).

Figure 85: Felt-tip pens. In airbrushing, the felt-tip pen is generally used to draft, sketch, or do color roughs. The ink may be water-soluble (figs. 85A and B) or alcohol-based (fig. 85C). Pens are manufactured with wide, medium, and fine points, allowing very different finishes.

Other accessories and tools

Figures 86 and 87: Brushes. The paintbrush is used to paint finishing details, to put paint into the airbrush, and to clean the paint jar of any remains. For the finishing details, the sable brush is best: it always has a perfect point, and the bristles bend at the least pressure from the hand, broadening to paint wider swaths then springing back to the initial shape. In figure 86, a display of sable brushes is shown. On the market they are classified from 0 to 14 depending on thickness. It is enough to have two or three thick brushes, Nos. 8 and 10, and two thin ones, Nos. 3 and 4.

Sable brushes are more expensive than other quality brushes, but they last longer given the proper care. They must never be left too long in water, and they must be rinsed and drained after use. But they can't be used with acrylics or in liquid masking, a process that can destroy sable. Instead use brushes with synthetic hair.

It's a good idea to have a set of brushes of different qualities and shapes, such as those shown in figure 87: a synthetic brush in the shape of a fan; a round brush of synthetic hair; a round long-haired brush; and a synthetic brush with a flat edge. To load the airbrush jar with color, sable, ox, or synthetic brushes can be used. Best is a brush made of bristle; it's harder and thus more resistant to the rubbing involved in the jar-scraping process. Always clean the brush between color changes.

Figure 88: Cutters and scalpels. These airbrush essentials are used to cut masks. Any cutting implement can cut masks, but the scalpel — similar to the one employed in surgery— is the most precise tool. It can, for example, cut through adhesive tape without damaging the paper or canvas underneath. Scalpels have interchangeable blades of varying forms and widths.

In this photograph, two types are

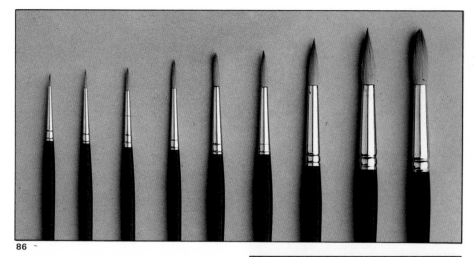

86

shown that are commonly used to cut masks of adhesive film and of polyester: a ceramic scalpel with interchangeable cap, lightweight and easy to handle because the blades do not have to be changed—this gives the tool a virtually endless life (A); and a scalpel with a rotating cap to cut curves (B). Also shown are two standard cutters: one that's normally used to cut paper (C) and one for cardboard (D).

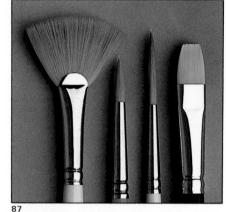

87

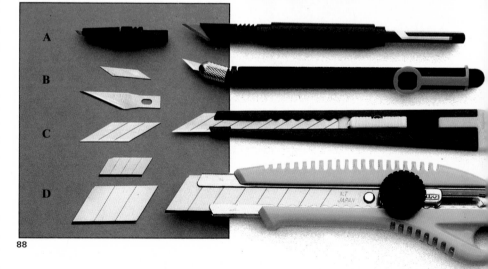

88

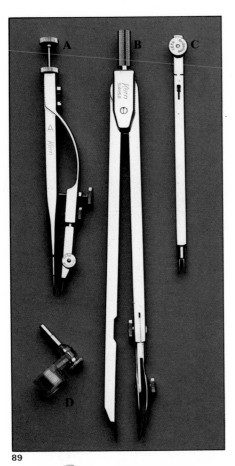

89

Figure 89: Compasses and ruling pens. It is not necessary to purchase a whole case of compasses or ruling pens. One or two will do just fine. Get pens of a couple of different thickness; they are loaded with a drop counter or brush. In compasses, two are sufficient: a bow compass to draw small circles, and an extension divider to hold a pencil or ruling pen for larger circles. An extension arm can also draw large circles. An adapter to attach a rapidograph to the compass may also come in handy.

Figure 90: French curves and templates. French curves are made of plastic and so, unlike metal rulers, can be damaged with the cutter or scalpel. But they're irreplaceable for technical drawing and can be used as guides in mask making. They come in many shapes—curved, square, oval, triangular, arrows, numbers, letters, and so on.

Some templates have specific applications with the ones in figure 90A, the artists can use both the inside and outside shapes; with the one shown in figure 90B, circles can be painted in perspective and in different sizes, depending on the oval used.

Like French curves, templates are used to draw and cut mobile masks.

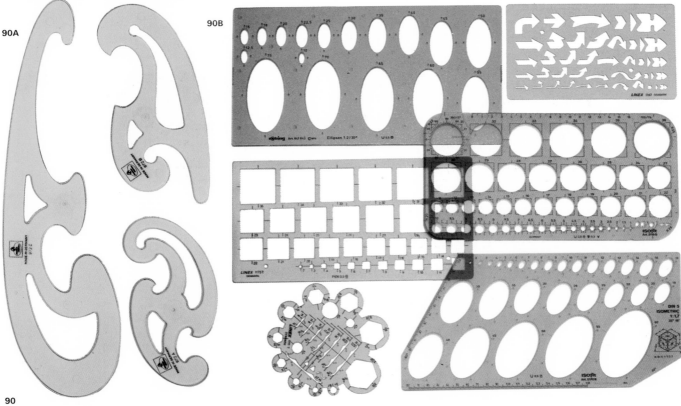

90

Painting surfaces

Airbrushing puts no restrictions on the artist's choice of painting surface. Paper, canvas, wood, metal, plastic, ceramic, and glass are all an open field for experimentation. The only criterion is choosing the proper paint for whatever surface you select.

Paper

Without doubt, paper is by far the most commonly used material, especially the smooth varieties such as bristol board. Paper makers are increasingly introducing new varieties designed especially for airbrushing, such as the lines from Studio Grattage, Aero Studio, and Canson, or Schoeller's smooth airbrush papers for technical drawing. Choose heavy stock —140-lb (300 gm) or heavier— to avoid warping. For larger sizes, it's best to set the sheet on a wooden board. Some types of papers come already mounted on cardboard, which guarantees rigidity but can't be scanned for reproduction by mechanical printing processes. (The scanner requires that paper be rolled through flat; cardboard is too thick.) Fine artists usually choose fine— and medium-grained paper (always of high poundage) or paper that imitates the texture of canvas. Such papers lend themselves to freehand airbrushing and texture effects (figs. 91B and C).

Fig. 91. Three samples of paper textures: At top, glazed smooth Schoeller paper (a); at center, goffered paper imitating canvas (b); and "pebbled" watercolor paper (c). In advertising and technical illustration, smooth, grainless paper is used almost exclusively; in the fine arts, fine— and medium-grain papers are often used.

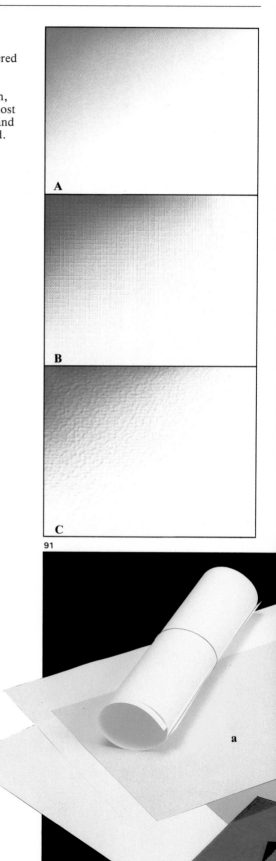

A

B

C

91

a

92

Photographic paper

In advertising, work is sometimes done directly on a photograph with either a matt (bromide-type) or glossy finish. Both varieties take gouache well, and this is the medium of choice. Since matt papers are generally thicker than glossy, they are more suitable for large-size works. They maintain their rigidity, can be easily mounted, and do not "spit" the gouache that's applied with a paintbrush.

Wooden boards

Solid planks and plywood panels are good backdrops for airbrushing, although they often require one or more primer coats and a careful polishing to pad and homogenize the surface.

Canvases

Ready-made canvases for oil or acrylic paints, with frame or mounted on cardboard, are commonly used by airbrush artists.

Metals and plastics

Both metals and plastics admit airbrush paint as long as the proper one is chosen. Aluminum plates, copper, or brass and sheets of acetate, polyvinyl chloride, and the like are all suitable.

Ceramic materials

Ceramists use the spray gun to paint works with a coat of enamel, which, once dry, will be glazed in a kiln. The airbrush is also used to restore ceramic pieces and to decorate unglazed pieces made of white pottery. The most common material in this application is a special cellulose ceramic enamel (*émail céramique de Paillard,* for example), which, on drying, acquires a great hardness.

Fig. 92. Virtually any material can form the backdrop for airbrushing. At right: different types of paper (a); glass (b); metals and plastics (c and d), which are used mostly in model making; canvas (e); wood (f), also used for models as well as in furniture making, where it is painted with industrial spray guns; cloth (g), with a growing application in the field of fashion; and ceramics (h), one fired in a kiln and the other enameled with a spray gun.

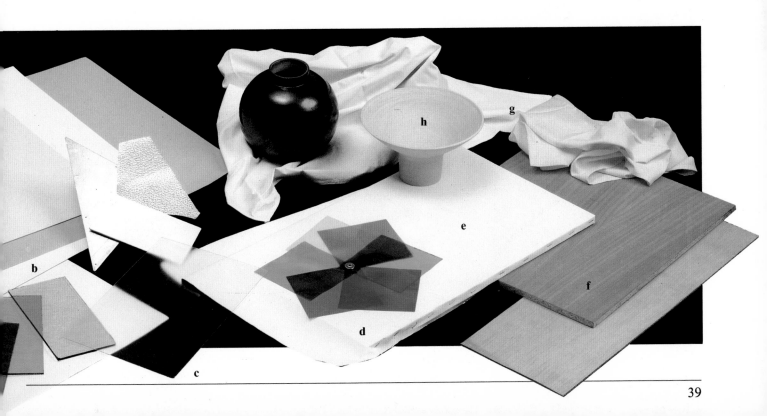

Types of masks

Masking —that is, the protection and preservation of discrete areas of an illustration— is a fundamental part of airbrushing.

The masks can be classified in four ways: *fixed, mobile, aerial, and liquid.*

The *fixed mask* is one that's attached to the paper or canvas, most commonly made of an adhesive film that is specially manufactured for airbrushing. It comes in sheets or rolls and is covered in a protective paper, which must be carefully removed once the film is applied to the backing. Despite its high adherence, which prevents the paint from slipping in from underneath, the film comes loose easily when it's time to remove the mask. Adhesive film provides a very thin mask, which helps to prevent the accumulation of color on the edges, so very clear outlines are obtained. It's also transparent, so the artist can see the masked-off area.

What's more, it's possible to draw on the film. Polyester paper is another type of fixed masking; it is applied with rubber cement.

The *mobile mask* is laid on the paper or canvas and is held by hand or with a weight. It may also be held some distance from the surface to be painted; in this way shaded-off borders are obtained. Mobile masks can be made of any material, from torn paper or cardboard up to rulers, templates, French curves, or even the fingers or palm of the artist's hand.

The aerial mask is held at a greater or lesser distance from the painting surface or stuck onto it with rubber cement or rolled bits of adhesive tape. Raw cotton is an aerial mask; when sprayed, the color is pulverized through it, resulting in shadings appropriate for representing skies with clouds, for example.

The *liquid mask* is used to block out tiny de-

tails. It is a solution of diluted rubber cement or latex, which is applied with a paintbrush; it dries quickly and leaves a film that can be easily removed, either by rubbing with a finger or with a crepe eraser. Don't apply liquid mask with a sable-hair brush— if the rubber dries on the hairs, it is very difficult to remove and the brush will be damaged. Instead use a synthetic brush and rinse with water right after use.

Figs. 93 to 95. These three pictures show how to protect the margins of your paper or canvas with adhesive tape. Tapes comes in different widths, which allows reserving any size margin. As can be seen in figure 95, on removing the tape the background and the shading stay clearly delimited.

Fig. 96. The illustration shows the most frequently used masks: adhesive tape (a), raw cotton (b), polyester paper (c), masking liquid (d), rubber cement (e), torn papers (f), templates (g), and adhesive film (h).

93

94
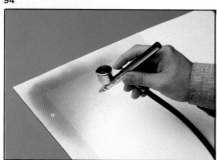

95
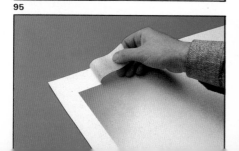

96
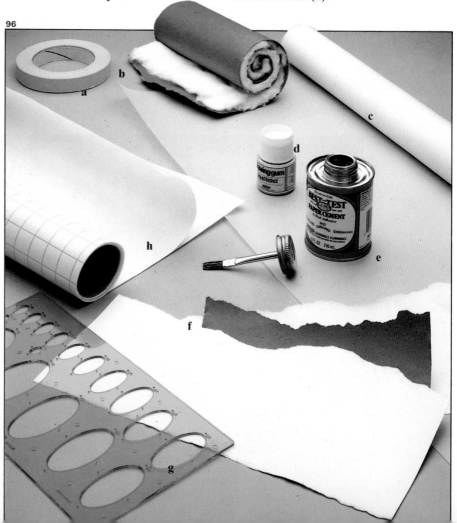

Basic techniques in mask application

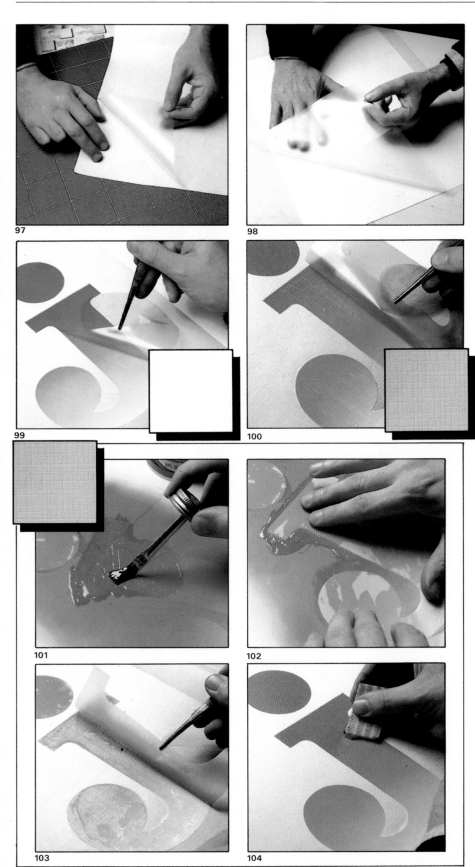

Figure 97. The adhesive mask is backed by a special protective paper, which must be peeled off before painting.

Figure 98. In this picture the adhesive film is being applied and smoothed into place with the hand. When masking large areas, a ruler or straight edge can be used.

Figure 99. When working on glossy paper —the quality most frequently used in airbrushing— outstanding results are achieved with the adhesive film mask. Upon removing the mask, the picture is found to be perfectly airbrushed.

Figure 100. On paper with a grain, removing the mask sometimes causes lifting and peeling of the grain, producing a faulty image.

Figures 101 to 104. A polyester mask is a better choice for grained paper. The mask is applied with rubber cement and when it is removed, it does not damage the image. Dry cement is easily removed with a crepe eraser.

Basic techniques in mask application

This page and the next show how to apply liquid, mobile, and aerial masks.

Figure 105. The masking liquid is used to block off small shapes — profiles, dots, letters, and the like. In this example, a liquid latex mask is applied to the lettering; when it has dried, it is rubbed away with a crepe eraser, leaving a perfectly defined negative of the letters.

Figure 106. Here a template has been used (inset) to outline the top face of a cylinder. To achieve the shading, the movement of the airbrush must be continous when spraying the inside border of the template.

Figures 107 to 110. Several examples of aerial masking: the artist's hand produces certain shapes in which shaded-off profiles are wanted (fig. 109), and raw cotton (fig. 110) can be used as masks and moved during spraying, producing special shading effects.

Figures 111 and 112. Here's another way to mask letter with press type (Letraset). The Letraset sheet is placed on the paper and the letter pressed on; then the color is sprayed. The press-type letter is lifted off with tape, leaving a well-defined negative.

105

106

107

108

109

110

111

112

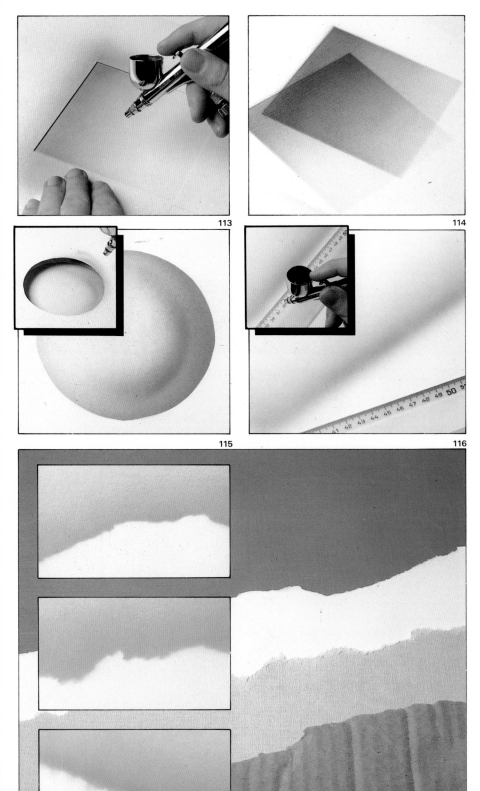

113

114

Figures 113 and 114. Different color intensities can be obtained by moving and overlapping the same paper mask.

115

116

Figures 115 and 116. The sphere in figure 115 has been masked with a template (seen here in perspective). For shading effects, the template abuts the paper only in the area where the most intense shades are needed. The ruler (fig. 116) is often used as a mask. It provides border lines more or less defined, depending on how close it is held to the paper.

117

Figure 117. Masks can be made with pieces of paper of differing qualities and weights torn to achieve shading effects that will vary depending on whether the mask rests on the paper or is held some distance away.

Step-by-step masking for illustration

These photos show, step by step, how the different types of mask applications produce an illustration.

Figure 118. First, a good drawing: it is important to draw a finely detailed picture, since masks must be cut with great accuracy for each area. It must be a line drawing, without taking into account the tones. The drawing must delimit every area of the illustration, and the artist must foresee where different masks will be required. The drawing, therefore, is a blueprint of all the masking that will be done.

Figure 119. First, the margins are protected with adhesive tape, as explained on page 40.

Figure 120. Raw cotton is used to mask the area of the illustration that forms the sky. The raw-cotton mask is held lightly to the paper with rubber cement or rolled bits of adhesive tape.

Figure 121. A torn paper mask produces the configuration of a mountain. The striation of the paper combined with raising the mask a little bit away from the backdrop yield a shaded-off profile.

Figures 122 and 123. Several adhesive-film masks block off different areas of the illustration, such as the figure of the woman, so that the beach area can be sprayed (fig. 122). Between this image and the next (fig. 123), the previous masks have been removed and a new sheet of adhesive film set into place.

118

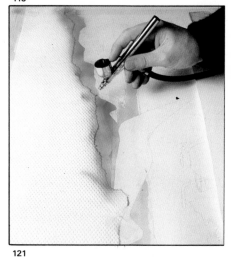

119

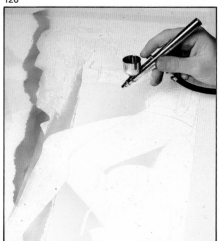

120

121

122

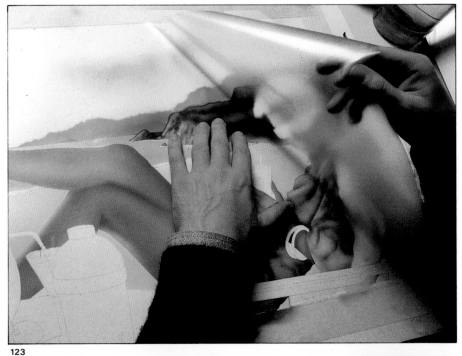

123

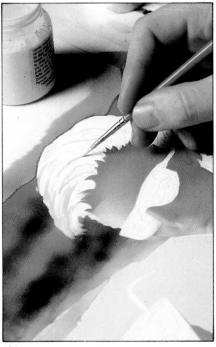

124

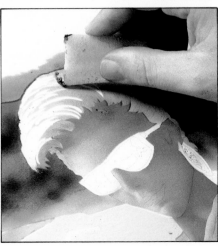

125

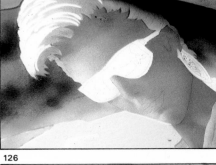

126

Figures 124 to 126. These figures demonstrate the use of liquid latex (masking fluid or rubber cement) to mask the shiny areas of the woman's hair (fig. 124). Once the spraying has been done (fig. 125), the liquid mask is removed with a crepe eraser (fig. 126).

Figure 127. By means of a paper mask cut for this purpose, the woman's hair is masked again to obtain the impression of locks.

Figure 128. The reflection on the sunglasses was created by liquid masking, as was the light and shade on the glasses frames. The face remains masked with adhesive film.

127

128

Step-by-step masking for illustration

Small areas are now masked to give the illustration its final touches.

Figure 129. The film masking the beach area is cut to shape the piece of watermelon.

Figure 130. A French curve masks the woman's leg; later, the airbrush sprays color to obtain the shades on the table surface.

Figures 131 and 132. Now the watermelon seeds are painted and a few color patches applied by brush (fig. 131); then the rest of the watermelon's color and texture are sprayed on with the airbrush (fig. 132).

129

130

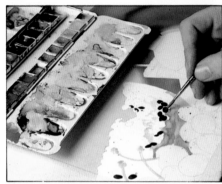

131

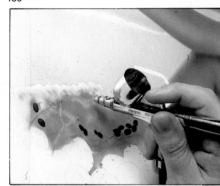

132

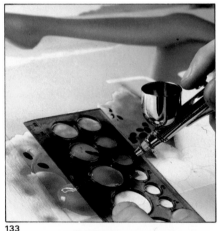

133

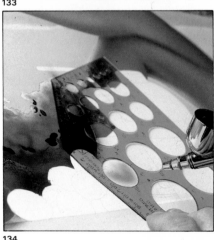

134

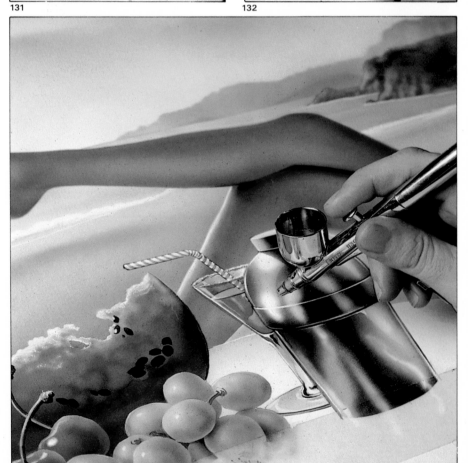

135

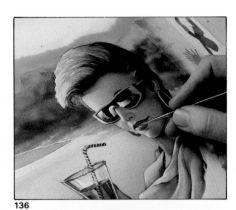

Figures 133 and 134. Once the color of the watermelon has dried, a template with circles is used to mask the shape of the cherries (fig. 133); another with ellipses handles the grapes (fig. 134).

Figures 135 to 140. The final details are now addressed: the reflections of the cocktail shaker (fig. 135); the lips, painted by brush (fig. 136); and the hair (fig. 137). White pencil retouches the tones of the blouse (fig. 138) and a blue felt-tip pen enhances the detailing of the straws (fig. 139). Figure 140 shows the finished product.

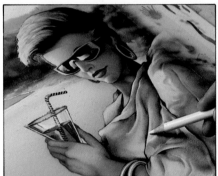

136

137

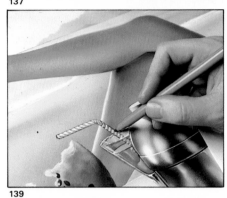

138

139

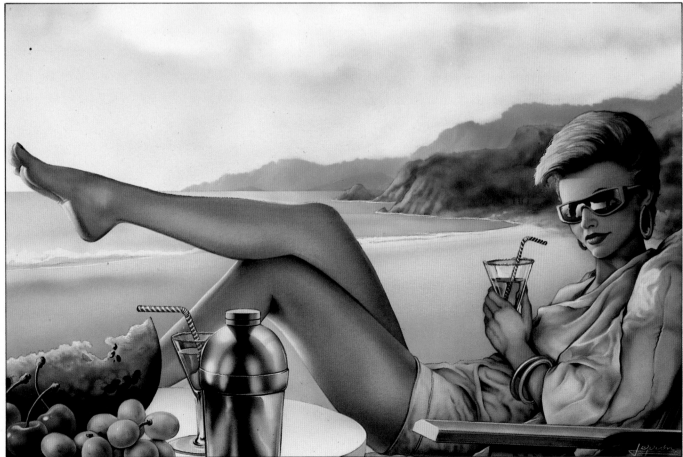

140

Photography has become a valued handmaiden for many types of artists. Photos may be used as reference, as a means to study the effects of light and shade, as a way to plot a composition, and—why not?—as models from which to paint with oils, pastels, watercolors ... or with an airbrush. But Christopher Isherwood notwithstanding, the artist is not a camera.

Artists must create, they must interpret. The creative process, and the use of photography to enhance it, is the subject of the following section. It offers a detailed explanation of techniques for reproducing and adapting photographs with the airbrush.

141

PHOTOGRAPHY AS AN AUXILIARY MEDIUM
—————TECHNIQUES AND REPRODUCTION—————
PROCESSES

Creative photography

The airbrush artist may paint from a color photograph or even on the photograph itself. This type of air-brushing may be as simple as retouching or may embrace a personal interpretation —the creation of an image, with a photograph as its base, that in the words of Delacroix "expresses your impressions, your emotions before the model."

To create a work of art that is his own image, not the photographer's, the artist must imagine the subject and study its graphic interpretation by means of several sketches. These sketches offer a way to study shape and color, point of view, framing, light. Many airbrush artists first get a concrete idea of what they want, then commission a good photographer to shoot it, directing the endeavor as to the situation of the camera, the point of view, the framing, and the composition —moving the model or the camera, defining depth of field, and attending to other technical problems, including light and contrast.

With the details of the photographic image solved, the artist must put into practice the *"three technical secrets in the art of interpretation,"* in the words of the French artist and teacher André Lothe:

1. *Increase*
2. *Diminish*
3. *Suppress*

By *increase,* Lothe means to enhance, exaggerate, darken a color, intensify a contrast, or increase the size of an object.

To *diminish* is to remove color, wash, soften, tinge, or reduce sizes.

To *suppress* means to eliminate, cover, cancel all or a part of a background, a foreground, or an object. All this is the artist's work—to create a fresh image that springs from the photographic one.

And what is it to create? Simply put, to create is *to adopt a new attitude before something we wish to improve.* The teacher Jean Guitton states that "creativity—which results from intelligence— cannot be taught ... but it can be shown to what extent our sight must be directed so that intelligence can visit us." An example may help show what he means.

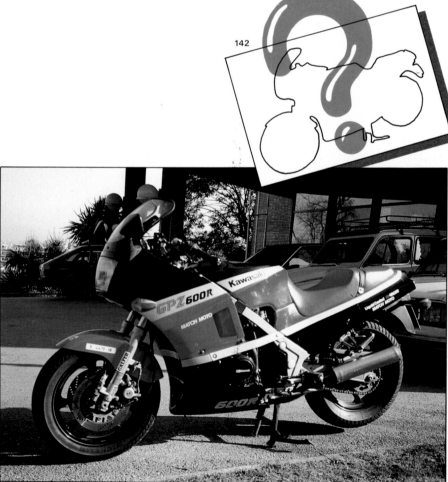

142

143

Figs. 142 and 143. The photograph of the product, in this case a motorcycle, is the first step toward an advertising illustration. The specific graphic idea is not developed yet, but from this image and the data provided by the advertiser or agency, a beginning has been made.

A practical case

Suppose that the manufacturer of the Kawasaki motorcycle 600 R wants to advertise his product in newspapers, magazines, posters, billboards, and so on. He calls an advertising agency and they call an airbrush artist, either directly or through the graphic studio where he works. The advertiser will explain what the client wants: a dynamic image that attracts the viewer's attention and sparks the desire to buy a bike. The agency gives the artist a photograph and asks for ideas (fig. 143).

Just as often, the artist's idea will come first and the photograph will follow.

The images here represent a synthesis of the creative process: the idea was to dramatize the height of the San Francisco skyscraper in a poster that would draw on the appeal of this city as a tourist spot. The artist made a rough sketch (fig. 144). A final photograph was taken (fig. 145) that formed the basis for the airbrush work (fig. 146). This process is similar to what will happen in our hypothetical Kawasaki campaign.

Figs. 144 to 146. Here we have an example of the processes often followed to produce an illustration with an airbrush. The client or agency asks the artist for a sketch, which he creates from an actual image. When the idea is approved, the artist hires a photographer to realize his sketch, directing the framing, point of view, and lighting effects he wants (fig. 145). The artists creates the airbrush illustration based on the photograph (fig. 146).

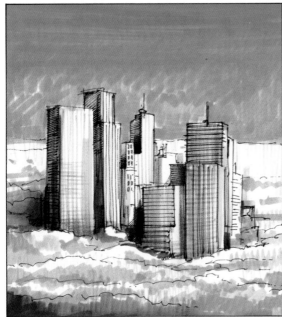

144

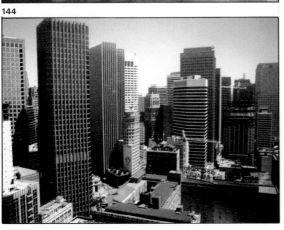

145

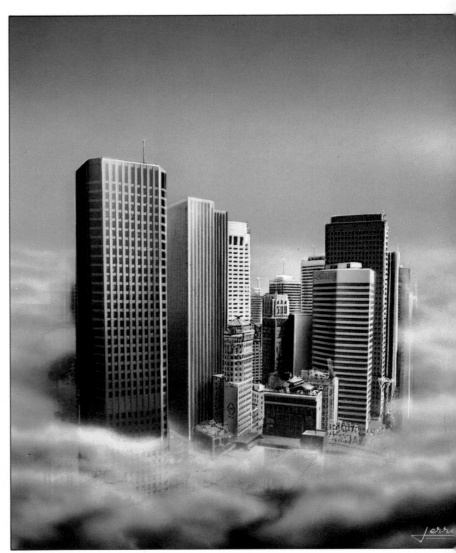

146

The sketches

147

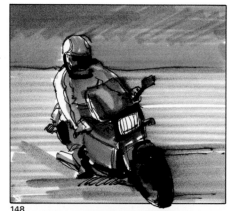

148

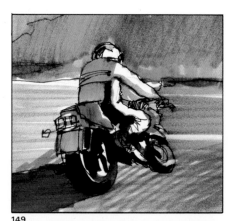

149

From the photograph given by the client (fig. 147) the artist familiarizes himself with the shape of the machine, enough to picture it running on asphalt and to attempt, pencil in hand, some graphic ideas that will later be transformed into concrete sketches. In the example shown here, the sketches have been made with felt-tip pens.

In the first of these sketches, the Kawasaki is seen from a rather high point of view, in three-quarter profile coming toward the viewer (fig. 148). In the second attempt, the bike is speeding toward the horizon and pictured from the rear from the same high point of view; the color spectrum now is colder (fig. 149). But these first sketches don't adequately show the aerodynamic design of the Kawasaki, so the artist tries a third sketch with the motorbike in profile (fig. 150).

This one is better, but it lacks dynamism, movement, strength. So the artist draws a final sketch: the Kawasaki, again shown in profile, is speeding from right to left and is represented as a flash of lights and diffused shapes (fig. 151).

Once the client and the agency accept the idea in principle, it's time for the artist to set up a photographic shoot. He calls a photographer, explains the theme, and makes an appointment to meet.

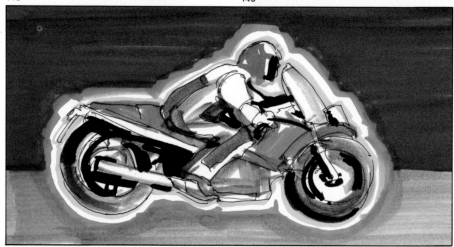

150

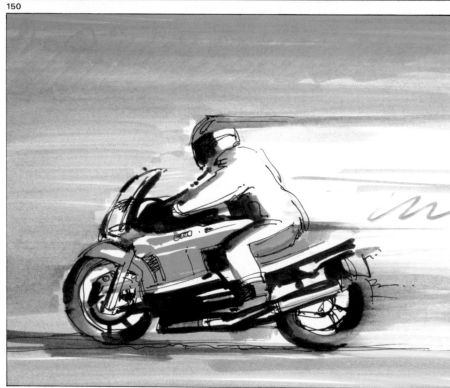

151

Taking the photograph

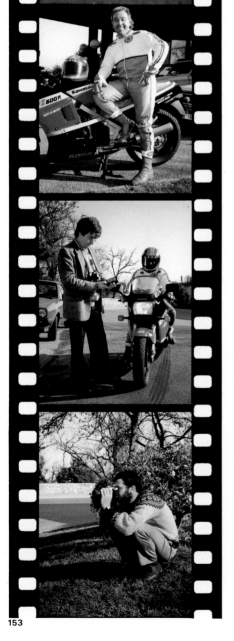

The photographer is going to work with a Nikon camera with a 200-mm lens and fast film of 400 ASA (fig. 152)—the equipment he considers adequate to shoot a motorbike running at a minimum speed of 45 miles per hour. The artist chooses the road and asks the motorcycle rider to make several runs in front of the camera. The motorcycle goes by again and again, the photographer clicks, and the artist, sketch in hand, studies the scene and imagines the final photograph. Suddenly the artist has a brainstorm: the illusion of speed would be enhanced if the shoot were moved to a street corner, with bike and rider leaning to one side as they take the curve. Better yet, the photographer should keep the camera angle low, shooting upward at the motorcycle.

Almost a whole morning has been spent taking photographs, moving locations, repeating, correcting, improving ... until the desired image is achieved (fig. 154): a photo of a motorcycle and rider from which the artist will interpret and create an image of the beauty and power of the Kawasaki 600 R.

Figs. 147 to 151. (Opposite page). This series of pictures shows the stages of the creative process. Often enough the artist in sketching a concept will produce some false starts (figs. 148 and 149). Creativity does not appear spontaneously; it is necessary to work, try again, and start all over from scratch —frequently over the course of hours or days— until the concept finally begins to take shape, as in figure 150 and even more so in figure 151.

Figs. 152 to 154. The photographer collaborates with the help of his equipment —cameras, lenses (long focal in this case)— and his knowledge of technique: lens setting, focus, and so on. But the artist has to choose the point of view, the framing, the distance between subject and camera, the light, the pose of the model. He must direct the photo shoot according to this vision.

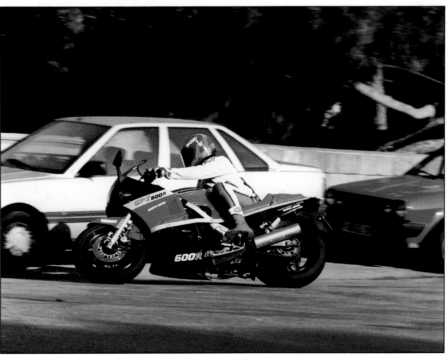

152

153

154

Systems to transfer a photographic image

155

Figs. 155 to 158. As you know, there are several systems for transferring a photographic image onto drawing paper. One of them consists of projecting the slide onto the drawing paper, amplifying it to the corresponding size, and drawing on the paper using the projected image as your guide.

After having chosen the best shot, the artist asks for the corresponding slide and a photographic copy enlarged to 18 by 24 inches. This photographic image will now be transferred onto drawing paper. This process can be handled three ways.

Transference through optical projection

This method consists of simply projecting and enlarging the image on the slide onto the paper, tracing with a medium-grade pencil and blocking out the shapes, then filling in all the details, including reflections and shadows (fig. 158).

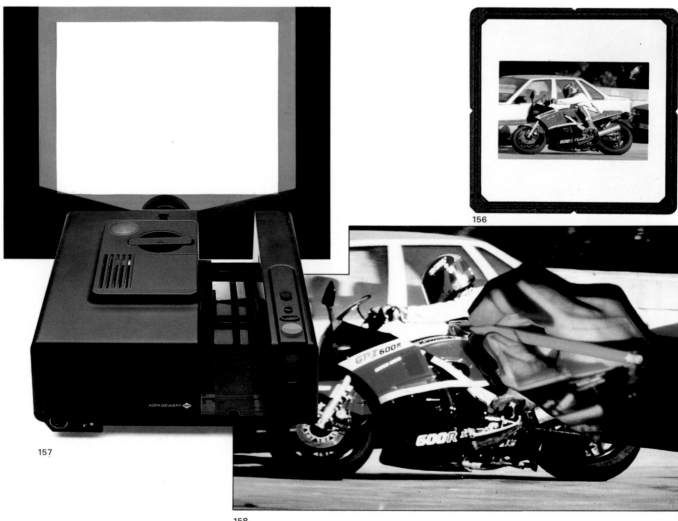

157

156

158

Transference by means of a plotting grid

This is probably the most common system used to transfer a photographic image onto paper. It consists of drawing a grid on the photograph, enlarging it to the desired size, and redrawing it, square by square, on the paper.

Many professionals prefer not to draw on the paper —which may be stained by the hand or rubbed by friction— instead drawing the grid and reproducing the enlarged image on tracing paper (fig. 160). In this procedure, a soft (2B) pencil is used to "paint" the black of the graphite onto the back side of the drawing, transforming the darkened tracing paper into a transfer paper (fig. 161). The tracing paper is placed on the drawing paper and the image is

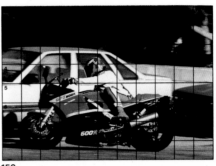

159

copied with the help of a drawing-point or a rather hard pencil (HB), taking care not to press too hard in order to avoid piercing the surface of the paper (fig. 162). Once the sketch is transferred (fig. 163), the artist may fill in some of the tiny details by hand.

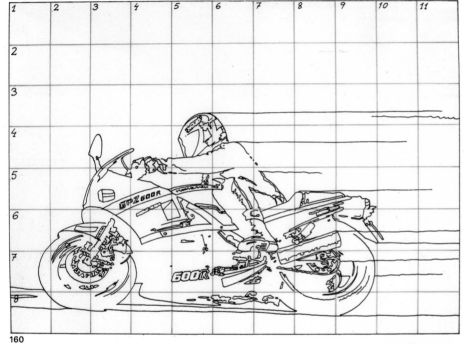

160

Figs. 159 to 163. One way of transferring an image, whether photographic or printed, consists of gridding off the original, copying it, enlarged or reduced, to tracing paper, then transferring this second image (figs. 161 and 162) onto the drawing paper.

161

162

163

Systems to transfer a photographic image

Transference by means of direct tracing

It's sometimes possible to obtain a photo that's of the same dimensions as the final drawing, or else a photocopy enlarged to the proper size. By placing the photo or copy on a light table, it can be traced directly according to the system explained on the previous page ("paint" or smudge the back of the tracing paper and transfer the image onto the drawing paper).

Once the drawing is completed, the airbrush work begins. The first step is to mask off the bike and rider and concentrate on painting the background. This seemingly vast surface of white paper must be addressed first so that the colors and the contrast between motorcycle and background can be properly adjusted. (It is worth bearing in mind the law of *successive contrasts,* which says that *a color is lighter or darker depending on the intensity of the color that surrounds it.* By initially painting the motorcycle and rider on a white surface, you run the risk of running "short," that is, painting with colors that are not sufficiently bright. Although they appear so on a white background, against blue they would lack intensity.)

Taking these and other factors into account, the artist gradually builds a final image, stressing the idea of speed by means of shapes, luminous trails, and the shaded repetition of the rear wheel, carefully painting the letter and tiny details of the engine, drawing and painting with brush and watercolor, shaping and retouching with colored pencils. The illustration will be finished by mechanically printed lettering in the upper area, for which sufficient space was purposely left.

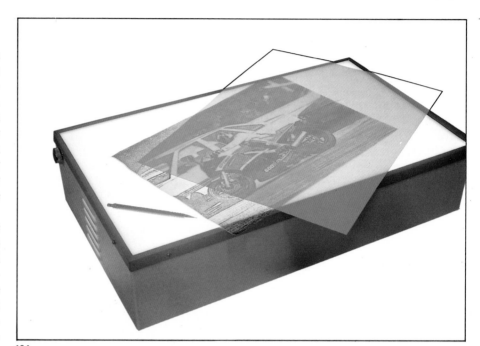

164

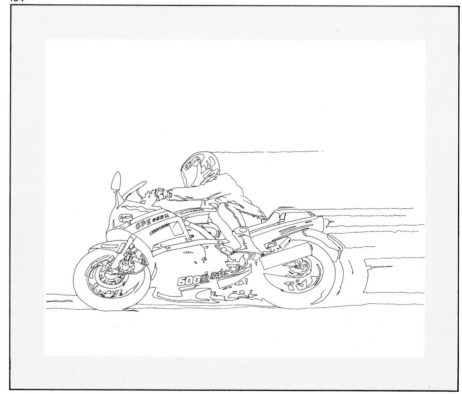

165

The finished image

Figs. 164 and 165. Another method of transferring a photographic image is by tracing. Take a photograph or photocopy —enlarged or reduced to the appropriate size— and, with the help of a light table, trace it directly onto paper or else transfer it to tracing paper, following the process explained on page 55.

Figs. 166 and 167. The end result: from an idea and a photograph springs an advertising illustration.

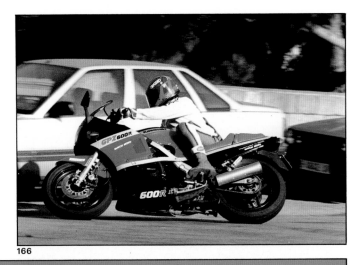

166

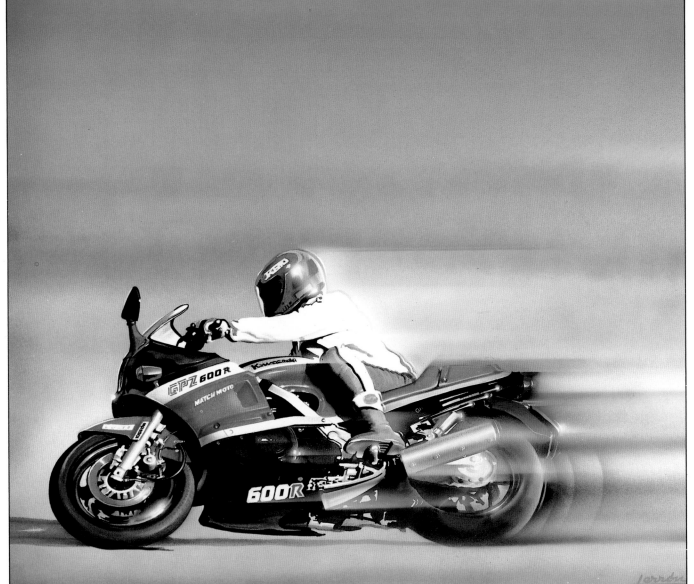

167

Some believe that in order to paint with an airbrush it is not necessary to know how to draw. They say: "I can reproduce this image without drawing it; all I have to do is trace." In theory they are right, and some people work this way, simply tracing photographs and then airbrushing the traced image. But without mastering the art of drawing or painting, it is practically impossible to reproduce colors and forms, to see and adjust the proportions, dimensions, values, and tones of the painting. How would it be possible to accentuate or reduce contrasts in tone and color? And what about painting and mixing, creating shades and colors? If one does not know how to draw, how can he achieve the contrast he wants? If that person can't paint, how will he obtain, say, a broken gray with a warm tone or create a color contrast by the juxtaposition of complementary hues? The following pages will discuss these issues.

168

FUNDAMENTALS OF DRAWING
—AND PAINTING—
APPLIED TO THE AIRBRUSH

Basic forms and structures

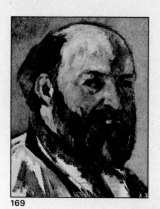

169

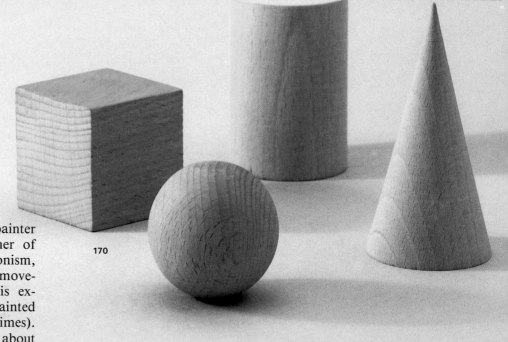

170

The French Impressionist painter Paul Cézanne was the father of modern art. Post-Impressionism, Cubism, and other modern movements were born out of his experiences and studies (he painted Mont Sainte Victoire 55 times). Among Cézanne's many ideas about art is a memorable insight into the basic structure of all forms. **"The problem,"** he said, **"consists of knowing how to reduce all forms to a cylinder, cube, or sphere."** An apple is basically a sphere, a cup reduces to a cylinder; as for the cube, it is found in an infinite number of bodies, from a match box to a skyscraper or a house. And if we combine cubes and rectangular

Figs. 169 and 170. Paul Cézanne. *Self-Portrait,* Orsay Museum, Paris. In the last years of his life, Cézanne constantly experimented with drawing from basic forms such as the cube, cylinder, and sphere, in perfect perspective.

Figs. 171 to 174. If you can draw a cube, rectangular prism, or cylinder in correct perspective, you can draw any object or body.

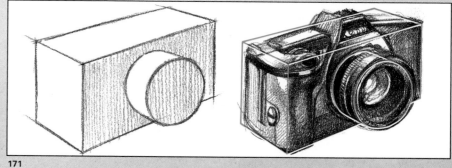

171

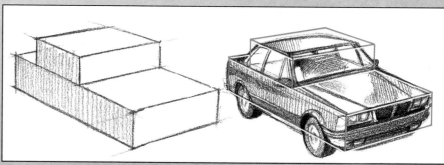

172

173

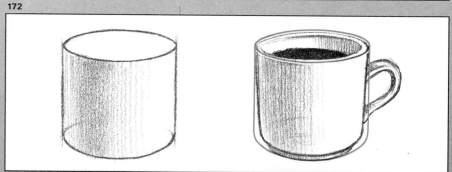

174

prisms, we can draw cars, cameras, etc. Apart from the cube, cylinder, and sphere, the artist can structure bodies from such simple geometric forms as a square, triangle, rectangle, or oval (see adjoining figures). It is a question of seeing: of seeing and drawing, first, the most representative basic form, the cube, prism, cylinder, square, or circle that best defines the model. This form is approximately calculated to create the proper dimensions and proportions (the height and width of the model) with the aim of sketching the definitive shapes. If this initial structure corresponds to a basic cube, cylinder, or sphere, the drawing's resolution will lead to an accurate perspective. This subject will be taken up later in the chapter.

Fig. 175. The drawing of a house is nearly always made up of one or several rectangular prisms. In this figure we can also see the construction of a rose and of a woman boxed within a rectangle and a triangle, respectively.

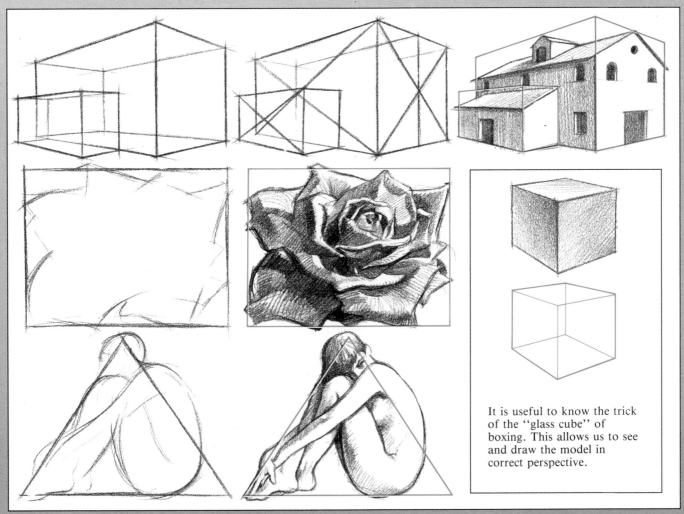

It is useful to know the trick of the "glass cube" of boxing. This allows us to see and draw the model in correct perspective.

175

Dimensions and proportions

The mental calculation of dimensions and proportions is carried out fundamentally by comparing distances, searching for reference points from which distances and forms can be interpreted. The artist must also imagine lines so as to situate forms and contours.

The experienced artist will make these calculations even before taking up his pencil by placing himself in front of the model and studying its forms and dimensions. The calculation consists of first roughing in the model's basic forms (fig. 177) and then comparing some of its parts with others, using one or two measurement modules (figs. 178 to 180). Before starting the drawing, he must decide what size he will draw the model in terms of the paper's format, setting up composition. It can be helpful to make a two-angled frame out of black cardboard: holding it by the hand and approaching or distancing it from the model helps to decide the drawing's size and choose the picture's best setting.

From mental calculations of dimensions and sizes, the next task is to figure out proportion, that is, to re-create the same proportion of form and distance that exists in actuality. A very useful method of gauging the dimensions of the drawing is to hold a pencil, paintbrush, or ruler, straighten out your arm at eye level, and place your thumb at the point of the pencil that coincides with the measurement of the model you are looking at. Compare these points with corresponding ones (figs. 181 to 183). This sizing-up procedure can be used to obtain the proportional reduction or amplification in height or width of the model and its various parts.

176

177

178

179

180

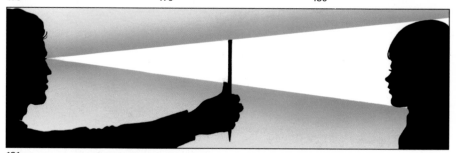
181

182

183

Figs. 176 to 183. All these objects can be structured from a basic form (figs. 176, 177) and allow a comparison of dimensions (figs. 178 to 180). Figures 181 to 183 demonstrate the old trick of calculating and comparing dimensions using your pencil and thumb.

Lights and shadows

184

185

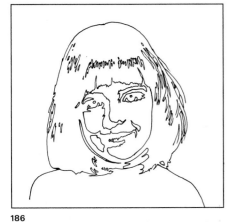

186

Figs. 184 to 187. Obtaining the effects of light and shadow when painting with an airbrush requires a close study to determine the precise limits between the areas of light and shadow. It requires first a rough ink sketch in black-and-white with no midtones to define the major light-dark patterns (fig. 185); from that you can make a line drawing like the one in figure 186, mapping out gradations and shading.

Any painting that is based on a bad drawing is destined to fail, and an airbrush painting is no exception. On the contrary, perhaps no other technique requires such great precision in drawing. Moreover, the airbrush artist should master what artists call the drawing *"block,"* which synthesizes the model's tones (fig. 184) and delimits the darkest zones (fig. 185). From this block —essentially, an imagined image of maximum contrast— it is possible to reach the drawing in figure 186, in which the zones of light and shadow have their corresponding contours (they remain delimited by lines). This is a sure guide to making the different masks and the overall plan for the airbrush picture.

Simplifying contrasts in order to explain form with a minimum of tonal elements —just light and shadow— is something that requires a certain amount of practice and a few tricks. One of the best known is to squint so as to only see the great "masses" in the composition and eliminate the details. This lets you control and highlight the dark forms, leaving the light ones out of the picture momentarily.

187

Fundamentals of perspective

Perspective is the science that teaches how to represent things on a plane (that is, in two dimensions, height and width) exactly as we see them, creating an illusion of the third dimension (depth).

Perspective is a complex and mathematical subject that could fill as many pages as this book contains. But airbrush artists are not mathematicians or architects. We must grasp the basic principles of perspective so as to avoid the errors of a beginner and to enable us to draw and sketch freehand, sometimes from memory.

At the same time, the airbrush artist's knowledge must be deeper than that of traditional artists and draftsmen, landscape or seascape painters who sketch with a pencil or who paint "sketches" in watercolor or oil. They, too, have to master perspective, but with less precision than airbrush artists. Impressionism and Expressionism, styles of painting that suggest forms and colors with scant reference to perspective, do not affect us. Airbrush painting is precise, exact, and generally hyperrealistic. There is no room for deformation, error, or lack of knowledge of perspective. To avoid making errors, you must grasp the following aspects of drawing in perspective.

The basic elements of perspective are the **horizon line (HL),** the **point of view (PV),** and the **vanishing point** or **points (VP).**

The horizon line is always located directly in front of the observer, at eye level. It is invariably at this height, and if the observer's position

HORIZON LINE

188

189

190

changes, so does the horizon line. In this way, as you can see in figures 188 to 190, the horizon line between sky and sea appears to descend when the observer crouches and to rise when she stands up again. The **point of view** is situated on the horizon line and indicates the situation toward the right, left, or center of the picture, from the observer's eyes. Only in parallel perspective does it have a certain usefulness, as we will shortly see. The **vanishing point** (or **points**) is also found on the horizon line. It brings together the perpen-

dicular parallel lines at the horizon (one vanishing point, parallel perspective), as well as the obliques in respect to the horizon (two vanishing points, oblique perspective). In aerial perspective there are three vanishing points.

Figs. 188 to 190. The basic elements of perspective are the *horizon line,* the *point of view,* and the *vanishing point* or *points.* The horizon line is found at eye level; it gives the appearance of moving up or down according to the viewer's position or point of view.

Parallel perspective

The fundamental rules of perspective are easily deduced from the study of a geometric body as simple as the cube—a regular prism made up of six parallel square sides distributed in pairs. When a cube is placed so that one of its sides is parallel to the drawing's plane, we find ourselves confronting a **parallel**

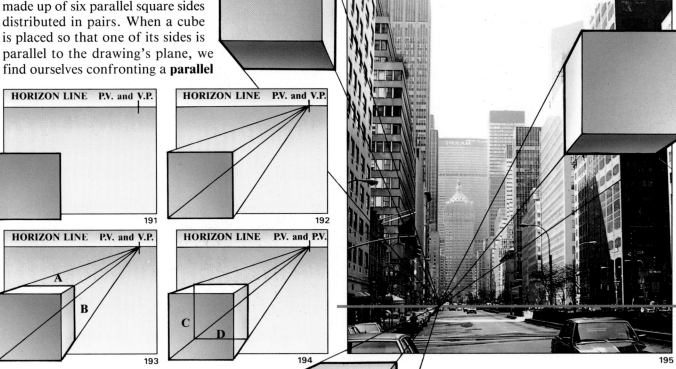

191 192 193 194 195 HL.

perspective, which is characterized by having only one vanishing point that corresponds precisely to the point of view.

Let's look at it in a more practical way, by drawing. Once the horizon line and point of view have been marked in the drawing, we will draw the front side of the cube, a perfect square (fig. 191). From the vertexes of the square, we will draw vanishing lines to the vanishing point (fig. 192). To create the illusion of depth in the cube's lateral sides, we draw in the edges A and B of the upper and lateral sides (fig. 193). Now that we have roughly determined the depth, it would be a good idea to check that edges A and B are correctly placed. The most practical way of doing this is to imagine that the cube is made of glass, allowing a view of edges C and D (we will shortly draw them) and of the hidden sides, above all at the base. They must look like a square, it's a very common error

to give them too much or too little depth, converting the figure into a rectangle instead of a square (fig. 194).

196

Figs. 191 to 195. One single vanishing point (which coincides with our point of view) and the horizon line intersect in parallel perspective, in which all the perpendicular parallel lines converge at the horizon.

Fig. 196. Here are some common errors in drawing cubes in parallel perspective. A: Proportional defect. B: Error in the drawing of the horizontal lines, which do not converge at the same vanishing point. C: The same error, but with vertical lines. At bottom right, drawing a cube as if it were made of glass helps when studying dimensions and proportions.

Oblique perspective

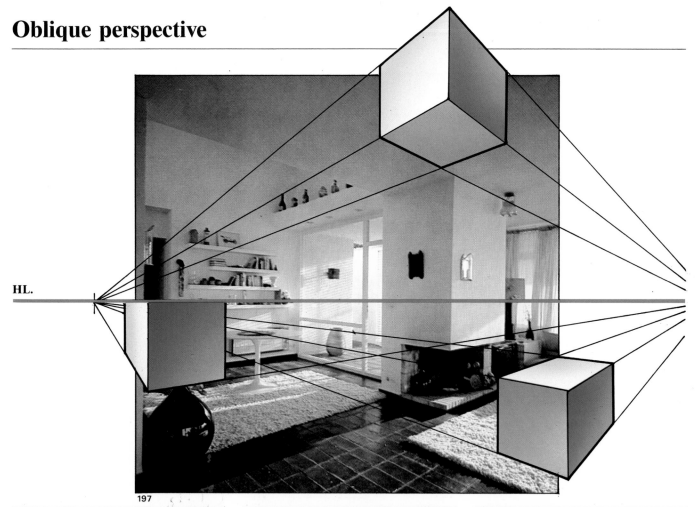

197

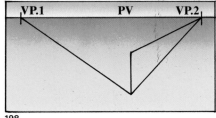

198

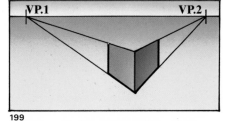

199

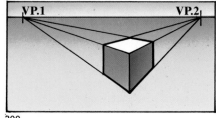

200

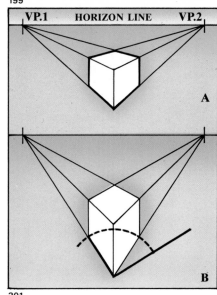

201

In oblique perspective only the vertical lines are kept parallel, while the rest are directed to the horizon. The result is two series of converting lines, each meeting at its corresponding vanishing point.

We can see oblique perspective in a cube in figures 198 to 200. We first place the point of view approximately in the center of the cube, sketch freehand the vertical line that corresponds to the nearest edge, and establish vanishing points 1 and 2 and draw the first vanishing lines (fig. 198). Next we draw the lateral sides (fig. 199) and finish off the drawing with the top side (fig. 200). In figure 201, note that the angle

formed by the cube's base is always greater than 90° (fig. 201A). When the angle is less than 90°, the cube will appear deformed (fig. 201B). Oblique perspective is the most commonly used in all kinds of drawings, especially interiors, as seen in figure 197.

Aerial perspective

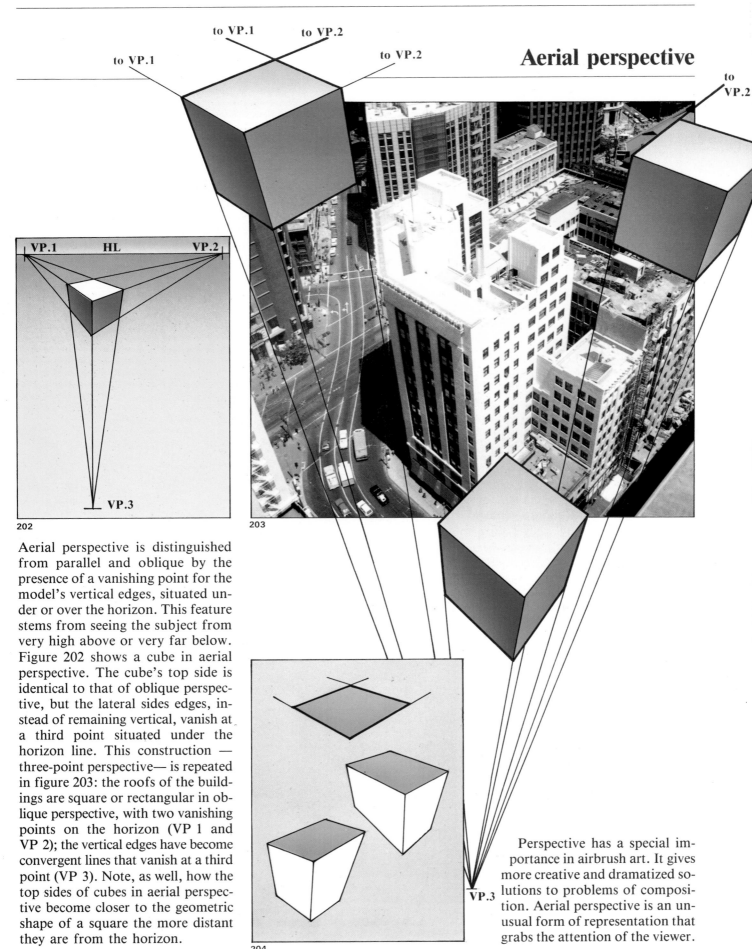

to VP.1 to VP.2

to VP.1 to VP.2 to VP.2

VP.1 HL VP.2

VP.3

202

203

204

VP.3

Aerial perspective is distinguished from parallel and oblique by the presence of a vanishing point for the model's vertical edges, situated under or over the horizon. This feature stems from seeing the subject from very high above or very far below. Figure 202 shows a cube in aerial perspective. The cube's top side is identical to that of oblique perspective, but the lateral sides edges, instead of remaining vertical, vanish at a third point situated under the horizon line. This construction — three-point perspective— is repeated in figure 203: the roofs of the buildings are square or rectangular in oblique perspective, with two vanishing points on the horizon (VP 1 and VP 2); the vertical edges have become convergent lines that vanish at a third point (VP 3). Note, as well, how the top sides of cubes in aerial perspective become closer to the geometric shape of a square the more distant they are from the horizon.

Perspective has a special importance in airbrush art. It gives more creative and dramatized solutions to problems of composition. Aerial perspective is an unusual form of representation that grabs the attention of the viewer.

Perspective of the cylinder and the circle

Now we will see how a circle or cylinder is drawn in perspective. It is a process that allows intuitive solutions in images like the one seen on the following page (fig. 212, still life with Alka-Seltzer). Producing this composition requires a precise drawing done with ruler and triangle, as well as a thorough study of perspective.

To draw a circle freehand, we will begin by drawing the square that circumscribes the circumference, its diagonal lines (fig. 205A) and its median lines (fig. 205B). On top of the median (or in the middle of the diagonal) we will indicate three equal divisions. Starting from the one farthest from the center, we will draw an inner square with its sides parallel to the other square (fig. 205C). In this way we will have points **a, b, c, d, e, f, g,** and **h,** through which the circumference will be drawn (fig. 205D).

Now we will see the correct way of doing this when starting off with a square in oblique perspective (figs. 205E and F). In practice, it's not different from the technique used in parallel perspective. The end result is an oval (figs. 206A and B). To draw a cylinder, start off with a rectangular prism, as seen in figures 207A and B. The following images show some of the most common errors in the construction of a cylinder. The first and most common consists of drawing the vertexes or angles on both sides of the circles (figs. 208A and B); another mistake that is also a product of a false perspective lies in the corresponding circle at the cylinder's base (figs. 209A and B). Another equally common error is drawing the cylinder's thickness without having taken foreshortening or perspective into account (figs. 210A and B).

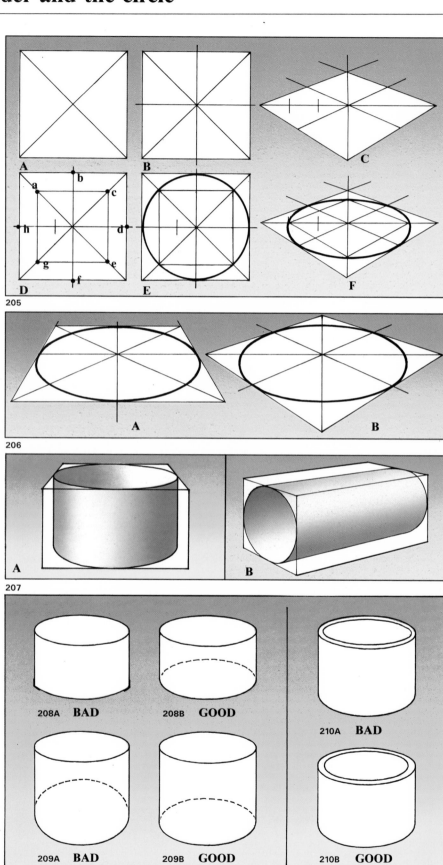

Practical application

Figs. 211 and 212. This is a good example of the necessity of mastering the perspective of the cube or rectangular prism (the box), the cylinder (the glass), and the circle (the plate). It is also a good example of the need to draw with maximum precision —with a ruler and triangle and a well-sharpened pencil (fig. 211)— to achieve the kind of quality result obtained by Miquel Ferrón in his magnificent illustration (fig. 212).

211

Here is an example of the application of the circle, cylinder, and cube (in this case, a rectangular prism). Co-author Miquel Ferrón drew it from a real model, without photographs, which required him to first do a sketch to study the forms, effects of light and shade, and perspective. Afterwards, once the position of each element had been established —that is, the composition had been mapped out— Ferrón made a drawing of the model (fig. 211) using a ruler and triangle to obtain all the basic elements of perspective: parallel for the glass, the plate, and the tablet, and oblique for the Alka-Seltzer box. The success of this illustration lies in Ferrón's mastery as an airbrush artist, but a great part of it is due to the perfect construction of the forms.

212

Depth in parallel perspective

How is it possible to determine in perspective a distance that repeats itself in depth? We will begin with the easiest case: a grid-shaped mosaic in parallel perspective.

First we draw the rectangle of the tiled area (fig. 213A) and divide the nearest side into as many equal spaces a there are tiles we want to situate in each row. From these divisions, we draw lines to the vanishing point. Then we roughly limit the depth of the square tiles—3 by 3, for example; this is box a in figure 213B. Now we sketch the diagonal line that passes by vertexes **b** and **c** (fig. 213C). The intersections of this

213

214

diagonal with the vanishing lines of the rows of tiles give us the points of reference needed to sketch the horizontal lines that complete the mosaic (fig. 213D).

Another system for attaining depth in perspective can be seen in figure 215. Here the problem is the positioning of columns (fig. 214) in perspective. It can be done by drawing what is called a **measurement line,** which, as you can see, is situated next to vertex **c**. Another point, known as a **measurement point (MP),** is situated on the horizon in the **a-c** vertical. From the measurement point, trace a diagonal line through the **d** vertex to **measurement**

e (at point **e**). Then divide the distance **c-e** into nine equal parts (fig. 215A). Now draw a series of diagonals from these divisions to the measurement point (fig. 215B). Drawing the verticals from the points established over depth **c-d,** you will have placed the columns in correct perspective (fig. 215C).

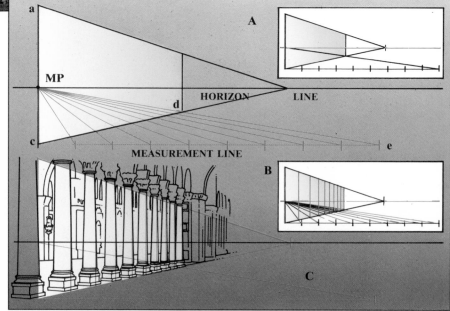

215

Depth in oblique perspective

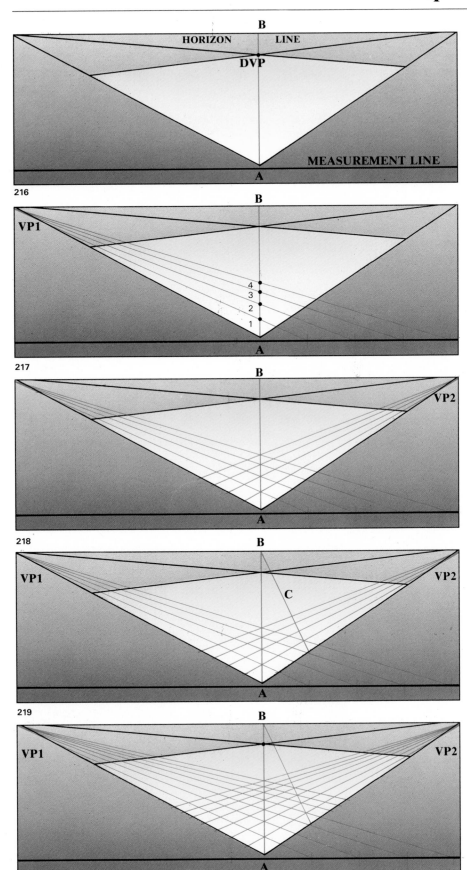

216

217

218

219

220

In order to draw a mosaic in oblique perspective, we must go through the following steps. First establish the horizon line and draw the oblique perspective of the square or rectangle that delimits the pavement. By the nearest vertex, draw a horizontal that will be **measurement e.** Then sketch the **AB** vertical from the measurement line to the horizon in order to find the **vanishing point of the diagonal lines (DVP)** as seen in figure 216.

Now we divide half of the measurement lines into, for example, four equal segments, short or long according to whether we want large or small tiles. From these divisions we draw vanishing lines to vanishing point 1 to obtain points 1, 2, 3, and 4 on the **AB** diagonal (fig. 217). If we draw vanishing lines to vanishing point 2, we will have a series of 4 by 4 tiles in perspective (fig. 218). By drawing a diagonal from the last tile on the right, we will obtain new reference points (fig. 219), which permit us to sketch new vanishing lines toward vanishing point 1 to achieve other points on the diagonal. Continue in this way until you complete the mosaic.

Figs. 213 to 220. The drawing of columns or a series of openings, doors, or windows, as well as the representation of mosaics in parallel or oblique perspective, are common tasks for the artist/illustrator. These themes demand a mastery of perspective. It may be useful to practice by drawing these and other examples.

Depth in aerial perspective

The procedure for achieving depth in aerial perspective is practically the same as that used in oblique perspective. The top base of the prism or cube remains unmodified by the vertical vanishing point, so this square is controlled by the laws of oblique perspective. The divisions that are obtained on the square's sides aid us in dividing, by width, the sides of the prism that vanish "to the bottom."

It will be enough to draw them to **vanishing point 3,** from the divisions obtained in the sides of the top part of the square.

Now let's examine the whole process, as shown in figure 221. We situate the measurement line, which will also be the vertex **A.** Take edge **B** past the horizon line in that way establishing the **vanishing point of the diagonals (DVP).** Then draw a diagonal from the **DVP** toward point **D,** passing through vertex **C.** Now divide the

distance **A-D** of the **measurement line** into a convenient number of parts —in this case, five— and from these divisions draw diagonal lines to the **DVP.** They give us point **E, F, G,** etc., from which we draw vanishing lines to **the bottom,** or the third point of the aerial perspective, **DVP 3.** This procedure divides the composition into equal spaces in depth.

A special case: several vanishing points in the same image

In parallel, oblique, or aerial perspective, what happens in a composition like the photo of a street (fig. 223), when the positions of the buildings create different vanishing points? The solution is quite easy: first a horizon line is established. It's provided, in this case, by the heads of the figures. As for the vanishing points, we have **VP 1** and **VP 2** cor-

responding to the houses in the foreground **(A-A)** seen in parallel perspective (the right-hand house forms a curve, which determines the two vanishing points. Vanishing point **3** of house **C** is in oblique perspective, as is house **B.**

To properly draw houses, containers, and the like, it's also necessary to understand shadow perspective.

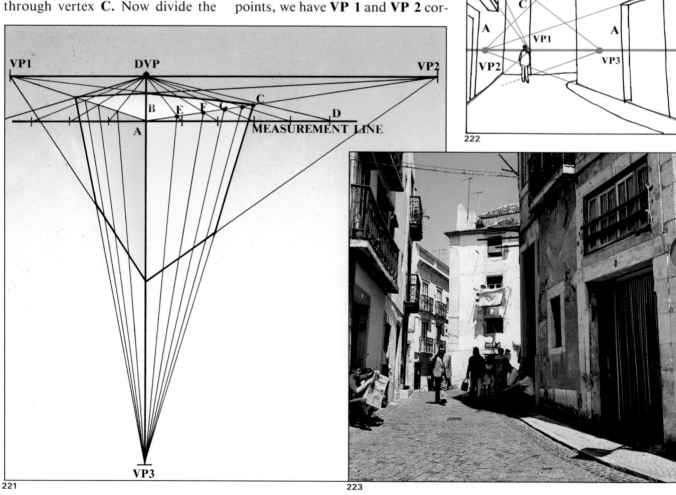

221

222

223

Shadow perspective

Working with natural light

Imagine a room with an illuminated light bulb hanging from the ceiling. Imagine a square-shaped object standing upright in the room and receiving lateral light. Taking into account that artificial light propagates straight lines in a radial direction, isolating the rays that illuminate our square surface would reveal the angle formed by the sides of the beam, **A** and **B,** with the vertex in the point of light. The beam is directed to the vertical square surface and, being interrupted by it, projects a shadow onto the floor (fig. 224).

With this image we arrive at a first conclusion: In shadow perspective, the point of light turns into a **light vanishing point (LVP),** the place where the rays that determine the form of the shadow converge.

In order to complete this system we need to consider another point that allows the position and direction of a shadow on the ground to be determined in respect to the light's posi-

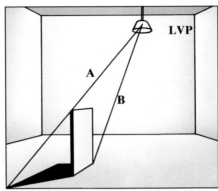

224

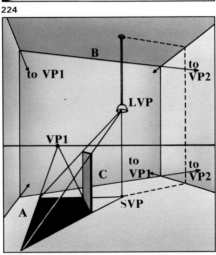

225

tion. There it is, in figure 225. It is **the shadow's vanishing point (SVP),** which you can situate by taking the light to the ground. To determine the level of the **SVP,** it's necessary to do a simple calculation of perspective, "moving" it to the ground or, more precisely, **projecting it** from the position of the light hanging from the ceiling. In figure 225, we can see an example of this simple projection operating with oblique perspective. In the same figure, we can also understand the conjunction of all the vanishing points. Vanishing point 1 is the point at which the edges of the room and the top and bottom sides of the illuminated square converge, as well as the limit **A** of the projected shadow.

Vanishing point 2 is another normal vanishing point, at which the horizontal lines **B** and **C** of the back wall converge. Finally there is the special vanishing point —the **light vanishing points (LVP)**— for drawing the shadows. This is where the lines or rays that determine the form of the projected shadow converge. The vanishing point of the shadows **(SVP),** from the ground, directly under the light, completes the form and perspective of the drawn shadow.

In order to understand this well, look at figure 226, a complete guide on shadow perspective in artificial light. Note that the woman's shadow and that of the rectangular object at right are projected on the ground and continues up the respective walls. Similarly the cylinder's shadow is interrupted by a rod-shaped object at the left foreground.

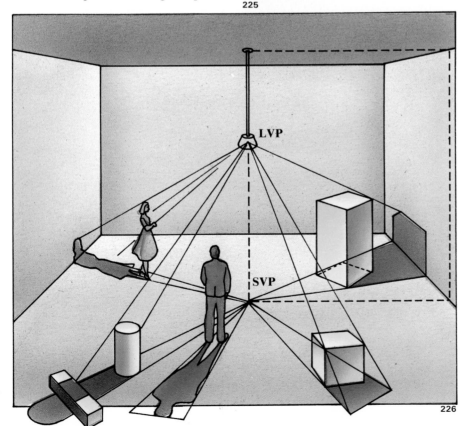

226

Shadow perspective

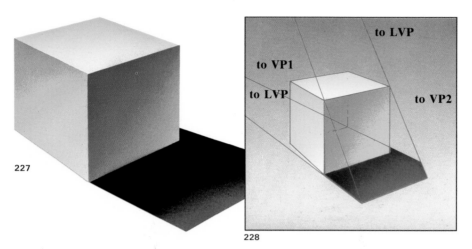

227

228

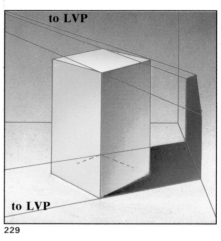

229

To better understand figure 226, we have drawn the geometric figures separately. Study them closely, checking once again the combination of light and shadow vanishing points that allow the creation of perspective in the shadow of each figure. Look closely, for example, at the special form taken by the cube (fig. 228), which is difficult to interpret without the knowledge of vanishing points and rules of perspective. In the case of the rectangular box whose shadow is "broken" by the vertical plane of the wall, observe that all we have to do here is to "lift it off the floor," using the same angles of illumination and the forms determined by the lines from the **light vanishing point** (fig. 229).

Figures 230 and 231 teach the same lesson for the shadowed profiles of a sphere or cylinder. Remember that the problem is reduced to boxing the circle within a square, projecting this square toward the ground, and drawing inside it, with the corresponding perspective, the shadow projected by the model. This formula is applicable to the drawing of shadows in perspective of heads and any other objects with an irregular or curved shape.

You may want to try your hand at drawing a cube, rectangular prism, and cylinder with their corresponding shadows in a variety of positions as an exercise in perspective and shadow perspective. This will help yu better understand the principles discussed. Working with **natural light** offers only one variant to artificial light, as you will see on the following page.

Figs. 227 to 231. The cube and rectangular prism in figures 228 and 229 are in oblique perspective with two vanishing points. VP1, on the left, and VP2, on the right —both of them on the horizon line. Between the two lie the corresponding shadow points: LVP and SVP. These relate to the basic points in the sphere and cylinder. To fully understand the workings of all these vanishing points, experiment by drawing figures like these in different positions with their corresponding light and shadow effects. It is the best exercise you can do in order master the problems of perspective.

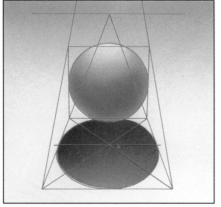

230

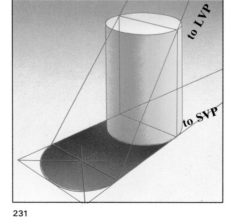

231

Figs. 232 and 233. (Opposite page). The vast distance between the sun and the earth makes *solar rays* propagate in a parallel direction. So when we see bodies from an elevated point of view, the shadows are also projected in a parallel direction.

Perspective of shadows in daylight (natural light)

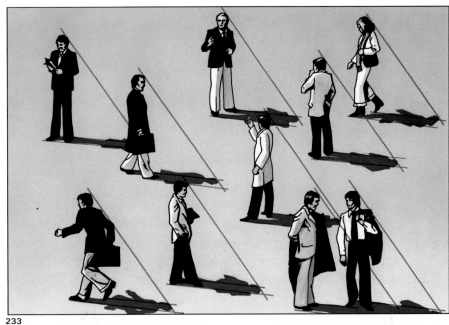

233

232

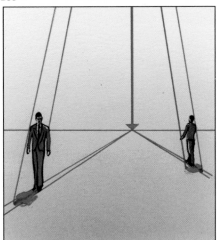

234

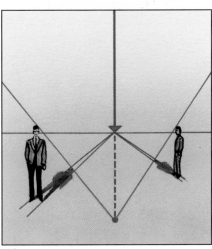

235

The colossal size of the sun as well as its enormous distance from the earth practically eliminates light propagation in a radial direction. As a consequence, **natural light** is **diffused in a parallel direction** (figs. 232 and 233); and that is how we see it in aerial perspective. But from a normal plane, there will always be a **shadow vanishing point** on the horizon as well as a **light vanishing point.** When the sun is in front of the viewer, the LVP will be the sun and the bodies will be back-lit, as in figure 234. When the sun is behind the viewer, the **light vanishing point** will be situated on the ground plane, under the horizon (fig. 235).

Figs. 234 and 235. Seeing bodies from the ground, when the sun is in front of us and the bodies are back-lit, the LVP is the same as the sun on the horizon (fig. 234); when the sun is behind us and the shadows vanish to the horizon, the LVP is on the ground under the horizon line.

In the middle of the nineteenth century, a Frenchman called Eugène Chevreul, a chemistry teacher and director of dyeing in the renowned tapestry workshop at Les Gobelins, Paris, published a work on the theory of colors based on the use of the color wheel. This development coincided with the beginning of an artistic movement perpetrated by a group of young artists who were struggling to clear the palette of dark colors, to paint in the open air, and to create harmonies of color. They were Manet, Monet, Degas, Pissarro, Sisley, Renoir, Cézanne, van Gogh ... the Impressionists. Through the use of Chevreul's color theory, they were able with just three colors to paint all the hues they found in nature. The Impressionists created harmonies and contrasts of colors never before seen, such as shadows painted with light colors. Moreover, they found a way to paint the light itself.

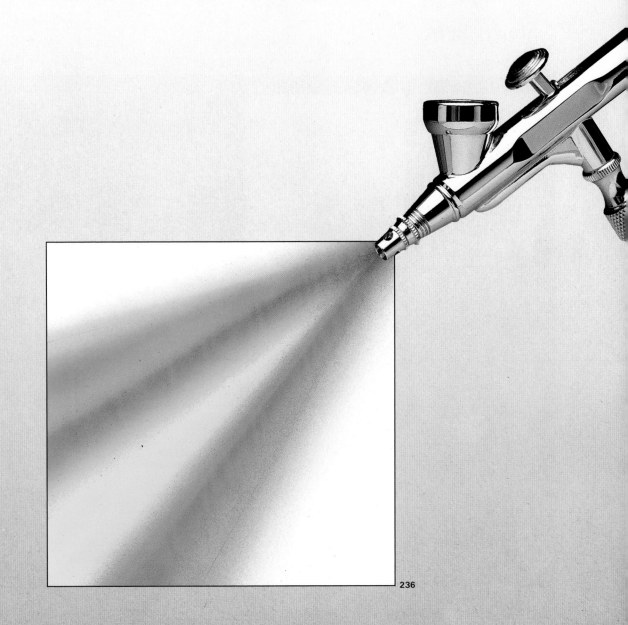

236

COLOR THEORY
APPLIED
TO AIRBRUSH PAINTING

Color is light

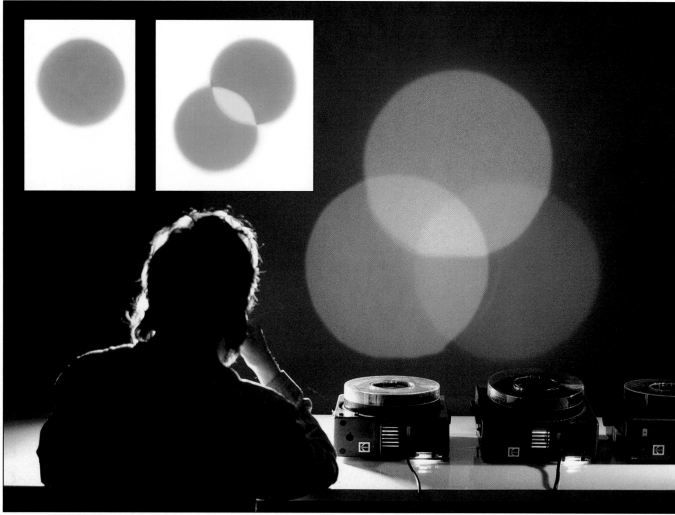

237

At the beginning of the nineteenth century, a young scientist named Thomas Young was living in London. He was a doctor by profession but was also interested in botany, archaeology, chemistry, and physiology. He was a renowned Egyptologist, and in addition to speaking French and German, he was also fluent in Greek, Latin, Arabic, Hebrew, and Persian. His special interest was the physiology of vision, and in studying it he discovered the power of the lens of the eye to adapt to light, a discovery he introduced to the German doctor and physicist Von Helmholtz. Von Helmholtz perfected the theory, which today is known as the Young-Helmholtz Theory. Young worked for years on vision and the theory of color, a subject that had been studied 100 years earlier by another famous Englishman, Isaac Newton, the physicist whose discoveries included the calculation of the infinite, the theory of universal gravity, and the nature of white light.

It is well known that Newton shut himself away in a darkened room one day, allowing only a small ray of sunlight to enter. He intercepted this ray with a crystal prism and succeeded in **breaking down** white light into the colors of the spectrum, thus demonstrating that **color is light.**

As for Thomas Young, he carried out an experiment with lanterns, projecting from six lanterns light in the colors of the spectrum onto a white wall. He thereby succeeded in projecting white light, confirming Newton's earlier experiment. Following this experiment, Young proceeded to change and eliminate rays of light, arriving at a new and definitive discovery: that the six colors of the spectrum could be reduced into three primary colors. That is to say, Young found that with **only three colors —red, green, and dark blue— he could re-create white light.** Amazing work by Newton and Young (figs. 237 and 238). I personally have carried out the three-lantern experiment, and I can verify that red light, when added to green, gives yellow, and when this is projected onto dark blue, white light is obtained.

The composition of light

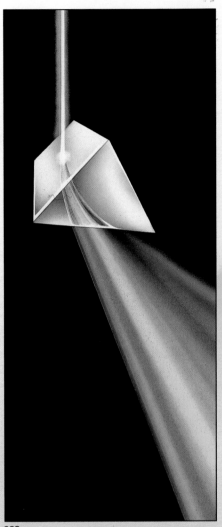

238

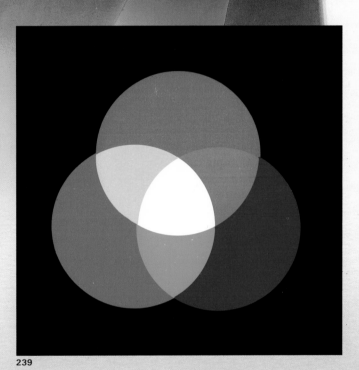

Figs. 237 to 239. Shut away in a darkened room, Isaac Newton succeded in breaking sunlight into the different colors of the spectrum. Passing a white light ray through a crystal prism, he discovered that color is light. A century later Thomas Young experimented with light beams to discover that all the colors of the spectrum can be synthesized from only three.

239

When it rains and the sun is shining, each drop of water behaves like Newton's prism, and thanks to these millions of prisms a rainbow is produced. Given that color is light and that the solar spectrum can be produced from light, we can confirm that the solar spectrum contains all of nature's colors.

Given Thomas Young's discovery that all of nature's hues spring from only three colors, we can understand the nature of **primary colors.** If all colors can be broken down into dark blue, green, and red, these colors must be the **three primary colors.**

Young's discoveries went further. In reproducing white light from only three colors, he then found that by projecting a ray of green onto red, he could obtain **yellow.** Projecting blue onto red produced **magenta,** and dark blue on green produced **light blue.** As a result, these three are considered the **secondary colors** (fig. 239).

A word of warning: remember that up to now we have been talking about rays of light. We are thus speaking of the **colors of light,** summarized as follows:

Primary light colors
Dark blue
Green
Red

Secondary light colors
Yellow
Magenta
Cyan blue

But light is not the artist's medium. We do not paint with colored light, we paint with colored pigments.

Colored light, colored pigments

Nature "paints" with **colored light.** In fact, when light is projected onto an object, this object reflects all or a part of the colors received through the **light.** (fig. 242, bottom of this page). A white object, like all objects, receive rays of light colored red, green, and blue, and as it receives them it deflects them, creating white light from the three colors. In a black object, the opposite occurs: It absorbs the three light colors, essentially leaving the object without light, which is the reason we see it as black. Let us now examine what happens with a yellow object: it receives all three light colors, absorbs the blue and reflects the red and the green. What we see, therefore, is the color yellow. In effect, then, light "paints" **by combining colors.** A red light ray added to a green light ray doubles the amount of light and produces a brighter yellow ray. Physicists call this phenomenon **additive synthesis** (fig. 240).

But when painting we don't use light. **We cannot obtain yellow pigment by mixing red and green.** The painter's mixtures always require the subtraction of light. Physicists call this **subtractive synthesis** (fig. 241). Consequently, our **primary-colored pigments** have to be lighter than the **primary-colored light rays.** We thus use the same six colors of the spectrum as a base but we change the value of some colors relative to others. **In painting, then, the primary colors are the secondary light colors and vice versa.**

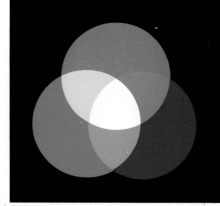
240

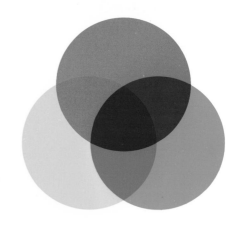
241

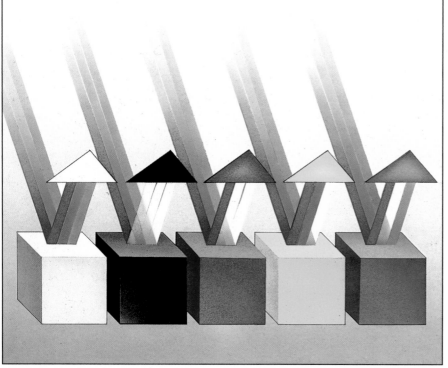
242

Fig. 240. **Additive synthesis.** Light "paints" by adding colors. Adding the three primary light colors produces white.

Fig. 241. **Subtractive synthesis.** Mixing pigment colors involves taking light away rather than adding it. When we mix magenta and yellow we get a darker color, red. Mixing the three primary pigment colors yields black.

Fig. 242. Objects reflect all or part of the light they receive. A white object receives the three primary light colors and reflects the sun as white; a black object absorbs all the colors and does not reflect any one, producing the perception of black; a yellow object absorbs blue and reflects red and green, the mixture of which gives yellow.

Primary, secondary, and tertiary paint colors

Here are our colors:
Primary colors (fig. 241)
Yellow
Magenta
Cyan blue

Mixing these primary colored pigments in pairs, we obtain the:

Secondary colors (fig. 241)
Cyan blue and magenta = dark blue
Cyan blue and yellow = green
Yellow and magenta = red

Now let's look at the color wheel, which shows the classification of colored pigments. Primary colors are indicated by the letter P, secondary colors by S. When the secondary colors are mixed with the primary colors, we get tertiary colors (indicated by the letter T).

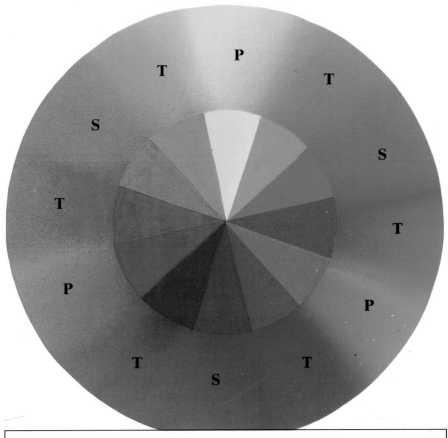

Fig. 243. In the color wheel we find the primary pigment colors (P), the secondary colors (S), and the tertiaries (T). The term cyan blue does not exist in the different color wheels: it was derived from theories in the graphic arts and color photography. It resembles Prussian blue mixed with white.

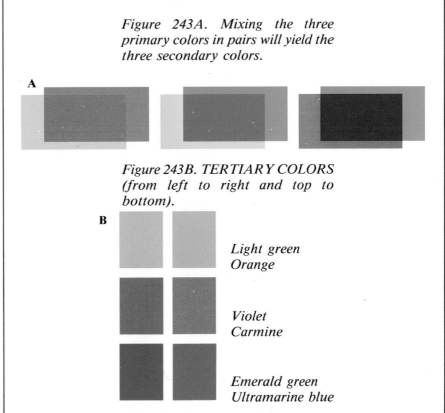

Figure 243A. Mixing the three primary colors in pairs will yield the three secondary colors.

A

Figure 243B. TERTIARY COLORS (from left to right and top to bottom).

B

Light green
Orange

Violet
Carmine

Emerald green
Ultramarine blue

243

All colors with only three colors

The color wheel on the preceding page contains only 12 different colors. Nevertheless, if we had kept on mixing tertiary colors with secondary and primary ones we would have obtained a new series of 12 colors, producing 24 colors in all. We could continue this process to produce an infinite number of shades, eventually obtaining all of nature's colors.

Following from this we can state the first and most important conclusion of color theory and its practical application to the art of painting: The perfect correspondence between the colors of light and the pigment colors (figs. 244 and 245) allows an artist to re-create the effect of natural light by simply mixing the three primary colors: yellow, magenta, and cyan blue.

Another conclusion, no less important, relates to the so called complementary colors. But what are complementary colors? On the next page, in figure 246, you can seee again the three lantern primary color experiment. If we take away the dark blue beam, its complementary color —yellow— appears on the screen. Yellow needs dark blue to create white light and vice versa.

Complementary colors
Yellow is the complement of dark blue, cyan blue is the complement of red, magenta is the complement of green, and vice versa (figs. 247 and 248, opposite page).

The color wheel illustrates the fact that all the colors are located oppo-

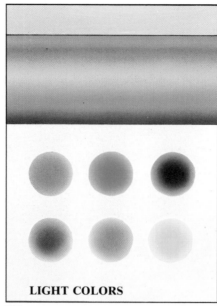

LIGHT COLORS

244

site their complements. Keeping this in mind and using the larger wheel, which shows tertiary colors, you can deduce the complementary colors. But remember, we are now painting by subtracting light. If we go further we will understand that mixing two complementary colors will produce the color black (fig. 248).

Complementary colors are used in painting in a variety of ways. First, they create color contrasts. If you put one color next to its complement —for example, yellow against dark blue— you will discover one of the most extraordinary contrasts imaginable. A knowledge of the complementary colors is very important to a painter. As the impressionists used to say, in the color of a shadow the complementary color of the main color can always be found (along

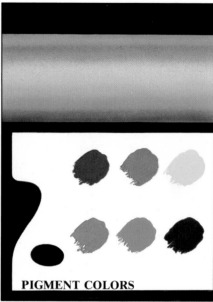

PIGMENT COLORS

245

with the blue that all shadows also contain). In the heart of a green tree, the color of the shadow is constituted by the mixture of the complementary magenta and blue, in addition to the dark green. With a knowledge of complementary colors, we have the opportunity to paint with a wide spectrum, as will be seen on the following page.

Figs. 244 and 245. Colors in the spectrum are the same whether we talk of light colors or pigment colors. This coincidence allows an artist to re-create all of nature's colors with only the three primary pigments: cyan blue, magenta, and yellow.

Complementary colors

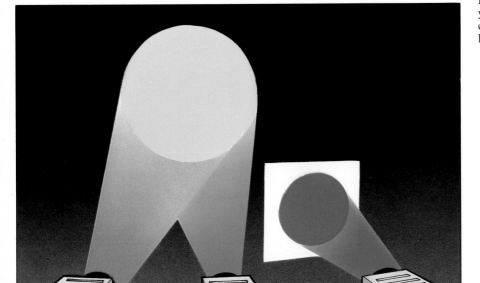

246

Fig. 246. Dark blue is a complement of yellow. As with all complementary colors, mixing them will re-create white light.

249

Fig. 249. (above) The color wheel shows the complementary colors.

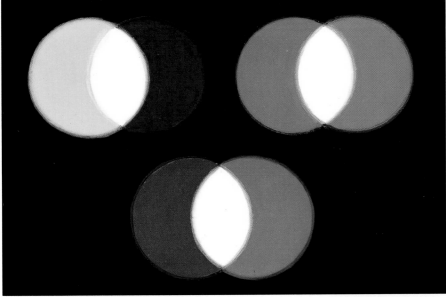

247

248

Fig. 247. The light rays on the left of each pair of circles —yellow, cyan blue, and magenta— are secondary light colors, each obtained by mixing two primary colors. You also need the primary dark blue, green, and red to re-create white light. So yellow is a complement of dark blue, magenta is a complement of green, and cyan blue is a complement of red.

Fig. 248. In light colors the mixture of two complementary colors gives white, but in pigment colors, such a mix produces black.

Color harmony

In all good works of art done with an airbrush there exists a harmony of colors and hues that is largely created by the artist. In part, of course, this harmony is supplied by nature, by the natural colors the artist is depicting and by the behavior of light. But the artist's mission is to accentuate or alter nature in his work, choosing a palette with, for example, a predominance of yellows, ochres, siennas, reds, and crimsons, assuming that warm colors are suitable for his subject. This palette illustrates another precept of color theory, color ranges.

The range of warm colors

This range is characterized by its ochre-sienna-red tendency and is made up of the following colors in the spectrum: greenish-yellow, yellow, orange, red, crimson, magenta, violet, and all their derivatives (fig. 252). The fact that we have excluded the greens and blues does not mean that these colors cannot be used in a range of warm colors.

The range of cool colors

This spectrum possesses a green-violet tendency and is basically composed of the following colors: greenish-yellow, green, cyan blue, aquamarine, and violet, along with their variants (fig. 253). Warm colors —yellows, ochres, reds, siennas, etc.— may be introduced into a cool palette for contrast.

The range of broken, or grayed, colors

The basic characteristic of this range comes from its gray tendencies. Colors are muddy, and gray tones and hues predominate irrespective of whether they are cool or warm (fig. 254). This range is basically made up of a mixture of the complementary colors and white. You can see this if you take two complementary colors —for example, crimson and green— and mix them in unequal proportions, adding more or less white. The result is a brownish khaki color, with a toned-down grayish cast.

The range of broken, or grayed, colors include all the colors of the spectrum, given that each has a complement with which it can be mixed, so the range of broken colors can have either a warm or a cool cast.

Fig. 250. Ramón González Teja. *El Shah de Persia*. This is an excellent example of the use of a broken, or grayed, color range with a warm tendency.

Fig. 251. Yu Kasamatsu. This is a superb illustration of what can be done with a cool range of colors.

250

251

Color ranges

252

253

254

Figs. 252 to 254. The color ranges are (top to bottom) warm, cool, and broken (grayed).

Figs. 255 to 257. These color wheels show the three color ranges (top to bottom): the broken (grayed) color range is formed by mixing complementaries in unequal parts (fig. 255); the cool color range has a predominance of blue, green, and violet (fig. 256); and the warm color range is basically formed by yellows and reds (fig. 257).

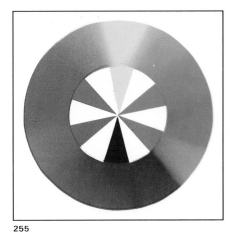

255

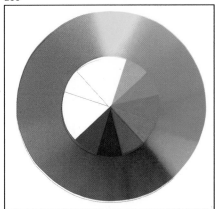

256

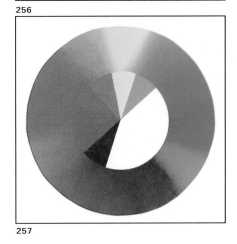

257

258

Fig. 258. Philippe Collier. A perfect illustration of the effects of the warm color range.

In airbrush painting, as in all the arts, practitioners must master a series of techniques that professionals call "craft." These are techniques for drawing straight lines, fine or thick lines, gradated, curved, or wavy lines, spirals, or dotted lines, and for drawing with the aid of a ruler, with a movable mask, or freehand. Other techniques are applicable to drawing basic shapes such as cubes, cylinders, and spheres. This know-how is the subject of the following chapter: the craft that's essential for painting any picture, be it a nude or a spaceship.

259

BASIC
—AIRBRUSH—
TECHNIQUES

Straight and wavy lines

In this chapter you will acquire a command of the basic techniques of airbrush painting by working through three series of exercises—the ABCs of how to proceed. The first series of exercises, carried out in just one color (pages 88 to 91), will teach you how to obtain different kinds of lines, dots, and gradations. The second series, using the three primary colors (pages 92 to 93), will enable you to work with transparent colors and with colors obtained from combining crimson, yellow, and blue. The exercises in the third series (pages 94 to 99) represent a step forward in mastering contrasts and color gradations by applying the basic techniques to painting geometric forms: cubes, sphere, and cylinders. Finally, there is a step-by-step exercise in painting a simple still life involving prisms and cylinders, which puts into practice all the basic airbrush techniques.

Figure 260. Preliminary tests.
Before starting, check to see to what extent the airbrush obeys your orders. See how it performs when drawing finer or thicker lines, dots of different diameters, even tones, gradations, etc. Carry out a good number of preliminary tests with a medium blue color, for example, that enables you to obtain pale tones when holding the airbrush away from the surface of the paper and darker tones by overlaying different sprays.

260

Figure 261. Drawing straight lines.
Practice drawing straight lines by resting the airbrush on a tilted ruler drawing it along the ruler's length. Draw from left to right, operating the spray-adjusting lever when your hand begins moving— not before. The line thickness will, of course, increase if the airbrush is moved away from the surface or when spraying on successive layers.

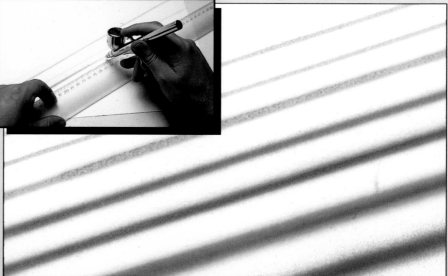

261

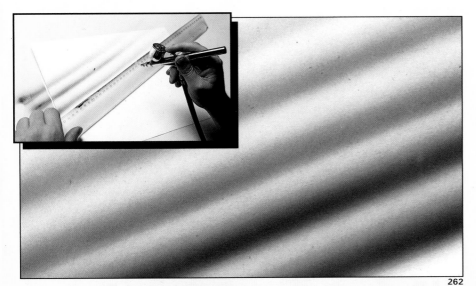

Figure 262. Gradated straight bands. With the aid of a ruler as in the previous exercise, gradate the tone of the resulting lines to achieve the effect of a rippled surface. Work from dark to light by moving the airbrush forward and backward with wide, lengthwise sweeps. Check also the intensity of the tone, varying the distance between the airbrush and the surface on which you are working.

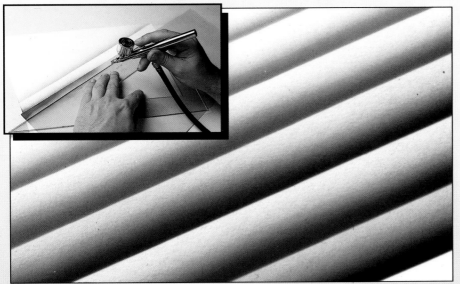

Figure 263. Gradated bands and accurate borders.
This exercise is very similar to the previous one except that instead of using a tilted ruler, you will use a piece of thin cardboard. A triangle or weight placed on top will prevent the cardboard from sliding and lifting. With a series of sprays along the fine edge of the cardboard, very near the surface of the paper, darken the lower edge of each gradated area, which, together with the previous band, will form a virtually perfect straight line.

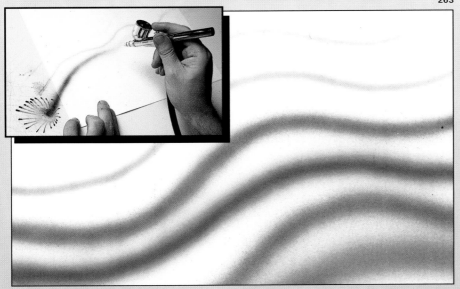

Figure 264. Drawing wavy lines without a mask.
Now it's time to paint freehand with the airbrush without a guide of any sort. Adjusting the pressure with the airbrush lever and varying the distance from the surface, experiment until you achieve different wavy lines of the same thickness. To avoid stains and spatters, begin spraying outside the surface of the paper (inset).

Wavy lines and dots

Figure 265. Using a cardboard mask or template.
Cut a wavy edge along a piece of cardboard. Place this edge carefully on the surface of the paper and work along the wave with the airbrush. The number of strokes and the distance will determine the tone and width of the gradation you achieve. If you wish to obtain a diffused edge, work with the wavy edge raised slightly off the surface of the paper.

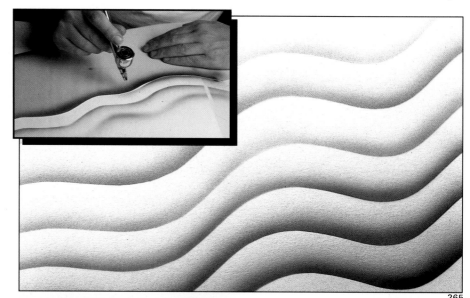

265

Figure 266. Freehand loops.
Try to draw a series of loops of even thickness just with the movement of your wrist or entire arm. Keep a steady distance between the airbrush and the surface. Remember: the greater the distance, the thicker the line and the greater the diffusion at the edges.

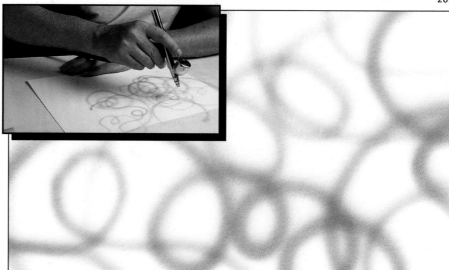

266

Figure 267. Painting dots.
Point the nozzle of the airbrush to the place where the dot is to be drawn, keeping the instrument as perpendicular as possible. Hold it still and carefully operate the lever. The spray will form a round dot, wider if the distance is greater and more intense the longer you keep spraying.

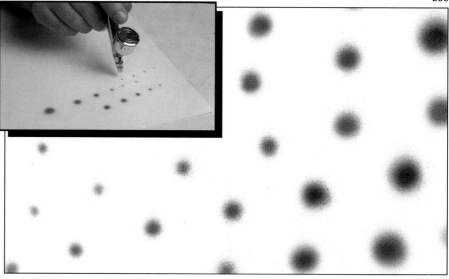

267

Gradations

268

269

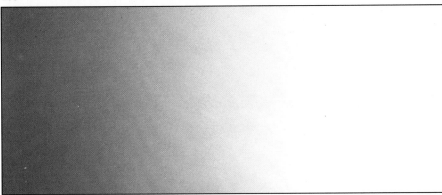

270

271

272

Figures 268 and 269. Protecting margins.
Mask your margins by covering them with adhesive tape, and spray the entire surface of the paper with the airbrush. When the mask is removed, you will have a white border around the painted area.

Figure 270. Gradated background.
Remember: do not depress the lever until your hand is in motion. Spray in broad bands, horizontally or vertically, and with the needle set for a wide jet. Begin spraying 5 to 7 inches (15-20 cm) from the surface and increase that distance as you reach the areas you want gradated. With the following passes of the airbrush, adjust the intensity and spread of the gradations.

Figure 271. Double gradation.
This is a repetition of the previous exercise but in both directions, starting from a darker central band. The tones should fade toward the left and right (or upward and downward if you are doing gradations lengthwise on the paper).

Figure 272. Evenly toned background.
Achieving colored surfaces and even tones with the airbrush is more difficult than it might appear, especially if you're working with transparent paints. Practice first on small surfaces and with highly diluted paints. Always spray in the same direction, 5 to 7 inches (15-20 cm) from the surface, and with the needle set wide enough to provide a wide jet. Make successive passes until you obtain the desired tone.

Exercises with the three primary colors

Here are several simple exercises with the three primary colors so that you can put what you have learned about color theory into practice with the airbrush —namely, that every color and hue can be achieved using red, blue, and yellow in varying proportions.

Prepare the carmine, the Prussian blue or ultramarine, and the cadmium yellow (watercolors or dyes, are suitable) and begin by discovering the tonal effects that can be obtained with a single color, as seen in figure 273. With the Prussian blue or the ultramarine, paint a series of parallel, gradated stripes; cover half the paper with even stripes, and if you wish, add some lines crossing the different color densities. Observe the wealth of tones the airbrush provides by merely superimposing successive passes.

In figure 274 you can see exactly the same exercise, but in yellow with an even, transparent blue stripe superimposed on it producing different green tones according to the hues of the yellow base.

Figure 275 is an interesting exercise carried out with black in addition to the primary colors and applied in the following order: yellow, blue, red, and black. The result is a wealth of ochres, greens, oranges, earth tones, and violet.

Figs. 273 to 279. It's important to carry out these exercises, not merely read about them. Prepare the three primary colors, using medium cadmium yellow, a purple or rose madder, and a Prussian blue or ultramarine.

273

274

275

276

277

278

Here is another experiment in obtaining a variety of colors by mixing the three primaries.

1. Take a piece of flat, matt paper and draw a 5 by 11 in. (12 by 28 cm) rectangle on it. Load the well of the airbrush with cadmium yellow and carry out a gradation, starting from the center of the rectangle —where the color will be most intense— and "fading" away toward both sides (fig. 276).

2. With carmine and starting from the left. gradate the color toward the center. On the white area you will obtain a pure intense red, and as the gradation covers the yellow, you will obtain a full range of reds and oranges (fig. 277).

3. Do the same with blue, beginning from the right. As the color gradates towards the center, you will obtain a range of greens (fig. 278).

4. Figure 279 shows the finished exercise. Observe the violet area to the left: it results from gradating blue over carmine.

279

Painting basic geometric figures with the airbrush

This is a highly effective exercise for learning to create contrasts, gradations, and gray tones with the airbrush. Here you must apply the basic airbrush techniques in order to achieve, with a single color, a perfect image of a cube, a sphere, and a cylinder. We recommend you use a medium gray color, which can be lightened and darkened with superimposed sprays.

280

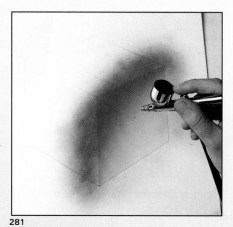
281

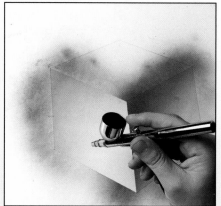
282

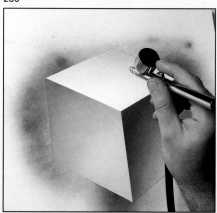
283

The cube

Figure 280. Draw a cube in oblique perspective. Then apply a mask over the entire work surface.

Figure 281. Unmask the right-hand face of the cube and paint it with an even, medium-tone gray. Gradate from left to right, somewhat darker on the upper face.

Figure 282. Cover that section and uncover the adjacent face. Apply a light-toned spray, which will later be darkened with soft gradation applied from left to right.

Figure 283. Last, finish off the upper face of the cube. Uncover it and apply a very light gradation, which, starting from the most distant face, will change from a gentle gray to the white of the paper.
The result is shown in figure 284.

284

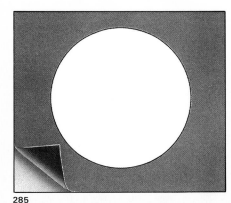

285

The Sphere

It is no easy task to achieve a perfect sphere with the airbrush. Being a geometric figure without edges, the sphere has no planes that would define exact limits for the tonal areas. On the contrary, the transition between different tones always involves an intermediate gradation that must be done freehand, with a circular movement. As a result, painting a sphere involves acquiring good control of the wrist and the arm with exercises similar to those we now present.

Figure 285. Once the circumference has been drawn, mask the entire surrounding area (the background).

Figure 286. With a very gentle colored dye, make the first application of color. Use a circular movement, and try to emphasize the tone toward the edge of the sphere.

286

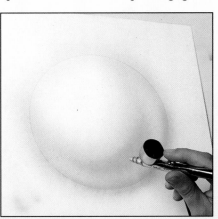

287

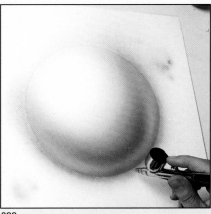

288

Figure 287. Now decide on the point that is to receive the most light (in our example, the upper left section). Darken the opposite area (lower right) with a soft gradation. Again, use a circular hand movement, following the shape of the sphere.

Figure 288. Go over the shaded area again and bear in mind that the darkest part is not to be found on the very edge of the sphere but rather, farther in. Between the edge of the sphere and the darkest area there should be a circular, rather lighter strip representing the reflected light. The very lightest point of the sphere is created later, with an eraser.
In figure 289 you can see the end product.

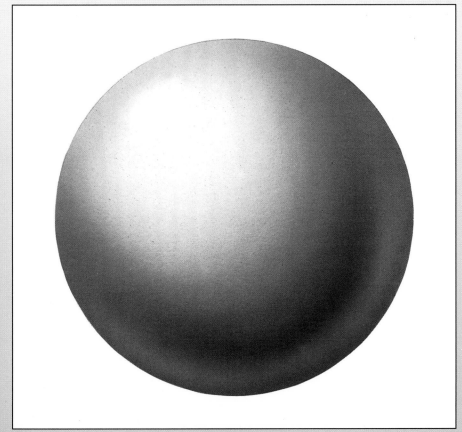

289

Painting basic geometric figures with the airbrush

The cylinder

To ensure that an airbrush image is not only correct but also attractive, the artist must manipulate light. In the case of basic shapes, this is essential if we wish a mere geometric shape to acquire a certain aesthetic value. We shall see this immediately by painting a cylindrical surface illuminated from the side and from above —that is, from a position located to the left of the point of view.

290

291

292

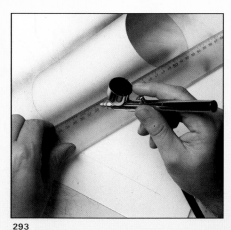

293

Figure 290. The first step is, of course, to draw the cylinder (with a fine pencil), bearing in mind the rules of perspective.

Figure 291. The mask we are going to use has two cutouts, one for the outer surface and the other for the interior of the "tube." We shall apply gradations to both surfaces, from greater to lesser, which will define the shaded areas.

Figures 292 and 293. These images show how to achieve the impression of volume. Painting the different gradated areas with lateral sweeps produces shading, reflections, and bright areas. As you can see, these areas can be painted best with the help of a tilted ruler.

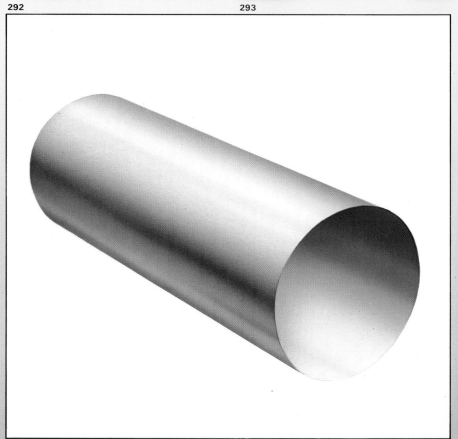

294

Practice summary

If you have carried out the series of exercises from the preceding pages, including the formation of basic shapes, you are now ready to carry out an exercise that incorporates all the techniques explained so far.

This consists of composing, drawing, and painting a still life made up of objects whose structure is that of the basic shapes: a cube or a rectangular prism, a cylinder, and a sphere. A model is shown in figure 295, but you will probably be able to compose your own still life with things you have at home —for example, a thick book, a plate, a cup, a sphere-shaped

295

lamp similar to the one shown. Place all the items as you choose, composing an image and deciding on illumination that best defines the volumes of the objects.

Co-author Miquel Ferrón is now ready to paint. Ferrón is going to paint with special airbrush paints from Schmincke with a Richpen 113-C airbrush and a sheet of matt, fine-grain Schoeller paper measuring roughly 12 by 14 inches (32 by 35 cm). First, Ferrón covers the borders with (adhesive) tape for masking and framing.

With plastic film, he then masks the shapes making up the composition: the lamp, the book, the plate, and the cup. The next step is to paint with a blue and gray gradation the upper part of the background (fig. 296). The artist continues with the orange hue of the table edge behind the lamp, then unmasks the globe. In a warm light gray, he paints the shadow of the globe freehand (fig. 297).

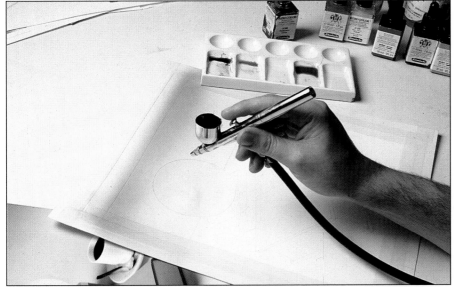
296

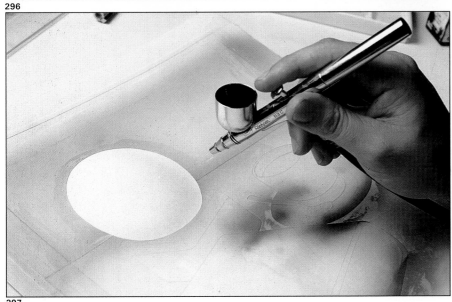
297

Practice summary

As you are aware, the creation of shapes and colors with the airbrush is subject to the continuous movement of the masks. A shape or color is masked so as to airbrush an adjacent area. That is what is now happening in our practice composition. After uncovering with a cutter the shape of the plate and cup, keeping the rest of the composition masked, Ferrón paints and models the cylindrical volume of the cup, resolves the shape and color of the circle of the coffee inside it, and then creates the values and tones of the plate, although the spoon is still masked (fig. 298). He now covers the cup and the plate and unmasks the rectangular stand of the lamp, first painting it with an overall layer of orange and then with a darker orange, which emphasizes the edge of the book cover (fig. 299).

In the following illustrations (figs. 300 and 301) the artist paints the yellow of the book cover, first with a basic yellow layer (fig. 300). Then, spraying from another angle and with the aid of a ruler used as a mask, he paints the gradated dark yellow of the book cover's nearest edge (fig. 301).

"I am going to do something very unusual," says Ferrón, as he masks the book cover again and then covers the entire illustration with the polyester film, now spattered from the previous spraying (fig. 302). "I think it's interesting to reveal this moment in the process of airbrush painting," continues Ferrón, "in order to understand the difficulty of working virtually blind, without being able to compare the colors, the values, the contrasts. It requires a constant effort of memory and imagination to keep in mind what has been done so as to avoid an unpleasant surprise when the mask is removed" (fig. 303).

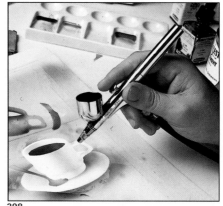
298

299

300

301

302

303

304

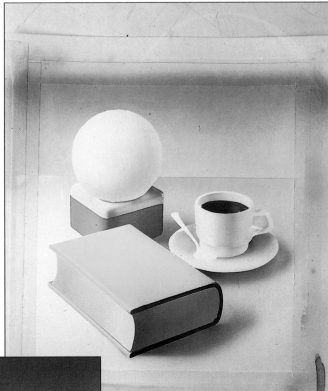

305

Ferrón removes all the masks, taking off the remains of the rubber cement (fig. 304), and carefully assesses the steps he must follow from this stage on (fig. 305). Now he begins the finishing work, retouching the tones and the borders, detailing shapes such as the coffee spoon, intensifying certain points to enhance contrast and volume. He emphasizes the bright, white areas of the sphere, the cup, the edges of the book cover, and so on until he is satisfied with the result (fig. 306).

306

Common problems, causes, and remedies

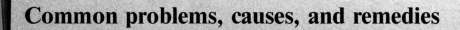

Problem	Causes	Remedies
Smudges **307**	Paint is too watery	Thicken the color
	Airbrush is too near the paper	Raise the airbrush to reduce contact
	Needle is set too far back	Change needle position and secure
Splashes **308**	Lack of air pressure Paint is too thick or is badly mixed	Regulate the pressure Empty and clean the airbrush Change the paint mix
	There are pigment particles in the nozzle or airbrush barrel	Disassemble and clean the airbrush thoroughly
Splashes at beginning and end of a line **309**	Lever has been released too sharply	Release and press lever more gently
Uneven line **310**	Unsteady handling of airbrush	Practice in order to achieve steadiness
	Nozzle blocked	Clean nozzle
Lines are too thick **311**	Needle worn	Replace it
	Nozzle or cover are badly connected	Take them off and connect them correctly

	Problem	Causes	Remedies
312	Lever does not return to original position after use	Valve spring not taut enough	Tighten or change spring (professional repair)
		Broken lever	Professional repair
313	Needle blocked inside airbrush	Dry paint is clogging needle Paint too thick, or badly mixed	Submerge the airbrush in water and carefully unblock the needle
		Damage caused by misuse	Professional repair
314	Paint flow is interrupted	Paint too thick	Dilute the paint
		Needle adjustment to nozzle is too tight	Separate needle and check lock screw
		Lack of paint in well	Fill paint jar
		Control lever is broken	Professional repair
		Dry paint is clogging nozzle	Disassemble and clean nozzle and needle
315	Excess air pressure	Compressor outlet is opened too wide	Reduce pressure
316	Air escapes from nozzle and bubbles are formed	Nozzle cover loose or badly fitted	Adjust nozzle properly
		Insufficient air pressure	Increase pressure
317	Air escapes when airbrush is not in use	Air-valve stem is not properly adjusted or diaphragm is broken	Professional repair
318	Air escapes from supply connections	Connections are loose or damaged	Adjust or change connections

On the following pages we present a miscellany of airbrush applications beginning with enamel on glass and moving on to photographic retouching, industrial paints applied to models and toys, as well as painting on textiles. In this practical chapter, you will find a "Selection of Masters," in which six famous airbrush artists explain the materials that they normally use and show us some of their works. Finally, there is a step-by-step development of four images painted with the materials, techniques, and solutions designed for four specially chosen themes: *painting a freehand illustration, a technical image, reflections, and the human figure.*

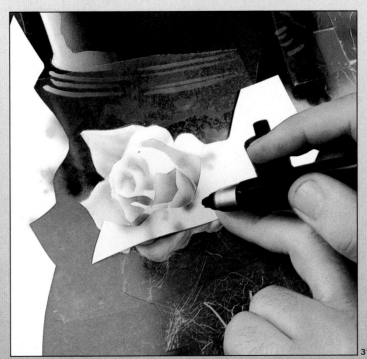

319

THE AIRBRUSH
—IN—
PRACTICE

Painting on glass with enamel

320

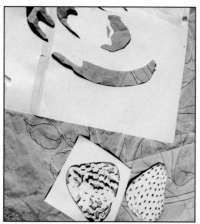

322

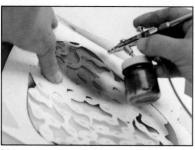

324

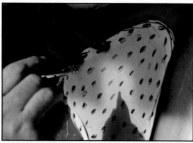

326

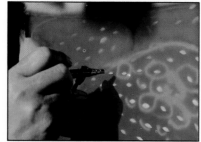

327

321

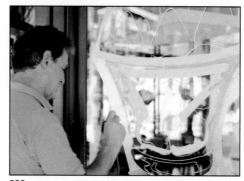

323

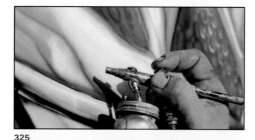

325

328

José Peña is a professional airbrush artist who specializes in the painting of images and large advertisements on glass. He paints with synthetic enamel, employs cardboard mask, and usually works with a single-action airbrush.

We are going to watch him paint an ice-cream ad. Peña prepares the colors outdoors, first dissolving the enamel paint in turpentine (fig. 321). The cardboard masks are set aside on the ground (fig. 322); and close at hand are Peña's auxiliary materials, including adhesive tape to attach the masks to the glass and a small pot holding acrylic paint, diluted in water, to paint the sketch.

He starts by roughing in the image with a brush and white acrylic paint (fig. 323). "It's diluted in water so I can rub it out as needed with a damp rag," Peña says.

The artist supports the mask of the sundae dish using adhesive tape and then paints the glass with his airbrush (fig. 323), immediately moving along to the strawberries. He finishes off the strawberries one by one, first applying a red base on top of which, using one of the masks, he applies, a lighter red (fig. 324). Then he uses a mask to paint the seeds yellow (fig. 325) and repaints them without the mask, highlighting the depressions in which the seeds sit (fig. 326). Peña finishes by painting freehand the butter-colored cream (fig. 327).

Peña is a real expert in this type of image. He has completed two ice-cream sundaes like this one (fig. 328), plus shop lettering, in the course of just three and a quarter hours.

Figs. 320 to 328. This is José Peña's process of painting an advertisement on glass.

Figs. 329 and 330. (Top right, opposite page). The retouching of a photograph can improve its appearance, making an old photo appear new.

Photographic retouching

Twenty years ago photographic retouching was still one of the most typical airbrush jobs. Commercial photography generally did not offer the color quality, the effects of light and shadow, or the sharpness and depth of focus that we see in the majority of images today. This was because the materials and means available now simply did not exist and also, perhaps, because photographers, for the most part, did not work with the dedication or skill that they now bring to bear.

So the majority of product shots —anything from a carpet-cleaning machine to a can of beer— were retouched, highlighting contrasts and colors, lights and shadows, whites and reflections.

Today photographs can capture these effects on film, so retouching is much less common, limited perhaps to intensifying a point, an edge, or a contour or highlighting a specific reflection (the shine of a star, for example).

But there are still cases where retouching can be necessary, as in the "OK" block retouched to appear more shiny and new (figs. 329 and 330). Another case might be when a client requires a change of shape or color in a photo that otherwise is perfect and is difficult or impossible to reshoot (figs. 334 and 335). Today's retoucher has access to fine pulverized pigmented colors, in matt and gloss, to assist his work. There are cool grays especially made for photographic retouching in black and white.

Figs. 331 to 335. From this photograph of the head of a woman on a blue-gray background, the two soft backgrounds, one gray and one blue, have been painted, and the hair retouched in areas that impinge on the background. The adjacent labels show the results of making this change in this photograph.

329

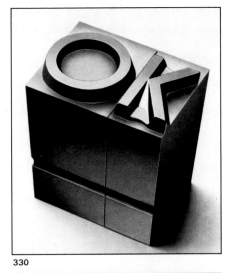

330

331

332

333

334

335

The airbrush applied to figures and toys

Using industrial paint in the making of dolls, models, and toys is one of the many applications of the airbrush. Porcelain or plastic dolls can be painted with acrylics, while latex, plastic, and similar materials accept acrylic and synthetic enamel paints, be they matt or glossy. The tool that is generally used for this type of work is the industrial spray gun, the same as that used for painting cars, or the airbrush pistol, a somewhat more sophisticated airbrush though still much simpler than even the single-action airbrush used in art. The majority of models and toys are painted freehand, without masks; but in special cases and for series production, prepared masks are employed.

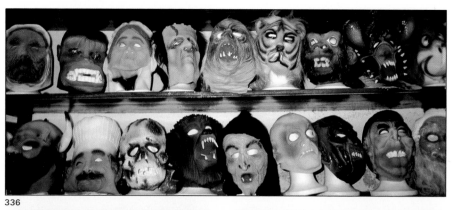
336

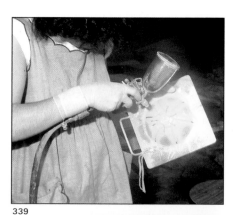
339

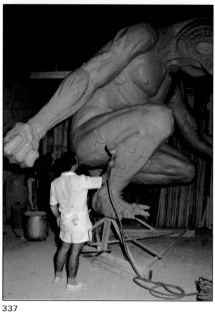
337

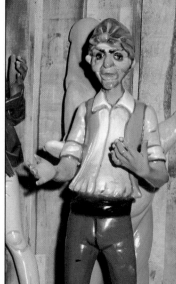
338

340

341

Figs. 336 to 338. Here are several examples of airbrush painting applied to the decoration of masks and figures.

Figs. 339 to 341. Industrial painting with the airbrush is done in toy manufacturing. The most widely used tool is the spray gun.

Painting textiles with the airbrush

Clothing such as blouses, shirts, jerseys, and so on, whether they are made of linen, cotton, silk, nylon, or other materials, can be painted with the airbrush to create decorative motifs. Of course, we are not talking about painting complex images, but only making simple designs that are attractive because of their originality. Here, Miquel Ferrón paints a white cotton T-shirt using Deka Perm-Air special colors. He painted this exotic subject using only three colors —cyan blue, purple, and yellow— plus black and white.

He uses a double-action Richpen— although a single-action airbrush would have worked just as well— and he works with movable cardboard masks that he supports with his fingers or with the first thing that comes to hand— an open pair of scissors, for example (fig. 343).

Before Ferrón started to paint he drew a sketch by means of projec-tion on paper, allowing him to create the movable masks. After placing the shirt on a table and holding it taut with adhesive tape, he can proceed with the painting. First he paints the palm leaves, using a green mixed with cyan blue and yellow (fig. 343); then he mixes yellow, purple, and a small quantity of cyan blue in order to make dark brown for the tree trunk (fig. 344). Finally he paints the sea with cyan blue, the curves of the bottom part of the tree with purple and yellow, and the gradation stain of the sand with yellow (fig. 345). The end product is shown in figure 346.

The colors chosen dry quite rapidly but the drying process stiffens the material as if it were starched. To remove the stiffness and allow the material to regain its natural softness, all that has to be done is to iron the area with a damp cloth.

Figs. 342 to 346. Miquel Ferrón shows us in these step-by-step images the process used to paint on textile. He uses special Deka Perm-Air colors and a double-action Richpen airbrush.

342

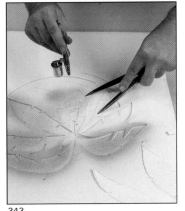

343

344

345

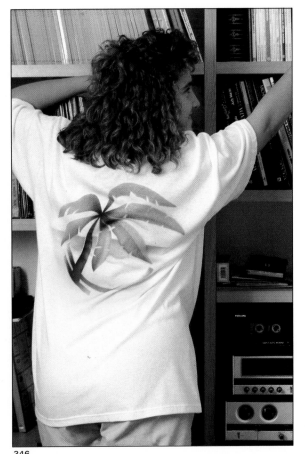

346

Airbrush masters and their techniques

PHILIPPE COLLIER
28, Avenue des Lilas
59800 Lille, France
Tel.: 20 06 39 50
Fax: 20 47 32 50

Technical data

Philippe Collier uses Fischer airbrushes, models F02 and B03, and, for certain work, a JR spray gun. But he is not a believer in using several airbrushes in the painting of one picture.

"What do you think is the best type of airbrush for the beginner?" we ask Collier. "The Fischer Top 02," he replies.

He uses a Fisch'Air compressor and typically works with Schoeller rag paper.

Collier uses special airbrush colors when painting on photographs; with paper he employs Spectralite and Dr. Ph. Martin's liquid watercolors, as well as Liquitex acrylics.

The masks he uses include movable paper, self-adhesive film, and almost anything else: "I even sometimes use my hand," he says.

RAMÓN GONZÁLEZ TEJA
Cartagena, 16, 5.º C
Madrid, Spain
Tel.: (91) 245 14 43
Fax: 245 14 43

Technical data

Unlike Collier, González Teja typically paints with two airbrushes per picture, one by Holbein and the other by Iwata. The airbrush best adapted for the needs of the beginner is, in his opinion, the Holbein. González Teja uses a Jun-Air compressor and prefers working on special glossy Schoeller Parole paper, as well as Canson paper. He paints with special airbrush colors and also uses gouache.

As far as masks are concerned, he works with self-adhesive masking tape, all types of movable masks, and masking liquid in certain areas. He finishes off his works with a brush and gouache and on occasion employs colored pencils.

GOTTFRIED HELNWEIN
Auf der Burg, 2
D-5475 Burgbrohl, West Germany
Tel.: (02636)-1481
Fax: (02636)-1483

Technical data

Gottfried Helnwein relies on three different airbrushes: a Binks Wren-B, a Grafo, and an Efbe. "I use one or another, according to the type of work and the area that has to be painted," he says. In answer to the question on the best choice for the beginner, Helnwein responds without a second thought: "I believe that a beginner should start with an Efbe." Helnwein usually paints on sheets of polyester using a creamy watercolor from a tube (diluted in water before use) of the German Schmincke and the English Winsor & Newton brands.

Helnwein masks with self-adhesive film, which complements his movable masks.

347

348

349

Philippe Collier

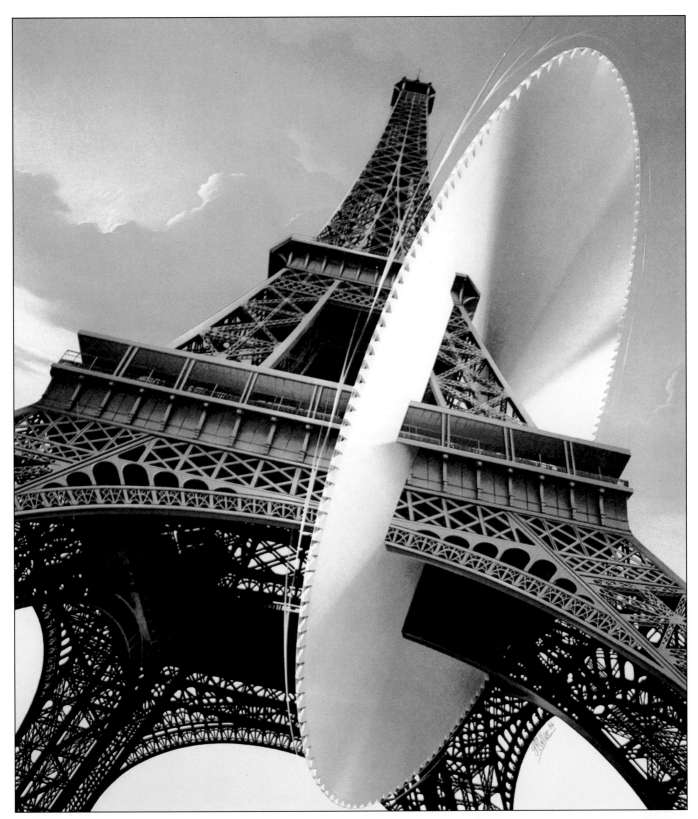

350

Eiffel Tower

Ramón González Teja

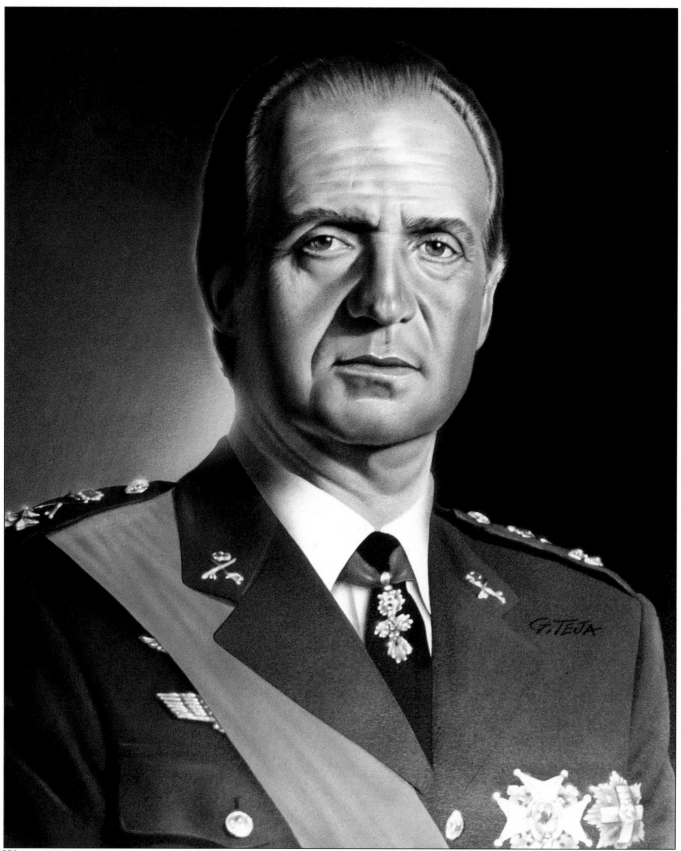

351

Portrait of Spain's King Juan Carlos I

Gottfried Helnwein

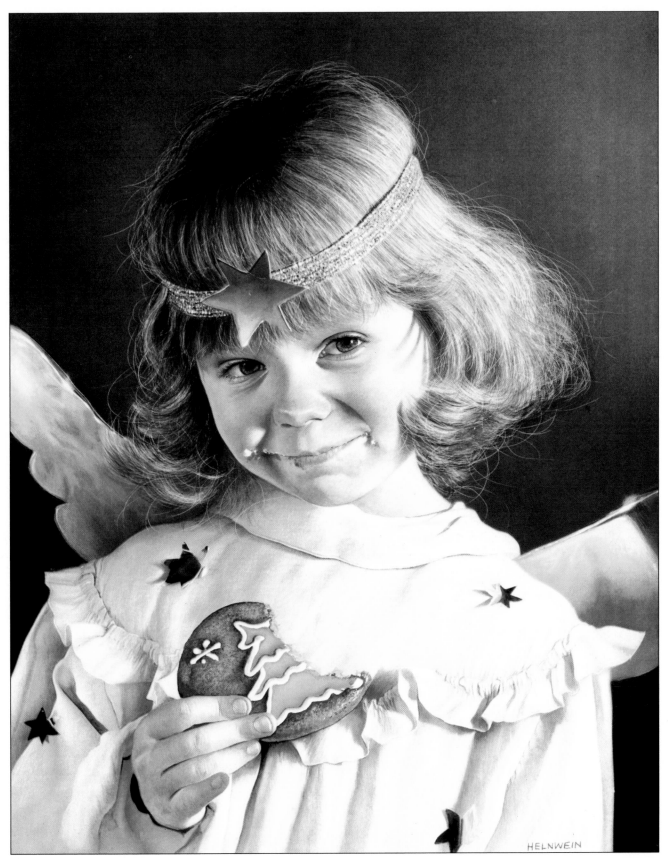

352

Airbrush masters and their techniques

YOICHI HATAKENAKA
303 Dsi-2 Velvet Mansion
4-8-7 Minami Ikuta, Tama-ku
Kawasaki-shi
Kanagawa, Japan
Tel. 044976 8481

Technical data

Hatakenaka's airbrush is a Gun-piece Rich GP1. He prefers to work with only one airbrush. He believes, there is no single best airbrush for beginners—the only criterion is that it should be a relatively unsophisticated model that can handle large backgrounds and broad strokes.

Hatakenaka uses a Homi Kapsel-Con 2 compressor.

He paints on prepared canvas with Liquitex acrylic colors diluted with water. The preparation of the canvas consists in priming it with three coats of Liquitex gesso applied with a brush; when the primer has dried the surface is polished with damp emery paper, which will yield a perfectly smooth, glossy finish.

He uses self-adhesive film for masking.

MASAO SAITO
Agent: Ms. Hiroko Janai
1-33-6-702 Shinmachi
Setegaya-ku, Tokyo 154, Japan

Technical data

Saito usually uses a Japanese Yaezaki Zaki and an American Thayer & Chandler airbrush, and believes the Yaezaki is a good choice for beginners. His compressor is also made by Yaezaki and is a Y3.

In general, Saito works on special Bristol board and paper used for illustrating, although on occasions he also paints on canvas prepared with Liquitex gesso primer. On these supports he paints with liquid watercolors, Liquitex acrylics, and gouache.

Masao Saito uses several auxiliary tools as well. Depending on the job, he may employ brushes, watercolor pencils, pastels, and, on occasions, even a lead pencil. He also uses an airbrush eraser. He masks with self-adhesive Frisk film but also uses acetate and all types of movable masks, including his hand and fingers.

EVAN TENBROECK STEADMAN
18 Allen St.
Rumson, N.J. 07760
Tel. (201) 758-8535
Agent: Tania Kimche
470 West 23 St., New York, N.Y. 10011

Technical data

Steadman is a firm believer in only one make of airbrush: the Paasche. He uses a Jun-Air compressor and works on bristol board but occasionally paints on canvas and wood as well. In regard to colors, Steadman prefers Dr. Martin's and Luma watercolors, as well as Lacaux and Winsor & Newton acrylics and Turner Design and Winsor & Newton gouache. The only other tools he employs are "a toothbrush and a paintbrush."

Steadman masks with self-adhesive Frisk film and acetate. But "I don't like working with masks," he says. "I don't like cutting them out; I prefer to work freely, painting freehand with my airbrush. But anyway, if I do have to cut out masks in the end, I use an Ulano Swivel knife; it's expensive, but very precise."

353 354 355

Yoichi Hatakenaka

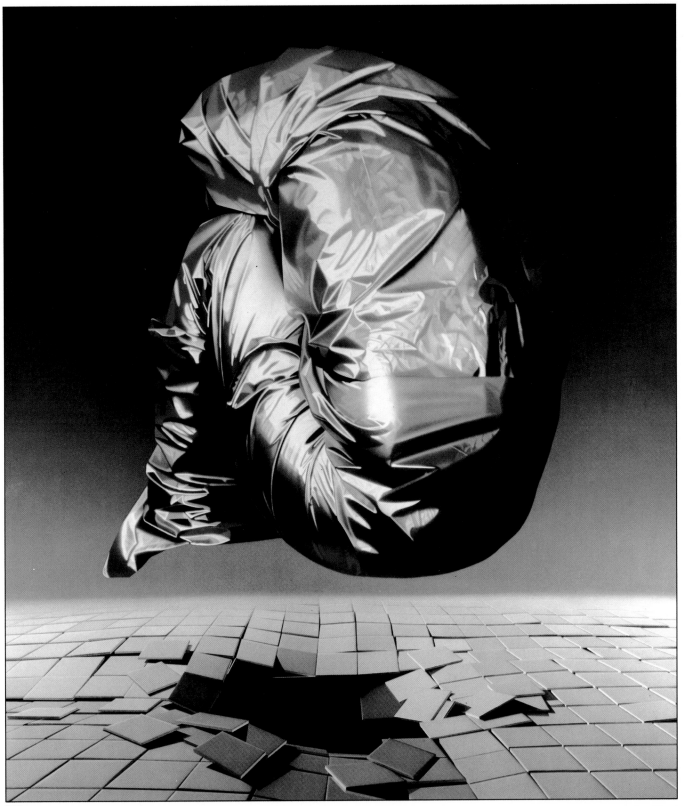

Floating above the Head

Masao Saito

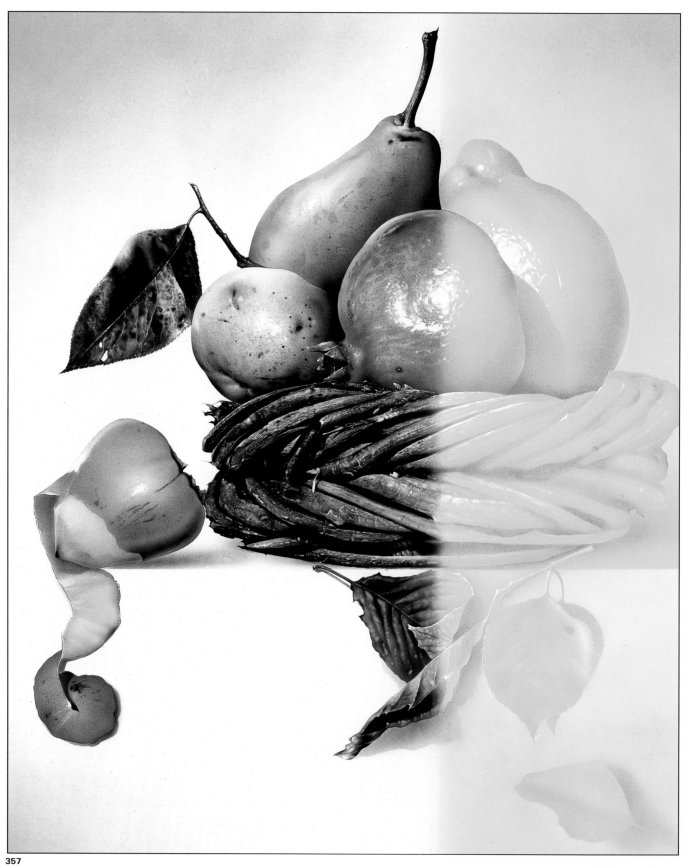

357

Autumn Harvest

Evan Tenbroeck Steadman

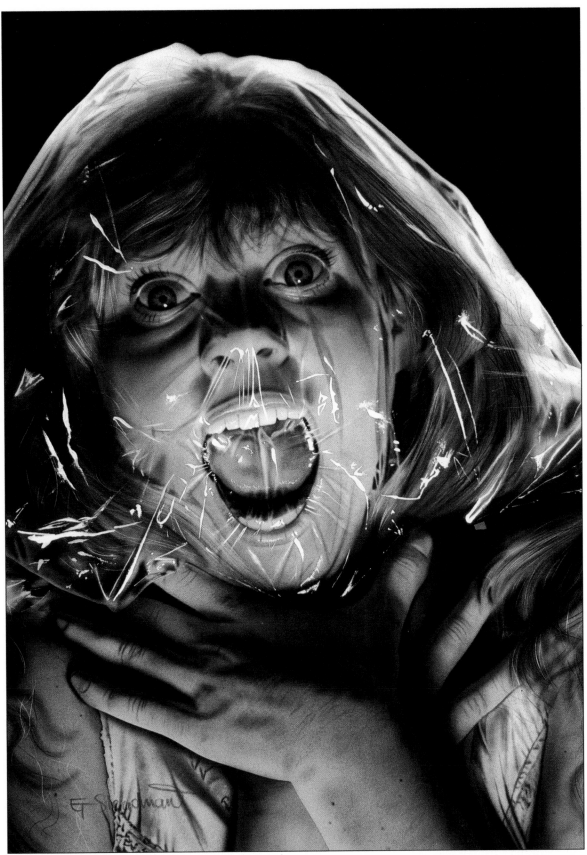

Painting an illustration freehand

Miquel Ferrón is about to begin an illustration of a tempestuous sea with great waves, foam, and rocks, a theme that calls for painting freehand. First we see the material that Ferrón uses, starting with the canvas —the same kind used in oil painting— which Ferrón is now preparing with a coat of acrylic colors made up of a mixture of ultramarine with a small amount of ochre and white. To paint the illustration he will use an American brand of acrylic airbrush paints, Dr. Ph. Martin's Spectralite. He will paint with ultramarine blue, green, violet orange, black, and white. His choice of airbrush is a Richpen Apollo. He will finish off the reflections and the whites with a long-haired synthetic brush (fig. 359).

In the figures 360 and 361, Ferrón composes the primer mixture and applies a first primer coat to the canvas, at the same time painting in the background of the illustration. For this he uses a long brush of synthetic hair with a shell handle. After waiting for the canvas to dry, he sketches with a blue watercolor pencil the basic lines of the waves, rocks, and foam (fig. 362). He finally starts to paint with the airbrush, first applying blue and black without the airbrush holder cap on, so that the needle is uncovered. The reason for this is that with acrylics, the paint flow can easily be obstructed, requiring the artist to press the lever and needle more and more to unblock it (fig. 363).

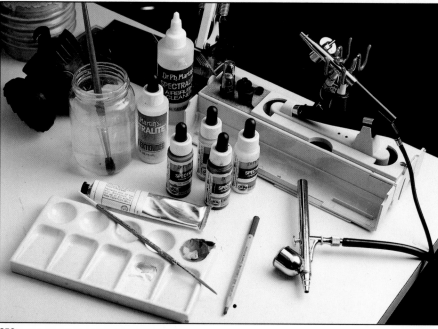
359

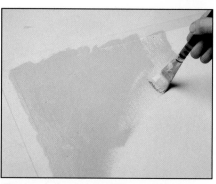
360

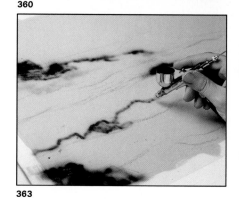
361

362

363

364

Figs. 360 to 362. Here Ferrón is applying a coat of light blue primer, then he draws with a gray-blue pencil.

Figs. 363 and 364. Here are the first strokes of the airbrush; the paint has been diluted with solvent to lower the tonal and chromatic intensity.

Fig. 359. Material and equipment used by Ferrón to paint an illustration freehand can be seen on these pages. Included are the canvas, the Dr. Ph. Martin's Spectralite colors, and the Richpen Apollo as a basic airbrush.

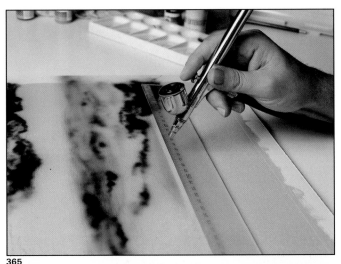

365

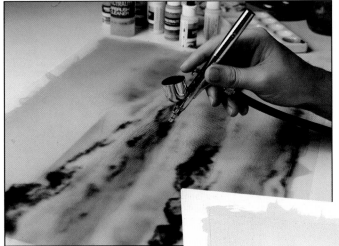

366

Acrylic colors can't always be thinned with water, so to obtain a partially or totally transparent effect you must dissolve them in a special solvent, in this case also made by Dr. Martin's (fig. 364). This product, like the Martin colors, is toxic, so the artist must wear a facial mask. Ferrón continues the process, painting with a blackish-blue, a medium blue, and a light blue, all the time maintaining the horizontality of the composition, at times relying on a ruler for help (fig. 365). Nevertheless, he paints freehand, without any kind of mask, always estimating more or less the position of the airbrush when painting a stroke or a small or wide gradation (fig. 366). "You've got to stop now and then, even if it's only to change the color or to remove the needle to help the paint flow more smoothly," Ferrón says. It's good to be interrupted, because you have the opportunity to better appreciate how the work is progressing. At this intermediate stage (fig. 367), Ferrón concentrates on draw-painting the broad outlines so the image begins to take form but without the fine details.

Figs. 365 to 367. The first steps are evaluating and painting the illustration's basic tones, always within the blue and black color range.

367

Painting an illustration freehand

368

369

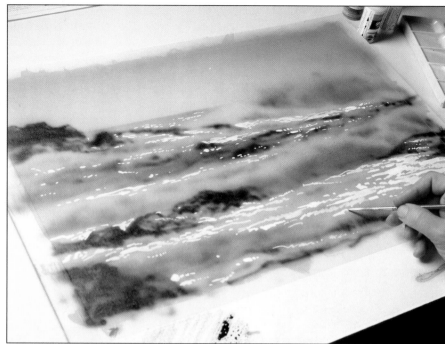

370

371

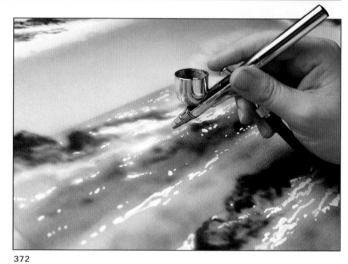

372

373

Figs. 368 to 370. Here we see Ferrón adding lights and white reflections with the aid of a brush and white acrylic paint.

Figs. 371 to 373. Now Ferrón softens the contrast in the white points, diluting and shading them. At the same time he paints the waves' outlines and volume.

This is the moment to evaluate the illustration and highlight certain areas with white acrylic. For this Ferrón uses a No. 4 synthetic brush, in which the hair is longer than in a regular brush. "The longer hair allows me to have more paint on the brush and a better point; it is more appropriate for painting fine lines and small details," Ferrón says. Notice that he's painting with fairly thick white paint, diluted to achieve pure whites (fig. 368). In effect, Ferrón is painting a series of very concrete white stains (figs. 369 and 370).

He continues by applying more white with the airbrush, at a greater distance for the gradated lights of the great waves (fig. 371) and closer to the canvas for the bright reflections (fig. 372). "It's a delicate job that requires improvisation and inventiveness so as not to fall into the trap of

an affected finish," he says. "The tones and colors have to be balanced, contrasts must be harmonized, limits and contours must be shaded to produce the foam and crests, but without going overboard!"

Ferrón is now working more slowly, calculating the contour of every rock, "thinking about the stroke," as Picasso would say. He continues painting freehand with the airbrush, but in certain places uses his little finger as a mask (fig. 373) "to accentuate a contrast, to reserve a zone or form," he says. But still he continues to paint the whole picture at once, moving from one side to the other, now darkening the top left-hand part of the sky, then going down to the sea in order to retouch a reflection, jumping over the wave of the foreground to retouch, add contrast, and shade the wave in the background. He continues this

process of continually going back and forth across the picture, which finally brings us to the "miracle" of the finished work (fig. 375).

Fig. 374. Dr. Ph. Martin's makes a liquid for cleaning airbrushes.

Fig. 375. This is the finished product: a freehand illustration painted with virtually no use of masks.

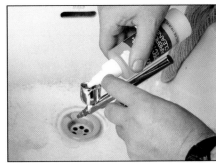

374

375

Painting a technical image: the Nikon camera

376

377

378

379

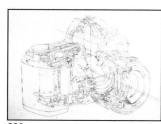

380

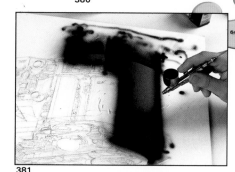

381

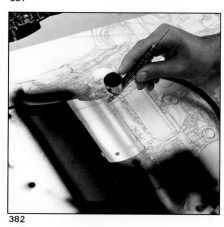

382

383

Miquel Ferrón has reproduced this technical image of a camera (fig. 376) from a slide that was loaned to him by courtesy of Finicon S.A., representatives of Nikon in Spain. The first thing the artist did was to photocopy the image, enlarged to roughly 26 by 20 inches (67 by 52 cm) in order to trace and transfer it as described on page 56. The backdrop is Bristol 4 board, made by the English company Frick. The cardboard's surface has been treated with a special coat of kaolin (a fine white clay) to make it absorbent and totally smooth, very appropriate for this kind of work (figs. 377 to 380).

With the drawing ready, Ferrón covers the whole image with a self-adhesive masking sheet and smooths it into the drawing by applying pressure with his fingers and the edge of a ruler to eliminate any air pockets. Then he begins to paint the Nikon with the airbrush, first cutting out the masks with a normal cutter as well as a special one for the curves, both made of ceramic. Then he covers and uncovers the forms, spraying, painting, and repainting, always varying and alternating some jobs with others.

On occasion he sprays with the image back to front or upside down (fig. 381 and 382). Sometimes he leans the airbrush on a ruler that serves as a guide for painting straight lines (fig. 383). He improvises a movable mask with a card (figs. 384 and 386, opposite page); moves the needle in order to unblock the airbrush (fig. 385); cleans a white spot with an eraser (fig. 388); masks the more detailed forms such as the "Nikon" name plate with masking liquid (fig. 389). The end result of the work done so far is shown in figure 391.

Figs. 376 to 380. Look at the model and the process followed to obtain a perfect drawing of it. This is the starting point for painting.

Figs. 381 to 383. Three phases in the initial painting, which combines freehand airbrush work with the use of a ruler.

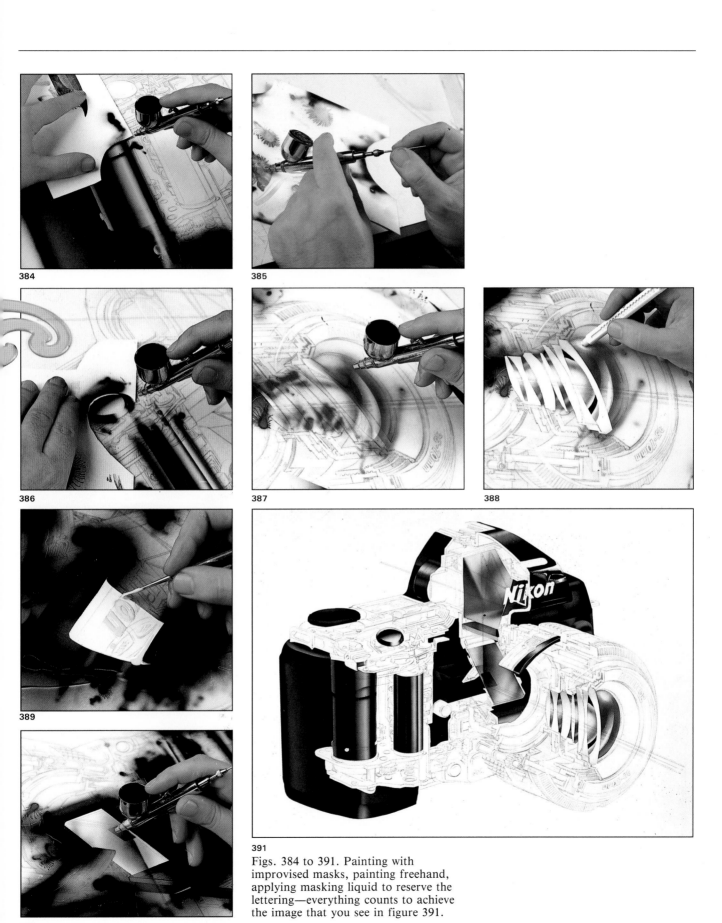

384

385

386

387

388

389

390

391

Figs. 384 to 391. Painting with improvised masks, painting freehand, applying masking liquid to reserve the lettering—everything counts to achieve the image that you see in figure 391.

The Nikon camera: second stage

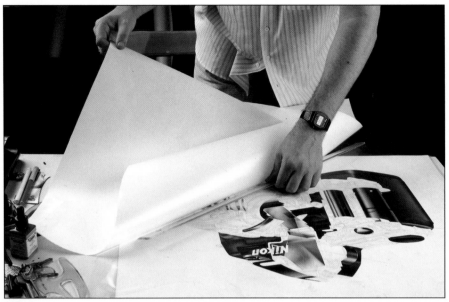

392

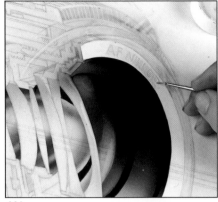

393

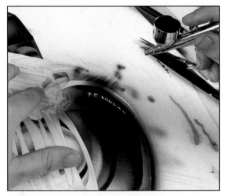

394

395

In order to better carry out this second stage, Ferrón decides first of all to substitute a new self-adhesive sheet for the remnants of the original mask (fig. 392). "It's got to be done," he says. In a technical image like this, composed of more than 100 masks and in which every piece must be brought to its finish, you get to a point where the self-adhesive mask causes great confusion that can only be solved with a new sheet of self-adhesive.

To better understand the problem presented by so many masks and pieces, turn back to figure 391(the state of the Nikon at the end of stage one). In some parts the pencil-sketch lines remain visible: the drawing's meticulous detail demands great precision in airbrush technique and masking. "You've got to draw everything, Ferrón emphasizes, even those pieces that will be eliminated by the spraying of the graying gradation. The artist must keep every line and detail in mind as he works. Ferrón has been working since the beginning with two airbrushes, a Richpen and an Efbe. The reason? "Productivity," he says. "One of them is for painting light colors, the other for the darks. This saves me having to clean them so thoroughly

every time I change from light to dark or vice versa, more so when the change is from black to white." The paints are the German-made Aerocolors from Schmincke.

This stage is a prolongation of the former, in which Ferrón continues alternating the cut-out masks with the spraying of the forms, masking with rubber cement or masking liquid (fig. 393); using curve templates (fig. 395); always working with the needle uncovered and controlling the spray's caliber by checking it on a separate piece of paper (fig. 394). Figure 398 shows the state of the Nikon image at the end of this second stage of work. Ferrón has so far been painting the large zones, that is to say, blocking out the image but leaving for later the intricate details, which are difficult to paint with the airbrush. On the following page we will see how he finishes this work.

Fig. 392. The Nikon image is comprised of dozens of little pieces, which means many many masks. This requirement obliges the artist to begin a second stage of work with a new self-adhesive sheet.

Figs. 393 to 395. Work continues with movable masks and curved templates.

396

397

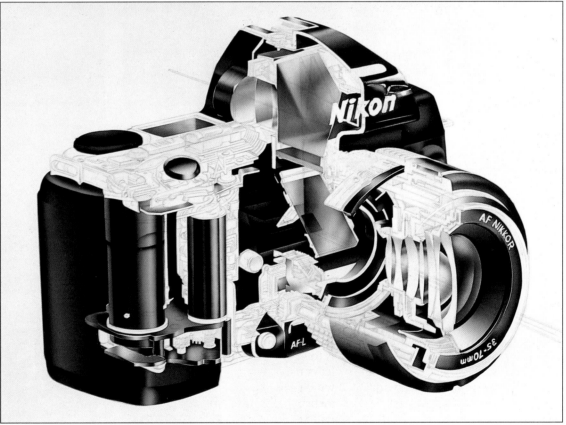

398

Figs. 396 and 397. Ferrón is working with two airbrushes: one for the light colors and the other for the darks. In this way he has no need to clean the airbrushes so thoroughly between color changes. Also, note how he works with the needle uncovered in order to keep the airbrush unblocked.

Fig. 398. The end of the second stage yields the Nikon's basic shapes; work on the small details is yet to come.

The Nikon camera: last stage

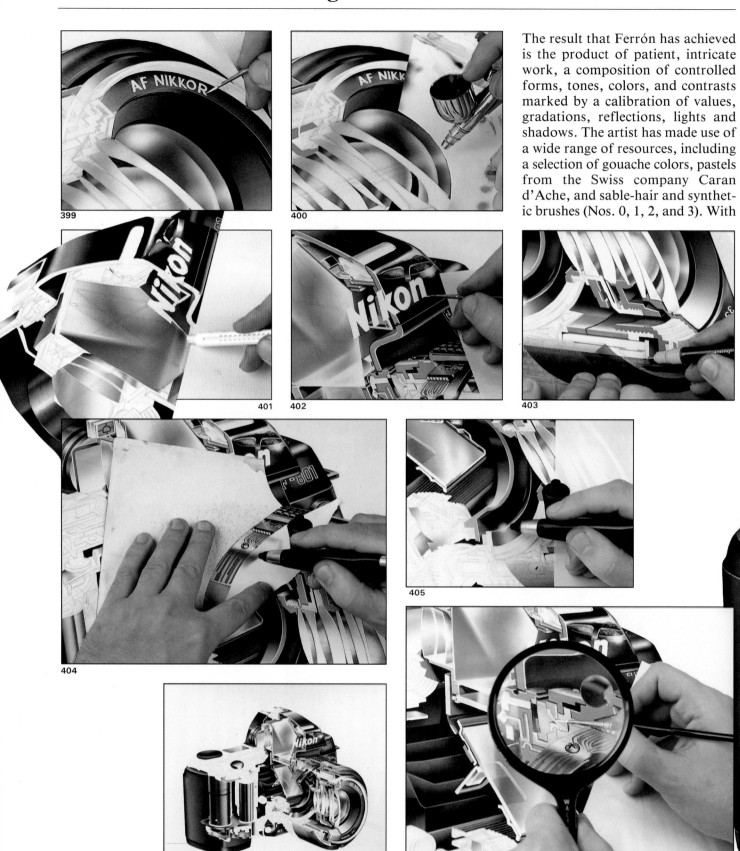

The result that Ferrón has achieved is the product of patient, intricate work, a composition of controlled forms, tones, colors, and contrasts marked by a calibration of values, gradations, reflections, lights and shadows. The artist has made use of a wide range of resources, including a selection of gouache colors, pastels from the Swiss company Caran d'Ache, and sable-hair and synthetic brushes (Nos. 0, 1, 2, and 3). With

399

400

401 402 403

404

405

406 407

these he painted the tiny details, profiled the name plates, retouched and finished the contours, etc. The adjoining images show some of the steps involved in achieving this complex work: the use of curved card masks, drawn with a compass and cut out by hand (fig. 400); the eraser used for determining luminosity (fig. 401); the Rapidograph for drawing precise straight lines (fig. 403); and the use of the new Kodak Aztek airbrush, which is capable of drawing fine gradations, extremely fine lines, and tiny points of light (figs. 404 and 405).

The Aztek and the No. 2 brush with the occasional help of a magnifying glass (fig. 407), have finished off this fine example of a technical drawing, as seen in figure 408. The impact of this airbrush image belies the strenuous work it took to finish it. It boasts an expert harmonization of color, apart from the basic color tone and one or more variants, virtually every piece of the Nikon has undergone at least a gradation, as well as a reflection and a profile highlighted by a light border. Note the local colors and reflected ones enriched by

the diversity of shades, always within a color harmony that seems perfect to the eye.

Figs. 399 to 408. The previous page shows the materials that go into the final phase of work, from the gouache and brush to the magnifying glass and the Kodak Aztek airbrush for the work on the small details. All of this brings us to the splendid end product (fig. 408).

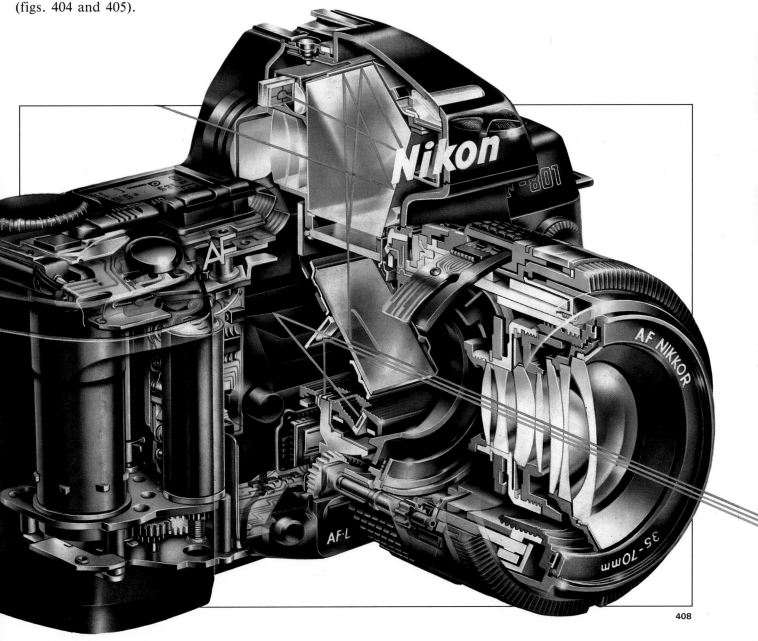

408

Trophy and champagne: an exercise in reflections

Here is a step-by-step examination of how to create the still life in figure 447 on page 133; a silver cup, a bottle of champagne, two champagne glasses, a silver tray, and a rose. This illustration is an object lesson in creating reflections. It also incorporates three basic components in airbrush art, as well as in drawing and painting in general —composition, interpretation, and color theory.

Composition: Plato defined a rule of composition almost 2,000 years ago which is still valid today. Composing, he said is finding and representing variety within unity. Variety in form, in color, in the position of the elements means creating a diversity of forms and colors. But the key is to organize this variety into an order and a unity of the whole. In the model (fig. 447) there is a certain dispersion of elements, a certain disorder: the rose is not integrated into the whole, the bottle's profile coincides with the profile of the champagne glass, the trophy remains visually isolated. Compare this model with the final image by Miguel Ferrón also an page 133.

Interpretation: The blue background in Ferrón's version is more appealing than the green; moreover, it highlights the glasses, thus creating a greater and better contrast with the orange-yellow color of the champagne blue's complementary color. The luminosity of the bottle's light green color defines its volume better; the slight twist of the bottle avoids the excessive symmetry of seeing the label straight on. The light and reflections on the table's surface create diversity and brighten up the image.

Figs. 409 to 413. (opposite page). These images show us the first steps in the illustration *Trophy and champagne,* an exercise in painting shiny surfaces and reflections. In order to paint the blue background (fig. 413), Ferrón wore a face mask to protect himself from the toxic fumes of the turquoise paint. By comparing the final result on page 133 (fig. 448) with the photograph of the model reproduced with it, you can see that the artist has noticeably improved the composition by means of a series of changes made to the background color, the luminosity of the bottle, the position of the glasses and rose, and so on. Ferrón painted this illustration with only three colors plus black.

409

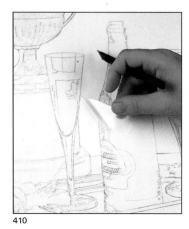

410

411

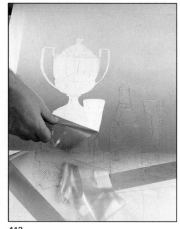

412

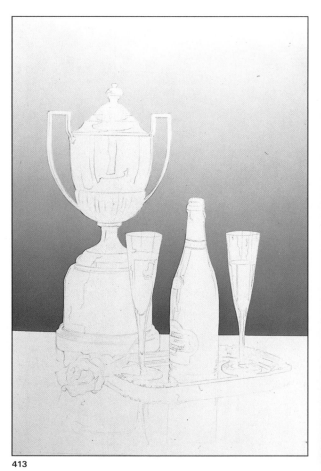

413

Color theory: Ferrón painted this illustration with only three colors and black, confirming the theories explained in the section on color theory. The colors in question —color tints by Holbein Drawing Ink— correspond to yellow primaries, turquoise blue (equivalent to cyan blue), and carmine (or magenta) as well as black. How these few colors can produce the final result will become clear as we follow the development of *Trophy and champagne.* In this work, the artist used a Kodak Aztek airbrush with its interchangeable nozzles, Schoeller paper mounted on cardboard, Schmincke white gouache, a gray pencil, self-adhesive and liquid masks, sable-hair brushes and long-haired synthetic ones, Nos. 2, 3, and 4.

The artist first makes a sketch on grease-proof paper, which is transferred onto the cardboard-mounted Schoeller paper (fig. 409). Next, a self-adhesive mask is placed over the entire drawing; the part covering the background is removed, leaving the mask over the objects and table (fig. 410). Then comes the spraying of the background with turquoise and the separation of the masks corresponding to the trophy, bottle, cups, and table (figs. 411 to 413).

Figs. 414 to 418. Covering with masking liquid the reflections at the base of the trophy and in the tray, and using masks for modeling the form of the base and the table, bring the artist to the end of this second stage, in which the background has been practically completed.

Now the table is sprayed with blue and black, masking liquid is applied over the reflections on the base of the trophy (fig. 414), and then the entire base of the trophy is sprayed in black except for the section masked at its left (fig. 415). The liquid mask is removed with a crepe eraser (fig. 416); the mask at the left-hand side of the trophy is removed so the reflection can be painted (fig. 417); and the drawing of the edge of the tray reflected on the surface of the table is painted, giving the result seen in figure 418 (the patchy areas in the top right-hand section are masks the artist has not yet removed).

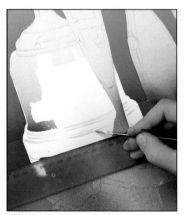
414

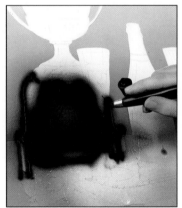
415

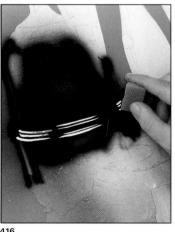
416

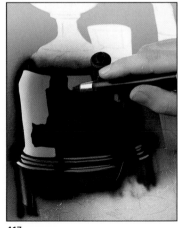
417

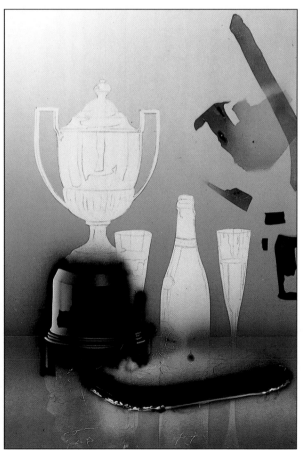
418

Trophy and champagne: second stage

419

420

421

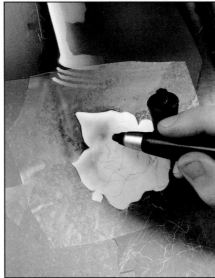

422

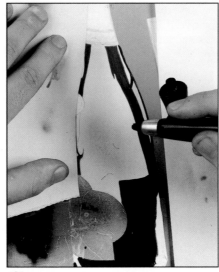

424

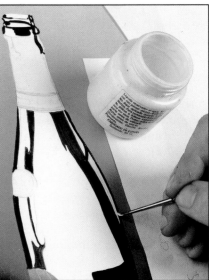

423

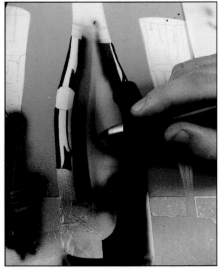

425

Before continuing the step-by-step development of *Trophy and champagne*, it is important to note that Ferrón is painting this image as if it were a traditional watercolor, a procedure in which the use of opaque white paint is prohibited; instead the color white in the final picture is the white of the paper. In other words, Ferrón is painting the colors of light or medium intensity by transparent means, with the aid of the white of the paper. Many inexperienced artists sidestep this rule of painting, instead using watercolors or transparent tints mixed with white gouache to achieve certain light colors. But it is not "clean," it is not professional. In Ferrón's approach, drawing and painting are inseparable, bringing to mind the remark of the French artist Ingres, who said, "You paint in the same way as you draw." So Ferrón starts the next stage of work by drawing with a brush (fig. 419) the images of the forms reflected in the cup, which, he then highlights with the Aztek airbrush (figs. 420 and 421).

This still life brings up a problem of some importance to painters, namely, how to represent silver, gold, or glass. Silver is white and gold is yellow, but in reality they take on the colors that are reflected onto them. A silver cup inside a yellow box could be confused with a gold trophy. The same holds true for gold —there is no one color to represent it only the colors that are reflected on its golden surface.

Figs. 419 to 427. By observing the images reproduced here and on the preceding page, it is easy to see that the artist has completed the tones and colors with the aid of the white of the paper, that is to say, by painting by transparent means. It can also be seen that silver, gold, and glass have no distinct color but rather, reflect the colors of other objects.

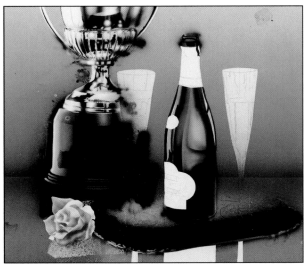

426

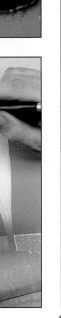

427

428

Fig. 428. In this riew, parts of the image —the trophy and rose— are almost completed, but bottle is still missing details, such as a label and drops of water. As in all works, there comes a final stage for perfecting details, accentuating contrasts, and correcting colors. You can see this by comparing this illustration with the final one (fig. 448).

The same holds for copper, tin, or any other type of polished metal. With respect to glass, it has no color— glass is "white," clear, transparent. We see in it a shine and the colors of other objects that are reflected in or seen through the glass. Perhaps the best advice for depicting these materials comes from Michelangelo, who advised his students on this subject to "copy everything exactly and stupidly."

In figure 422, Ferrón is using a fragment of self-adhesive film to mask off the outline of the rose, which he paints with the Aztek. Then he does the bottle of champagne: The reflection on the right side is reserved with masking liquid (fig. 423), so he can spray the transparent green in the center, a green made up of yellow, blue, and turquoise. This hue contrasts with the dark green (more blue than green) and black that appears around the outside of the bottle (figs. 424 and 425). Now Ferrón paints the labels with a mixture of carmine, yellow, and a little black in order to achieve a somewhat muddy red (figs. 426 and 427). Finally, he removes the masks that are covering the glasses, the tray, portions of the rose, and the base of the trophy (fig. 428).

Trophy and champagne: third stage

The painting is almost done. First the tray is finished, then the reflection of the rose and the base of the trophy on the table, and finally glasses and the champagne inside them.

The tray is the product of whites and reflections that were reserved with masking liquid (fig. 429); and a quick, somewhat transparent, spray with turquoise blue on the surface of the tray (fig. 430). The base of the left-hand glass and the tray's molding are finished off (fig. 431), and the masking liquid removed with a crepe eraser (fig. 432).

Completing the rose's reflection and that of the base of the trophy (figs. 433 to 435) is an easy freehand job, accomplished without masks, thanks to the Aztek airbrush. "It's like a pencil," says Ferrón.

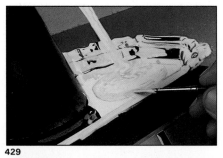

429

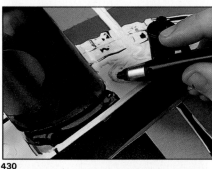

430

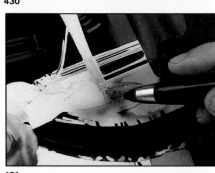

431

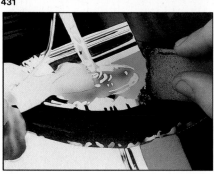

432

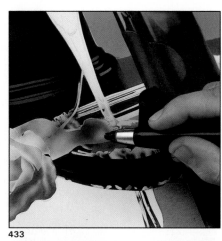

433

434

435

436

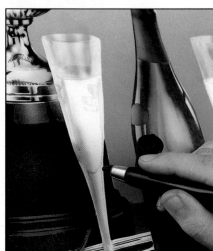

437

Figs. 429 to 437. Attending to details is painstaking work involving using masking liquid on the shiny parts of the tray and adjusting forms and colors with the Aztek airbrush, which handles fine work with the ease of a pencil or brush. Lines, points, and profiles are adjusted and defined freehand, as if the artist were painting in a traditional mode.

"You can draw fine lines and details as thinly as you might with a pencil." Finally Ferrón starts the drawing and painting of the glasses and champagne, with the help of masking liquid, self-adhesive masks, and the Aztek (figs. 436 to 439).

Reaching the end of this third stage of work (fig. 440), it seems as though the illustration is already complete. But there are still a few finishing touches needed, as seen on the following pages.

Figs. 438 to 440. The masking liquid and Aztek airbrush almost complete the glasses, as seen in this penultimate image (fig. 440). All that remains is the final retouching and the addition of highlights and reflections.

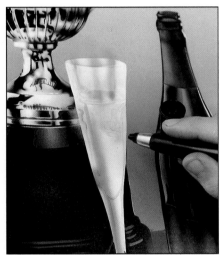

438

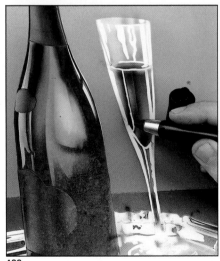

439

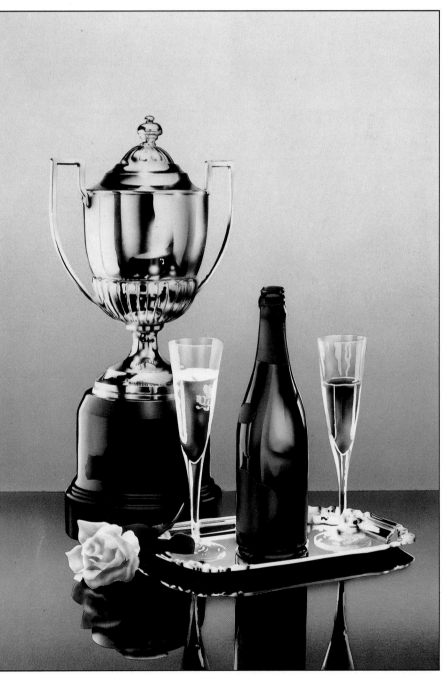

440

Trophy and champagne: fourth and final stage

441

442

443

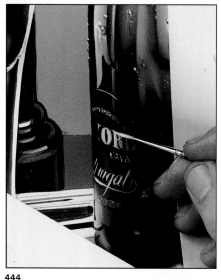

444

445

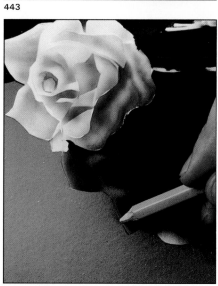

446

These final details, shown in figure 441 to 446, include retouching and profiling whites and reflections, perfecting forms, painting the champagne's bubbles in the glasses, writing out the labels (using different colors to reproduce the shine of the golden letters), painting the drops of water on the green glass of the bottle, and, last, highlighting contours with a gray pencil.

Before announcing the completion of his work, Ferrón painted the top part of the background with a coat of transparent pink and then lightly sprayed the same color on the trophy creating a soft reflection. *Trophy and champagne* is now complete.

Figs. 441 to 448. "This is the most agreeable phase, or perhaps the most passionate," Ferrón says as he paints, draws, retouches, and applies the finishing touches with a brush. He highlights the shine of a glass, accentuates the color values of the rose, draws in the champagne bubbles, highlights the letters on the bottle's label, and adds small but important details such as the pink color in the upper part of the background, subtly reflecting in the trophy. He also adds or accentuates lights at the base of the trophy, in the projected reflections on the table, and in the glasses. Before finally leaving the illustration, Ferrón adds star-shaped points of light at the foot of the trophy and on the border of the tray.

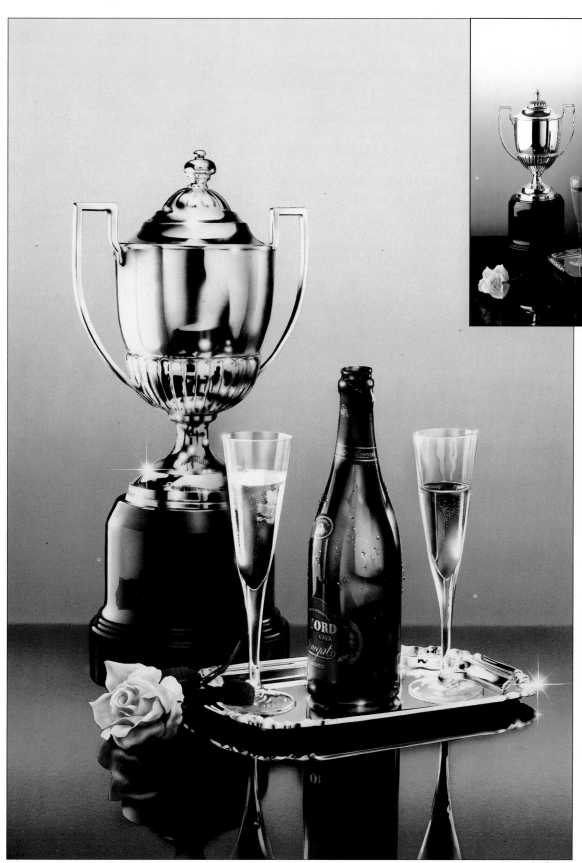

447

448

Painting the head of a woman with soap bubbles

This is the big number in our program: the head of a young woman, problematic in terms of the flesh color and hair —the latter made even more difficult because the hair is curly. Another problem is posed by the back-lit illumination. As if all that were not enough, the woman is holding a little tube in her mouth through which she is blowing soap bubbles. Let's first look at the materials and equipment Miquel Ferrón will employ when he paints this image. In figure 449 from left to right and top to bottom we can see a rolled-up sheet of polyester for making masks (a); a special pencil sharpener for colored pencils (b); a can of Best-Test rubber cement (c); a jar of masking liquid (d); a set of Caran d'Ache gouaches —14 colors in cake form, plus white in a tube (e); the Kodak Aztek airbrush (f); a box of 42 Cumberland colored pencils (g);

a compass and ruling pen set (h); a selection of Schmincke Aerocolor paints (i); scissors, tweezers, and crepe eraser for removing masking liquid (j); a lead pencil (k); brushes, Nos. 0, 1, 2, and 3; two ceramic cutters, one designed for cutting curves; and a ruler (l).

Ferrón will use a sheet of 13-by-13-in. (44-by-34-cm), fine-grain, 140-1b (300 gm) matt Schoeller paper. This is a thick paper that allows him to paint without the need of mounting it on a backing. Besides his Kodak Aztek, Ferrón will also use a Richpen Apollo to paint the blue of the background.

Keep in mind some important facts about these materials. During the summer, self-adhesive masks produce certain residues that create defects in the picture's finish. This is why Ferrón is using polyester. When used as a mask, polyester is

equally transparent and can be cut with the same facility. To attach it to the support, rubber cement is applied, a process that gives more control over the register. This is sometimes more complicated with self-adhesive masks. The Richpen has a fixed tank with a capacity of 7 cc, enough to avoid having to refill it too often. And Schmincke Aerocolor paints can be opaque or transparent depending on the amount of water you mix with them. When dry, they are not soluble and offer a matt-like appearance.

Ferrón starts the illustration by making an enlarged photocopy of the initial photograph and transferring it as a line drawing onto the Schoeller paper. He then masks the drawing with the polyester and rubber cement and cuts out the background mask (figs. 450 and 451), leaving the figure's mask intact for the moment.

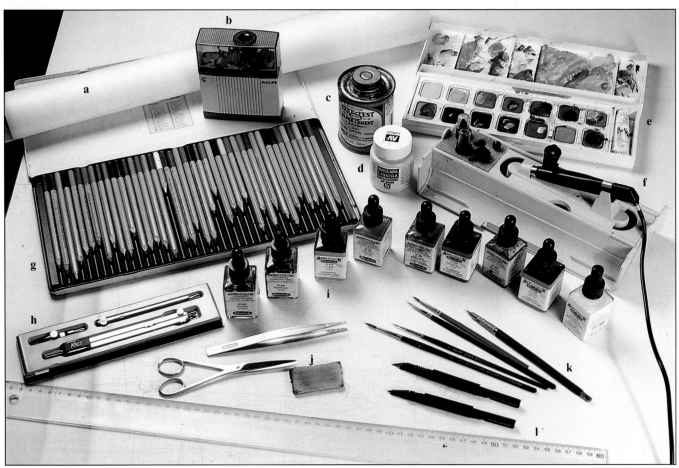

449

Then he paints various coats of blue, wearing a facial mask to protect himself against the cyan blue's toxic fumes (fig. 452). With the background completed, he uncovers the figure (fig. 453) and covers up the background (fig. 454). Now he masks off the little tube or straw that the woman uses for blowing the bubbles with masking liquid (fig. 456), and then he starts to use the Kodak Aztek airbrush, first testing the flow and thickness as well as the color intensity on a separate piece of paper. This operation will be repeated time and time again during the painting process (fig. 455). Now he begins painting the face's flesh color with a mixture of sepia, scarlet, and ochre, behind which he must make judicious use of the white of the paper (figs. 457 and 458).

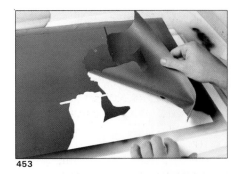

453

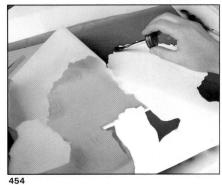

454

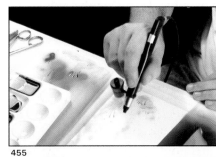

455

450

456

457

451

452

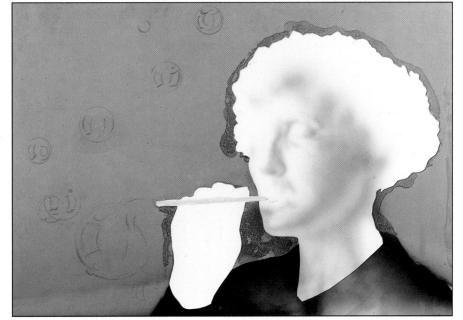

458

Second stage: color sketching of the features

459

461

460

462

Airbrush painting requires total mastery of the art of drawing, considering proportions, making mental calculations, positioning shapes, and plotting each illuminated and shaded area.

Ferrón is accomplishing this as if he were draw-painting with a traditional medium, painting the face's features, freehand. He delineates the shape of the eyelids, nose, cheekbones, cheeks, chin, and neck, painting them all with the "stroke" of this very unique airbrush, the Aztek. "Sometimes it feels as if you were painting with a colored pencil, such is its adaptable constant fluidity," he says. Although painting freehand, at certain moments Ferrón employs a mask or some type of template, curved or straight, to paint a particular profile, such as the one under the nose (fig. 459).

The flesh color being used to paint the face has an orange tone that is somewhat strident. But the artist notes that this is a base color, "a background color over which I am thinking of determining forms, superimposing other shades in which carmines and blues can intervene in order to complete the forms, colors, and shaded portions." In fact, Ferrón now applies a very soft spray of ultramarine blue to the shaded part of the left-hand side of the face. Then he paints with a dark sienna, evaluating the play of light and shade in this area of the face (fig. 460).

463

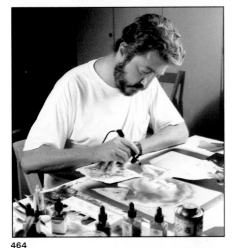

464

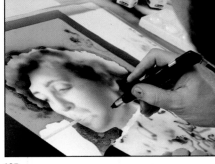

465

466

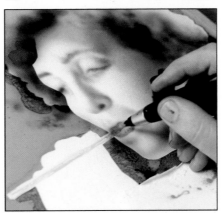

467

With the initial mask he used to cover the face, Ferrón masks the forehead and begins painting the hair (fig. 461). Afterwards, painting exclusively freehand with the sporadic help of an improvised mask (fig. 466, where the lips are profiled), Ferrón continues with the hair and face. He works on the details of the eyebrows, eyes, and lips, as well as on the completion of the chin and neck (fig. 465), until we can even see the beginnings of the form and base color of the hand (fig. 468).

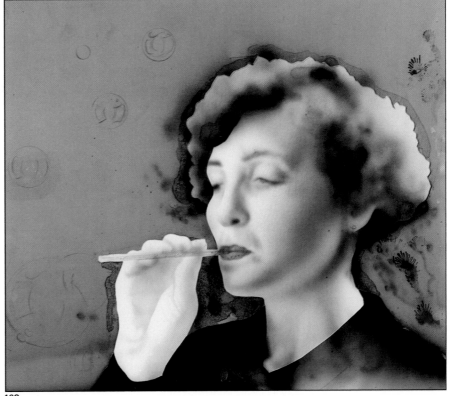

468

Third stage: the perfecting of the figure

469

471

472

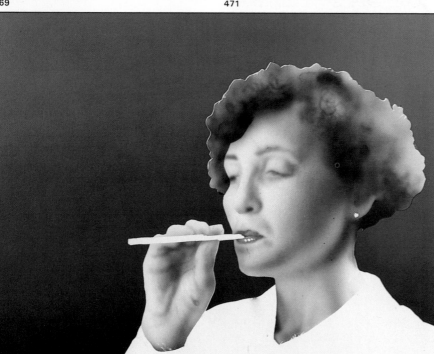

470

473

And with the brush, colored pencils, and the occasional use of the airbrush (figs. 472 and 473), Ferrón draws and paints, intensifies forms and colors in the face and hand, balancing the contrast between figure and background.

Ferrón is painting at the moment like a hyperrealist who is working with a classical procedure like gouache. He paints and draws with a brush over the base color that was applied with the airbrush. He paints the right eye in black and white, and the border of the lower eyelid and the eyelid fold in flesh tones. In the end he is painting with all the colors and shades that belong to the human face.

Ferrón begins this third stage by removing the general background mask and the one covering the woman's dress, as well as the adhesive tape that was covering the margins. With the crepe eraser he eliminates the masking liquid on the little tube (fig. 469), the two points of liquid gum in the earring, and the shine of the lower lip. While he retouches the shine of the lower lip (figs. 470 and 471), a tonal imbalance between the figure and the background is noted (fig. 471). This effect is produced by the law of successive contrasts, according to which the figure's light colors seem lighter due to the inten-

sity of the background. The artist will adjust this soon, when he starts to work on intensifying the color of the hair and face.

"In a half-finished image like this one," says Ferrón, "it's normal that some aspects can be improved. In figure 471 there is a certain displacement between the figure's mask and the background, a lack of register which is noticed in the limits of the background. But these apparent defects —hard outlines, displacements in respect to the background, and so on— are resolved with retouching, using a brush along with the airbrush. You'll see."

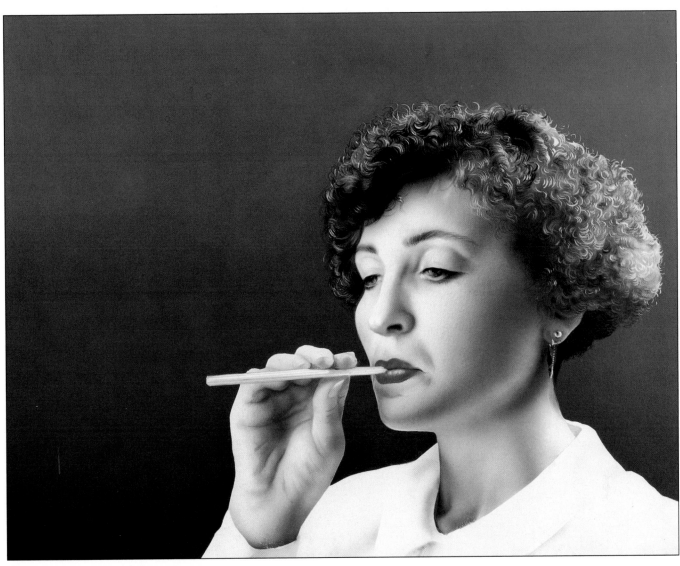

474

He also paints tones that configure lights and shades, such as the soft shine of the nose, the shape and color of the eyebrows, the shadow of the eyelid.

Then, with a mixture of black and dark sepia and using a No. 0 brush, Ferrón starts painting and drawing the spirals that represent the curls of the hair (fig. 473), at the same time establishing the limits and contour of the hair in regard to the background. Without haste and without pauses, he draws and paints each curl, spiral by spiral, alternating dark colors with light ones. Among them are, natural sienna, orange, and white. Sometimes it's necessary to repaint over holes that let the blue background show through. The result of this patient work is seen in figure 474.

Fourth and final stage: soap bubbles and the finish

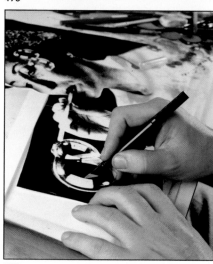

475

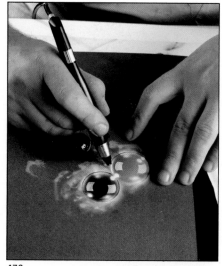

476

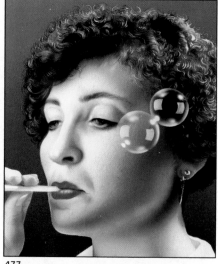

477

478

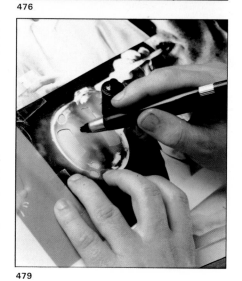

479

480

We are now in the final stage: Ferrón has first painted the blouse, then he will paint the bubbles, and finally he will do the finishing touches, retouching some points, intensifying color, accentuating contrasts, gradations, and contours. "When contours and forms are profiled with gouache and brush, the image hardens," he says. "It loses its sensation of atmosphere, of a flowing image. But this effect can and must be recovered with later work of the airbrush on these forms and contours. What's important is seeing it, I mean seeing the defect, so as to modify and improve it."

Ferrón is now carrying out work on the figure's finish, highlighting, intensifying, and harmonizing the work with brush and airbrush. He softens contours and contrasts in an attempt to return the finish to its original state through patient, careful work (compare the previous stage with figure 481).

Finally, once the hand and head are totally finished, Ferrón starts on the bubbles. From an ordinary piece of cardboard he cuts circles the same size as the bubbles situated on the face. He places these masks on the image and paints the most intense shines and reflections with gouache and brush (fig. 475), then draws the spheres of the bubbles with the airbrush (fig. 476).

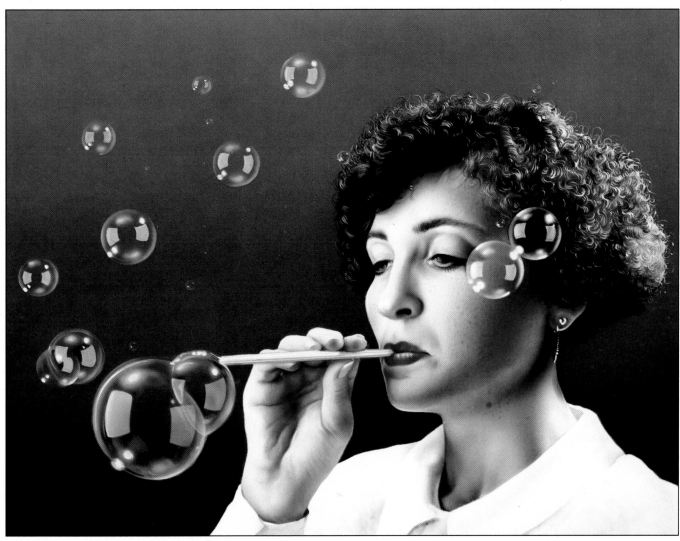

481

"This is one of the major difficulties of the airbrush from an artistic point of view," he says. "You work almost blind, without the possibility of controlling whether the colors come together, or whether they contrast or not. You don't know anything, you must memorize, remembering what there was and taking a risk until you lift the mask to see if you did it all right or not" (fig. 477). He then proceeds with the remaining bubbles on the blue background (figs. 478 to 480) and stops his work. "I prefer to wait until tomorrow, look at it again, and decide if it's finished." The next day Ferrón goes back to blacken the eyes, paint a light blue reflection in the bubbles on the face, lightly darken the color and the drawing of the eyebrows, and add more and more spiral curls in the hair. The final result: figure 481.

Glossary

A

Acetate. Transparent film used in animation that is employed to cut movable masks in airbrushing.

Acrylic paint. Medium made up of colors manufactured with synthetic resins. It is soluble in water, but, once dry, forms a waterproof film.

Airbrush eraser. A very sophisticated airbrush; instead of painting, it sprays abrasive material to erase the paper or canvas.

Air filter. Unit placed between the exit of the compressor and the airbrush to eliminate any particles in the air being compressed and to control humidity.

Air valve. This allows the air to pass through the airbrush nozzle and can be controlled at will.

Alignment screw. Found in some airbrushes, it allows the user to fix the lever in a certain position.

Atomization. The mixing of paint and air under pressure in order to form an aerosol spray. Atomization is internal when it is produced within the body of the airbrush, external when it is produced outside of it.

C

Card. Some quality papers, especially those designed for the airbrush, are produced already mounted on cardboard supports, forming a single compact, rigid piece. The drawback is that most cardboard supports cannot be mechanically reproduced with the scanner system of printing.

Compressor. A mechanical air pump that produces air at a determined pressure. In tank compressors, the air is stored inside a tank where its pressure is constantly maintained.

D

Deckled edge. Uneven, or "feathered" border of handmade drawing paper. Feather edges are a characteristic of quality paper.

Double-action airbrush. Airbrush designed so that the air and paint flows can be regulated by the control lever. Double-action airbrushes can be independent double-action, when the same lever controls the quantity of either air or paint, independently, or fixed double-action, when the quantity of air and paint are controlled in a fixed proportion for each position of the lever.

E

Enamel. Cellulose-based paint that is diluted in turpentine.

F

Feeding. System by which the paint is incorporated into the air flow. Feeding is by *air suction* when the air, having formed a depression at the exit of the paint tank (situated under the air-flow pass), sucks out the color. It is because of *gravity* that paint in the tank, on top of the air flow pass, drops into the path of the air flow.

Fixative. Liquid that is sprayed onto drawings and paintings when the medium employed (pencil, charcoal, pastel, and others) can be easily removed or smudged. It is sold in aerosols and in jars, to be applied with a mouth pulverizer.

Fixed masks. These masks are affixed to the surface of the illustration or held there immobile with the hand or some other attachment.

Frame. Wooden frame, sometimes folding, used for mounting a canvas.

G

Glaze. Transparent coat of paint applied on an area or on the whole surface of a work, with the object of modifying existing colors.

Glossy paper. Low-grain paper, generally semi-matt, very adequate for airbrush work with tints and special colors.

Gouache. Similar to watercolor, this medium is characterized by its opaque colors and matt finish.

L

Lacquer. Natural lacquer is a natural resin substance that derives from certain trees in India and, diluted in alcohol or a similar solvent, yields quality varnishes.

Linseed oil. This dryish oil, obtained from seeds, when mixed with turpentine is the best solvent for diluting oil paints.

Liquid watercolor. These pigmented liquids, diluted in water, are very good for airbrush work due to their transparency and the intensity and high luminosity of color.

M

Mask. In airbrush painting, a mask is any type of covering that protects parts of an illustration that are not supposed to be painted.

Masking film. Very fine, transparent, self-adhesive film used for covering ("masking") surfaces of a picture that should not be touched by the paint spray.

Medium. The type of color used in a painting —watercolors, oils, and so on. Medium is also the term for the liquid vehicle in which pigments are bound. For example, linseed oil is a medium of oil painting, and gum arabic diluted in water is the medium of watercolor.

Movable masks. These masks are not fixed but are held, usually at a distance from the canvas, by the hand. They can be moved or dragged as the artist paints, yielding either sharp contrasts or irregular, somewhat shaded contours.

N

Needle. A component of the airbrush that controls the quantity of paint flow through the nozzle.

Nozzle. Normally cone-shaped, it encloses the airbrush needle in whose interior atomization takes place. Some airbrushes have interchangeable nozzles that permit different spray thicknesses.

P

Perspective. The science of drawing that teaches how to represent the effects of distance on shapes and the position of objects. Perspective varies according to where the viewer is.

Pigment. Substance of mineral, animal, vegetable, or synthetic origin that, when mixed with a binder, yields what we call a color.

Primary colors. The basic colors of the solar spectrum. The primary light colors are red, green, and dark blue, while the primary pigment colors are magenta, cyan blue, and yellow.

Primer. Traditionally, a coat of plaster and glue that is applied to a canvas or board to prepare the surface for painting; nowadays, this term usually refers to a primary coat of gesso or acrylic white on a painting surface.

Pulverizing. The spraying with a wide squirt to obtain a granulated effect.

R

Regulator. It is found in compressors to adjust the amount of pressure desired for each spray. Many incorporate an air filter.

Resin. Rubbery substance, natural or synthetic, that hardens when dry. Resins are the base of varnishes and binders for different mediums.

Retouching. Modification of an already existing image. In airbrush work, retouching normally refers to the photographic image.

Rubber cement. Latex solution that is very useful for masking small details of a painting. Once the painting is done the cement is removed by rubbing with the fingers or with a pencil eraser.

S

Security valve. Automatic valve that opens when there is too much pressure in the compressor tank.

Single-action airbrush. Those airbrushes whose control systems permit the user to regulate the air flow not the paint flow.

Support. Any surface on which a picture can be drawn or painted —canvas, paper, board, and so on.

T

Tank. *In the compressor*, a tank in which air is compressed. *In the airbrush*, the tank is the paint holder. It is connected to the air-flow pass through *the feed tube.*

Texture. Visual and tactile quality of the surface of objects and material in general. In painting it is the quality of the surface, or finish, of a painting; it can be smooth, rough, fragmented, or granulated.

Turpentine. A vegetable-oil-based substance that along with linseed oil, is the principal solvent for oil paints.

V

Value. The relative lightness or darkness of a color, often determined by the effects of light and shadow on a given model.

W

Watercolors. Dry or paste colors formed of pigmented gum arabic. They are soluble in water and are very transparent.

Acknowledgments

The authors would like to extend their thanks for collaboration of the following people and companies: to Casa Teixidor, for their advice on materials and their use; Prisma, S.A., Radio Costa, El Ingenio, MB Juegos, S.A., Finicón, S.A., and Trofeos Mincar, S.A., for materials, models, and objects that were used for several illustrations; to Remei Piqueras and Joan Fabregat for their collaboration as models; to the artisans Eugeni González, Doñato García, and José Peña, for their industrial-type painting work, and also to the artists Gottfried Helnwein, Ramón González Teja, Philippe Collier, Yoichi Hatakenaka, Masao Saito, and Evan Tenbroeck Steadman, for the works that they so kindly lent us for publishing in this edition.

We would also like to thank the following artists:
Hideaki Kodama, Spoon Co., Ltd., Osaka, Japan.
Shiro Nishiguchi, Spoon Co. Ltd., Osaka, Japan.
Yu Kasamatsu, Pt W-4 - 4-3, Sengen-cho, Fuchu-shi, Tokyo, Japan.

Copyright © 1990 by Parramón Ediciones, S.A.

First published in 1990 in the United States by Watson-Guptill Publications, a division of BPI Communications, Inc., 1515 Broadway, New York, NY 10036.

Library of Congress Cataloging-in-Publication Data

Parramón, José María.
 [El gran libro técnico del aerógrafo. English]
 The big book of airbrush: basic techniques and materials / José M.
 Parramón and Miquel Ferrón.
 p. cm.
 Translation of: El gran libro técnico del aerógrafo.
 ISBN: 0-8230-0164-4
 1. Airbrush art. 2. Artists' materials. I. Ferrón, Miquel. II. Title.
 NC915.A35P3613 1990
 751.4'94—dc20 90-38581
 CIP

Distributed in the United Kingdom by Phaidon Press Ltd., Musterlin House, Jordan Hill Road, Oxford OX2 8DP.

All rights reserved. No part of this publication may be reproduced or used in any form or by any means—graphic, electronic, or mechanical, including photocopying, recording, taping, or information storage and retrieval systems—without written permission of the publisher.

Manufactured in Spain
Legal Deposit: B-23.701-90

1 2 3 4 5 6 7 8 9 / 94 93 92 91 90